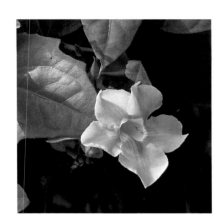

Terrestrial Paradise

Terrestrial Paradise

OVIDIO GUAITA

Botanical notes by Laura Cucé

THE MONACELLI PRESS

First published in the United States of America in 1999 by
The Monacelli Press, Inc.
10 East 92nd Street, New York, New York 10128.

Copyright © 1998 Leonardo Arte S.r.L., Milan
English edition copyright © 1999 The Monacelli Press, Inc.

Library of Congress Cataloging-in-Publication Data
Guaita, Ovidio.
[Il giardino nel mondo. English]
Terrestrial paradise / Ovidio Guaita.
p. cm.
Includes bibliographical references.
ISBN 1-58093-036-0
1. Gardens. 2. Gardens—Pictorial works. I. Title.
SB465.G83513 1999
712—dc21 98-52139

Printed and bound in Italy

Translated from the Italian by Lawrence A. Taylor

Contents

Terrestrial Paradise

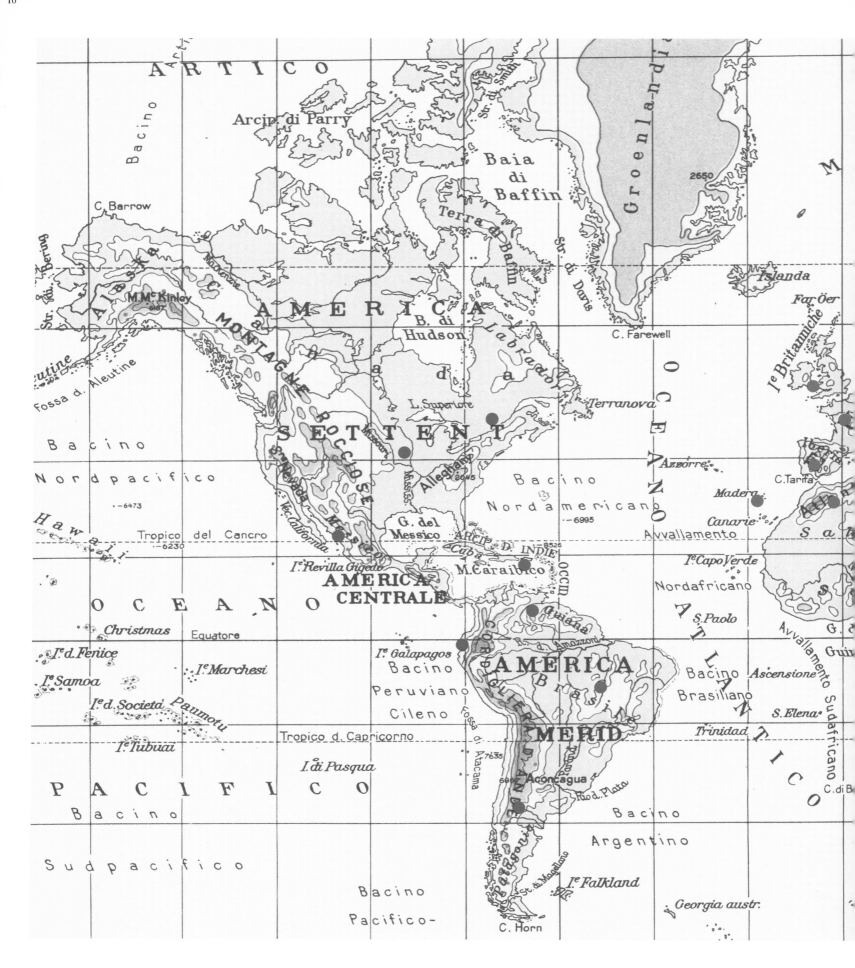

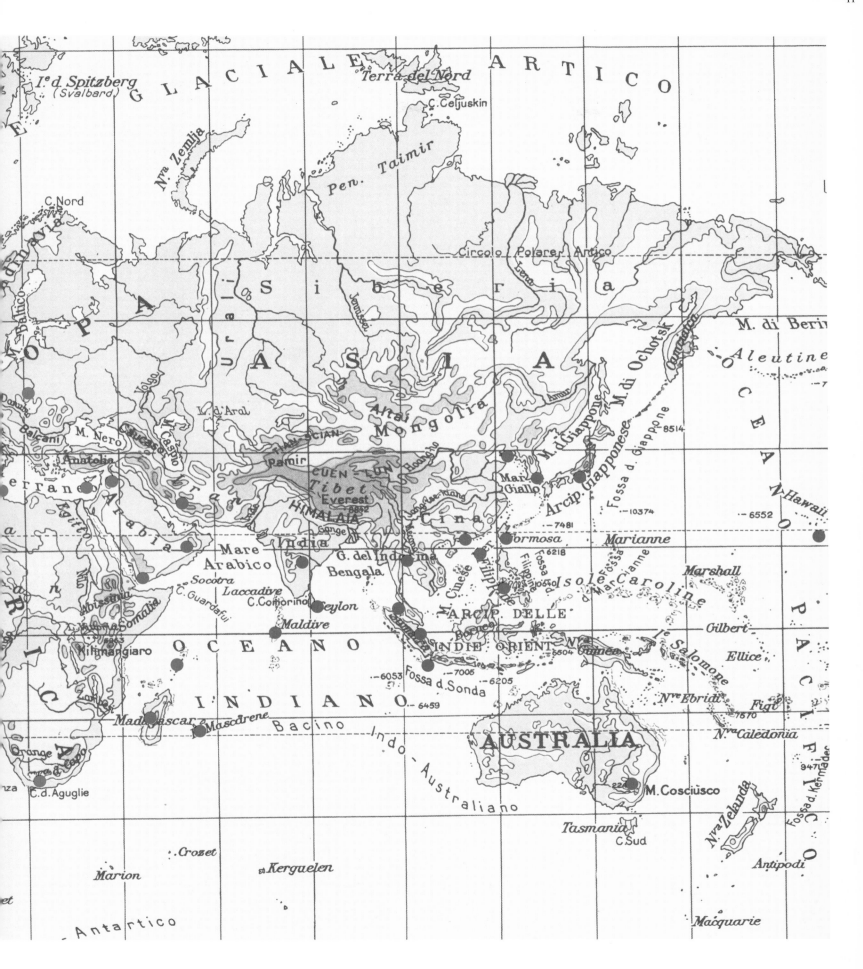

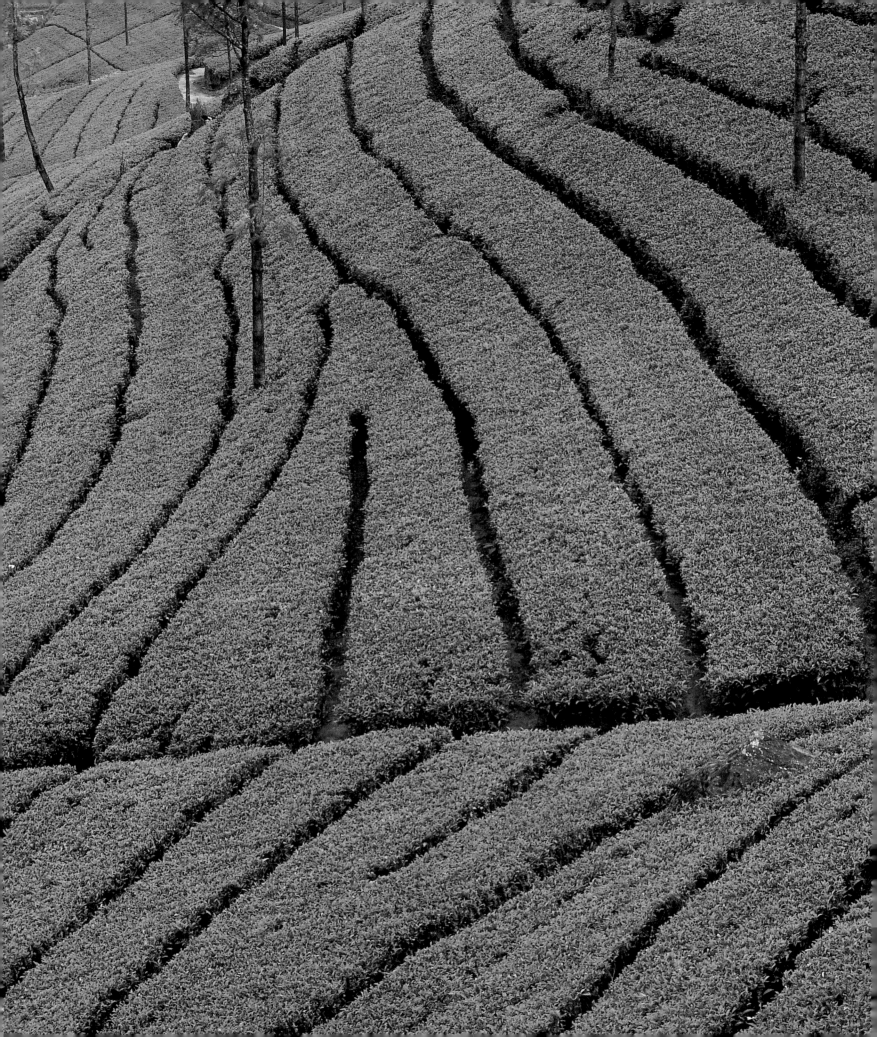

Terrestrial Paradise

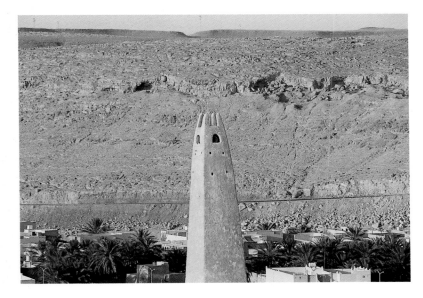

Above:
The oasis of Gardaïa in Algeria, which represents, like other oases, a garden prototype.

Right:
The remains of the park of Maruhubi, a stately residence in Zanzibar.

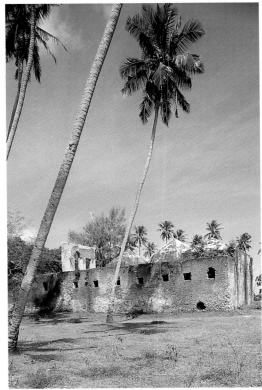

Opposite:
Long narrow paths cutting the hills of Sri Lanka, where renowned tea plantations are found.

Eden—terrestrial paradise—is the ancient reference for the garden. It communicates nostalgia for a place of perfection and represents the aspiration for an idyllic symbiosis with nature in a place of peace, well-being, and prosperity. It recalls the original ideal of life later lost, but promised for the afterlife; constituting an unattainable model, a primitive form, it has survived through the centuries as an important conceptual prototype.

In the Middle East, the roots of the garden are found in the contrast between oasis and desert. For peoples accustomed to living in an arid and inhospitable environment, paradise could be represented only by a place covered in luxuriant vegetation and graced with the continual flow of water, the most rare and precious luxury. Thus the garden emerged as a plot of nature organized according to humankind's needs; it both nurtures the body and delights the senses and the mind. Contemporary Middle Eastern gardens unite natural beauty and artistic beauty while evoking the four elements of water, air, earth, and fire. The green spaces are thus places of well-being that are generally isolated from daily life by tall hedges and walls. In addition, the garden often expresses religious and sacred meanings.

The first gardens documented (through written descriptions only) are the *paradeisos*, large green spaces found in the Orient; they were for the first time so named in the Greek translation of the biblical text *Gan'eden*, produced in the third century BCE. Ideal places of perfection, these gardens were carved out of terraces supported by pillars and volutes and planted with herbs chosen for their beauty and fragrance, or for their medicinal or magical powers; Homer described them as a triumph of the senses.

In China, the art of Oriental gardens arose around the third century BCE during the Qin and Han dynasties but only in the first century CE did it reach a mature style, which would influence the traditions of many countries, including Korea and Japan. Korea and Japan, however, very soon developed their own styles and traditions. The designers were poets and painters, once again emphasizing the close relationship between gardens and the arts. Inside these great spaces were numerous buildings amid pools and ponds; the water is synonymous with tranquillity and does not reproduce the movement and gaiety of European traditions.

Paintings found in Egyptian tombs evince the diffusion of the garden in Africa, showing enclosed spaces with fruit and palm trees, pools populated with aquatic animals, and architectural pavilions. These models were assimilated and passed down by the Persians, who occupied Egypt in the sixth century BCE. Combined with Greek culture, such traditions were transmitted to the Italian peninsula by the conquests and commercial exchanges of the Romans, spreading a principle of aesthetic domestication of nature previously unknown in the region.

Virgil concludes the *Georgics* describing certain villas he visited: "rosebushes of *Pesto* flowering twice a year . . . narcissus which later blooms . . . the curved acanthus trunk and . . . the pallid ivy and . . . the graceful myrtle of the seaside." The phenomenon was so widespread that Horace emphasized that "very little space will

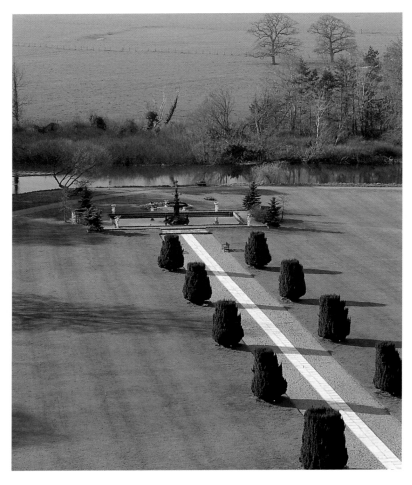

Above:
A symmetrical garden alley at Kildare Manor in Ireland.

Right:
Dwarves and mytho-logical personages in the theater of greenery at Lotusland in Montecito, California.

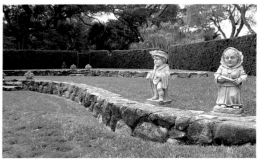

Right:
A curious "green" sculpture in the park of the Sofitel Hotel in Hua Hin, Thailand.

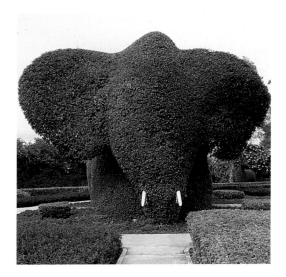

now be left for the plow around the superb palaces; pools bigger than Lake Lucrino will be seen everywhere. The celibate plane tree will triumph over the oak; bunches of violets and myrtle and all the gaily colored families of flowers will spread perfume" (*Carme* II, 16); he lamented the attention dedicated to gardens rather than to agriculture. But most other writers celebrated the garden as a place reserved for intellectual leisure, where people could forget the trials of daily life due to the contact with nature and the distance from the city.

In imperial Rome, urban gardens were composed of terraces, staircases, birdcages, and peristyles—ample courtyards delineated by porticoes and a pool in the center—housing rich collections of art and rare and exotic animals. With or without the peristyle, the green space was delimited and divided by perpendicular alleys with fountains and basins at the crossways. The few existing representa-tions of imperial gardens show luxuriant plant life, birds, flowers, dwarf plants, and numerous channels and jets of water on series of terraces. Great importance was given to topiary art, and myrtle, cypress, laurel, holm oaks, and box hedges were pruned into inter-esting and unusual forms. Each component, each illusory space in the gardens, contributed to an intense interplay between nature and construction. Roman gardens are the first known examples of architectural green spaces where geometrical organization origi-nated from the axes of symmetry, representing the ideal interrela-tionship of house and nature that would become characteristic of the Renaissance.

In the sixth century CE Japan began to develop its own garden traditions, which would gradually become quite different from the Chinese style. The *Sakuteiki* ("The Garden Book"), a ninth-century manuscript that is the oldest treatise on the art of the Japanese garden, recommends that the garden designer reproduce natural nature in its various aspects, that a project mirror the per-sonality of its creator, and that the green space be harmoniously inserted into its site. Later, in the thirteenth and fourteenth centuries, the Buddhist monk Kemko wrote the *Tsurezuregusa* ("Moments of Leisure"), a classic of Japanese literature, in which he says: "The autumnal moon is of incomparable beauty. He who imagines that the moon is always the same, independently of the seasons, and therefore incapable of seeing how different it is in autumn, must really be deprived of sensitivity." In the same way the Japanese garden is ever changing; miniaturization, abstraction, synthesis, and simplification transform it into a philosophical work where the presence of humankind is seen as an intrusion. Each green space represents the search for an absolute form, for a pure and enchanting place.

After the Roman Empire was divided into provinces, the politi-cal center of the ancient world was displaced toward the east. The pillage of Alaric and Genseric dispersed the artistic sensitivity and technical knowledge necessary for the conception and realization of gardens. Moreover, the advent of Christianity had introduced new values to test and, in a certain way, to punish the body and spirit rather than gratify them. At the fall of the Roman Empire

neither villas nor gardens survived; these works—and the lifestyle associated with them—disappeared.

Interest in nature and cultivated green spaces was slowly rekindled, starting with a new appreciation for the countryside and the attempt to reproduce it in miniature inside an enclosure. A noteworthy influence was exercised by the Arabs, who upon their arrival in Sicily around the ninth century imported new varieties of cedars and citrus, refined Babylonian and Egyptian irrigation techniques, and indulged a taste for growing olives, pomegranates, almonds, apricots, and pears. In fact, it was in gardens—whether those of the Mediterranean or those of the Near and Middle East—that the Arab genius was best expressed. In the search for a serenity imitating paradise, the senses were fully gratified: sight, by colors; smell, by perfumed flowers; taste, by succulent fruits; touch, by fresh leaves and light breezes; hearing, by the murmur of water and the songs of birds. The poet Ibn Básrûn described King Roger's realm of Palermo: "Here are the gardens, which vegetation has clothed in delicate prizes, / Covering the fragrant ground with draperies of silk from Sind! . . . See the trees laden with the most exquisite fruit; / Hear the chattering birds who, according to their way, compete to greet the dawn from the horizon!"

Emperor Friedrich II, nephew of Roger the Great and keeper of a learned court of artists and writers, preserved the tradition of Norman gardens—itself descended from Arab precedents—testifying to the Muslim style of construction brought from the Orient. The forms of such medieval green spaces—royal courts and monasteries—were reduced to essentials: a field with a well at its center, two perpendicular paths bordered by flowers and aromatic and medicinal herbs and spices. Gradually fruits took on a more important presences in the cloisters: apples, pears, peaches, and almonds and—surrounding the religious complex—vines, olive trees, and orchards that quickly transformed themselves into experimental sites for new agricultural techniques brought from the Saracens and as a result of the Crusades. The augmented cloister was important not only as a physical center but also for its role in the spiritual and intellectual life of the monks and for the cultivation of useful herbs. The cloister garden achieved high levels of refinement, so much so that in 1216 in certain places it was prohibited to keep exotic birds or flowers in cloisters for pleasure.

Unlike the medieval cloister, the garden of the early-fifteenth-century humanists was a space in evolution. It was geometric and sometimes enclosed, underlining its position at a remove from the outside world. It was a place for ideal life but contained the first iterations of those dynamic elements created by humankind that projected their forms into surrounding nature. Long paths of gravel or pavement intersected, creating small piazzas and flowerbeds. At the center was a fountain elevated on a platform, and at the borders arose pergolas covered in ivy and other climbing vines to shade fanciful stone seats. Vases of flowers and citrus plants also provided decoration. In the fifteenth century, the pleasure garden was differentiated from simple gardens, where useful plants were grown; from herbariums, where precious botanical

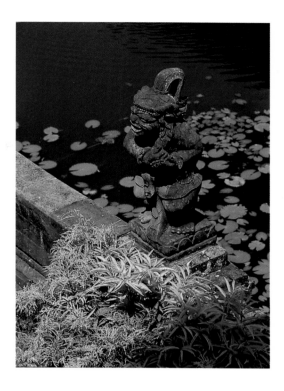

The guardian of a fountain in Indonesia, where each house has its own protective spirit.

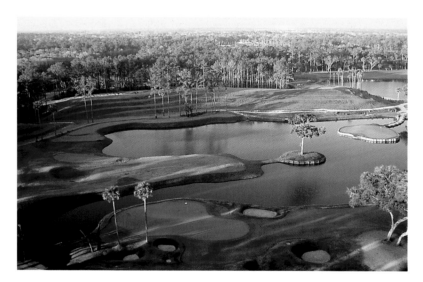

An exemplary union of garden and landscape in the golf course in Sawgrass, Florida.

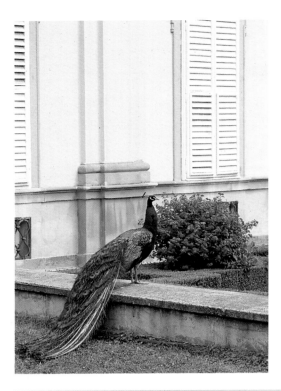

*A garden peacock,
chosen to adorn the
landscape because of
its elegant appearance
and multicolored
feathers.*

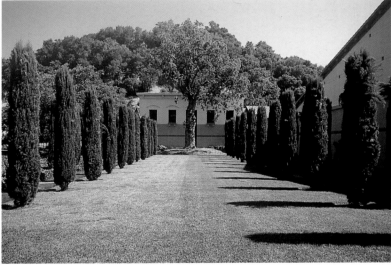

*The Clos Pegase
Winery in California,
where architect
Michael Graves
designed an elegant
green space to link
the production areas
and the vineyards.*

species were carefully cultivated; and from the erudite and detailed *tacuinum sanitatis*, veritable treatises of medicinal herbs.

The rediscovery of the classical world disturbed the harmonious and elemental medieval cloister garden. Ancient Greco-Roman experiences and the origins and "architectonic" arrangement of green spaces (where gardens became virtual edifices striving for harmony between the construction and the surrounding vegetation) were revisited. As the influence of the Renaissance spread, small gardens were transformed into microcosms where nature was re-created in order to dominate and reduce it to known forms, thus betraying the aspiration for a superior reality. A vast network of mythological correspondence symbolized the culture and power of the owner; the garden was far from the Albertian conception of a green space as the natural complement of a stately residence.

Simultaneously, the Islamic garden became ever more refined. In Samarkand, the imperial city of Timur, the *bagh* ("gardens") had, by the beginning of the 1400s, assumed noteworthy dimensions. It maintained its rectangular form enclosed by walls with turrets; a centrally located pool was connected to four canals representing the rivers of the Islamic paradise.

During the same time, Arab domination of the Iberian peninsula began to wane. The Moorish gardens of Andalusia, in particular the Alhambra and the Generalife of Granada, were fundamental formal and technological examples of plays of water, of which Arab technicians were the indisputable masters. Water became the most important playful element of gardens in the 1500s; it was used for fountains, cascades, musical organs, mock naval combats, and various "jokes." It provided an aural accompaniment reminiscent of the refined atmosphere of Oriental gardens.

Among the most beautiful extant Islamic gardens are those of the Moghul period of the late 1500s. They are found everywhere in India but above all in Kashmir, where they were built throughout the 1600s. Relatively small but quite interesting are those commissioned by the Safavide dynasty, particularly those in Esfahan. In Syria, Iran, and Iraq, however, where the Arab garden originated, few examples remain.

In the 1500s the humanistic garden of Europe evolved into worlds of astonishing and bewitching magnificence. A renewed interest in alchemy, botanic novelties imported from the New World, and the debate on the roles of humanity and nature were a few of the inspirations for new scenarios created with *ars topiaria*, which introduced sculpted walls and green backdrops into a city setting. From the first half of the sixteenth century on, the predominance of Italian garden style, especially Florentine models, was acknowledged by the European courts, which often borrowed workers and landscape architects. Gardens in France, during the first half of the 1600s, followed the Italian style, as did those in the south of Germany, Holland (where French influences were also felt), and Bohemia.

Yet while the Renaissance garden was a place for quiet contemplation, mannerist and baroque exemplars offered a sumptuous frame for the parties and ceremonies of a society that used such

sites to celebrate itself. In the 1500s and 1600s, geometry—the ancient "art of measuring land"—assumed an importance and an exaltation previously unknown, permitting green spaces to reflect the regular forms of the villa. Sequences of ordered spaces, distributed according to various points of view, recalled the rows of rooms in nearby dwellings.

The axis of symmetry generally passed from the villa entrance to a belvedere (or a pool, or a sculpture); secondary axes crossed the main axis. To the sides were square and rectangular flowerbeds delineated by low box hedges or rows of trees—usually the "architectonic" cypress—and low walls or colonnades. These spaces, called *parterres*, where hedges shape regular forms and volutes amid fountains, pools, and grottoes, represent the most recognizable element of the Italian garden.

A continuous search for the best views led to gardens being constructed on sloping or raised terrain; thus the beds were distributed on terraces. This technique was developed in ancient times in order to cultivate land that was otherwise inaccessible. Flights of steps connected the different levels; the steps, a functional element, became a dominant compositional element, refined scenography for the activities of the times. In the baroque era the garden was transformed more and more into a fantastic machine. The separation between social classes was reflected in the disappearance of views of cultivated fields and in the distancing of farm service areas, no longer an integral part of the villa but located outside the main residence.

At the same time in the rest of Europe, the garden became a constructed landscape, an extension of and complement to architecture on a territorial scale. Gardens were thus extended and united with nature: cultivated fields, woods, and adjacent clearings. By the middle of the 1600s, Italy had begun to lose its leading position in garden art in favor of baroque France. While the garden *all'italiana* was based on a rapport between humankind and nature, with humankind at the center of the universe, the large-scale garden *à la française* expressed humanity's desire to dominate nature. First Vaux-le-Vicomte and later Versailles represented this desire, as well as the desire of Louis XIV, the Sun King, believed to be able to rule the entire world.

The masterpieces of André Le Nôtre exercised great influence on seventeenth- and eighteenth-century European realizations, constituting ample and complex "visions of the world." Single significant elements were composed in relationships more and more phantasmagoric and, above all, on a very large scale. In Italy, Sweden, Germany, Russia, and England, the gardens of Versailles were the preeminent model and source of inspiration. On the Iberian peninsula, however, the Portuguese continued to create green spaces characterized by the unmistakable *azulejos*, blue ceramic tiles derived from Arab traditions.

In almost all of Europe, the eighteenth-century garden became the irreplaceable scene for the social rites of the nobility. Such green areas were defined by a quality of scenography: vegetal walls were based on a micro-town-planning scheme in which urban

A simple wooden gate onto the countryside at Akureyri, Iceland, marking the passage between designed and natural nature.

Below:
A garden "above" the house, outside of Reykjavik.

Bottom:
Artworks in the Kepenyes garden, with the sunlit hills of Acapulco in the background.

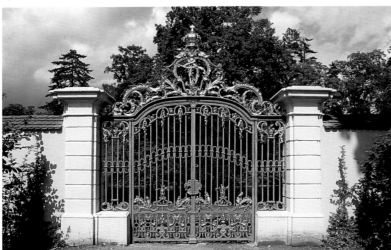

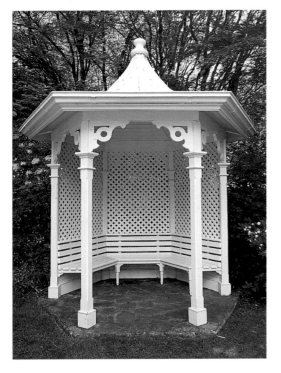

Top:
A small palace at Drottningholm in Stockholm.

Above:
An elegant gate leading to the garden of Schwetzingen in Germany.

Left:
A small Victorian gazebo in a romantic park in Australia, which draws from the Anglo-Saxon landscape tradition.

Opposite left:
The precise green spaces and buildings at Sanssouci in Potsdam, Germany.

Opposite right:
An unusual peristyle with a pool in a garden in Cuernavaca, Mexico.

forms alternate with those in the rococo style. The great eighteenth-century innovations in the theatrical scenography and, in particular, the new *per angolo* scenes contributed to shattering axial visions. Consequently, multidirectional perspectives with humanity at the center—an essential concept in Renaissance culture—evolved into an empirical and systematic "scanning" of reality typical of Enlightenment culture.

As the potential for experimenting with great size became exhausted, clients and landscape architects began to lay down the premises for a radical flight from everything "constructed." The strictly geometrical garden approached its end: pools and ponds grew larger, paths became tortuous, and British landscape traditions became more and more popular. "Natural" nature—meant not to be dominated but only softened and rendered more pleasant in the image of the idyllic scenes of romantic painting—was rediscovered and reevaluated in all of its haphazardness; it was "aided" only when it did not seem casual enough.

In the second half of the eighteenth century, the myth of Eden was replaced by that of Arcadia, a sort of secularized paradise with grottoes, ruins, and temples populated by flute-playing shepherds, satyrs, nymphs, and, above all, the goat-footed god Pan. Arcadia is a classical myth invented by Virgil and reborn in the Renaissance; at first it was only a literary fashion but later conquered the visual arts and landscape.

Anglo-Saxon landscape traditions became more significant as models for gardens, influencing the development of the garden throughout Europe during the nineteenth century. England had never completely accepted the grandiose classicism of the French garden; the British love of the countryside required more harmony. Britons preferred to live "in" and not "on" nature, and did not attempt to dominate or remodel it.

Italian-style garden terraces were embellished like the flights of stairs that had served to connect them. Landscaping became undulating, without abrupt interruptions, live corners, or perpendicular, severely trimmed green walls. The axes of symmetry also disappeared, and bordered areas and meandering paths avoided right angles. William Kent wrote "Nature abhors a straight line," and so *parterres* were replaced by undelineated fields that often came right to the door of the stately residence. Plays of water also disappeared in favor of placid streams or pleasant lakes. No trace of labyrinths or *ars topiaria* survived.

In the first half of the eighteenth century the Milanese Jesuit Giuseppe Castiglioni, painter and architect, visited China. Through him the West came to know the tranquil exoticism of pavilions, pagodas, and other chinoiserie elements that characterized daily life in the 1700s and 1800s. These pieces were admired not for intellectual or philosophical reasons but instead as new additions to the repertoire of the romantic park. Scientific literature contributed to the evolution of the taste for natural things, as did a book by architect William Chambers, *Designs of Chinese Buildings, Furniture, Dresses, Machines and Utensils.* Chambers stayed a long while in the Orient and was very impressed by it:

"Chinese artists, knowing how strongly contrasts influence the soul, constantly effect sudden transitions and a strident contrast of forms, colors, and shadows. Hence limited perspectives and vast panoramas are produced; objects of horror and joy; lakes and rivers, plains, hills and woods; dark and melancholic colors oppose others more brilliant and forms complicate simple ones." It was only because of the scarcity of visitors that the wonders of other Oriental regions—Thailand or Bali, where gardens arose next to every temple and palace—were not discovered.

New elements and themes drawn from the accounts of travelers were inserted into gardens; these foreign influences were freely interpreted rather than strictly used as the basis for revival styles, which attempted a more encyclopedic analysis. From China were imported plants like the rhododendron, the magnolia, the camellia, and the azalea; alongside poplars, sycamores, cypresses, and plane trees, they contributed to the passion for collection that would affect both the vegetation and the composition of the new Anglo-Chinese compositions. Oriental-style buildings were placed next to neo-Gothic, Moorish, and neoclassic ones, forming a great catalog from which landscape architects drew ideas in an effort to unite distant and diverse cultures. Aesthetically and formally, the results were not disappointing: the new typologies fused easily with the materials and the European climate, becoming part of the imaginary collective—though they did lose the sense of exoticism that was responsible for its success.

The importance of greenhouses grew simultaneously. The so-called winter garden comprised those plants that could not be acclimated to the local climate. And an Italian architect also made a significant contribution to the development of the romantic garden: Giovanni Battista Piranesi, whose engravings of classical Rome furnished an iconographic source for—and in a way codified—archaeological and architectonic ruins. Thanks to his work romantic parks were filled with obelisks, urns, inscriptions, benches, sarcophaguses, statues, and busts. Ruins, themselves formal testimony to their origins, wedded to the world of vegetation the idea of a sumptuous and culturally advanced past. "New" ruins were presented in an irreparable condition, victims of irreversible decay that witness the definitive wane of their own cul-

tures. Furthermore, the ruins appear inaccessible (or almost), hence restoring to nature a sense of historic continuity.

Ornamentation disappeared from the romantic garden; it was replaced by harmonious compositions of trees, fields, streams, lakes, and miniature islands and bridges. Birdcages, miniature palaces, fantasy castles, glaciers, and pyramids appeared. Deers, sheep, and cows grazed freely among the ruins and temples. In place of the late-Renaissance belvedere arrived the gazebo, a structure with analogous functions; its name was derived from the verb "to gaze." These places of contemplation and aesthetic pleasure arose in elevated positions and offered views in different directions. The search for spontaneity, which testifies to the freedom of human nature, guaranteed the integration of the garden into the landscape and thus, hypothetically, greater longevity.

In the United States the season of gardens began only toward the end of the nineteenth century. At first green spaces were inspired by the geometrical shapes of Dutch and French models and then by Anglo-Saxon romantic traditions. At the beginning of the twentieth century, the landscape architect Gertrude Jekyll experimented with a happy union between formal and natural, an "American style," that continues to enjoy great success. In other areas of the world that had been colonized by Europeans, gardens were inspired by Dutch precedents—as in South Africa in the 1700s and 1800s—and by the natural park—as in the Far East and Indochina.

For the most part, the time of great garden landscapes drew to a close in the twentieth century. The financial power of the upper class had diminished, and so neither hereditary landowners nor the newly rich could afford the construction and maintenance of these luxuriant monuments to power, wealth, and personal culture. Gardens have become ever more modest in size and decoration. Nevertheless, exceptional landscape architects like Geoffrey Jellicoe, Pietro Porcinai, Roberto Burle Marx, and Luis Barragán have invented new garden traditions while maintaining the vibrant earlier ones. With renewed attention on the environment and the landscape characteristic of the turn of the millennium, the twenty-first century garden will have much to offer.

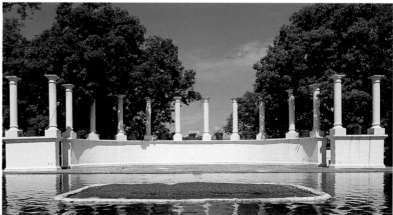

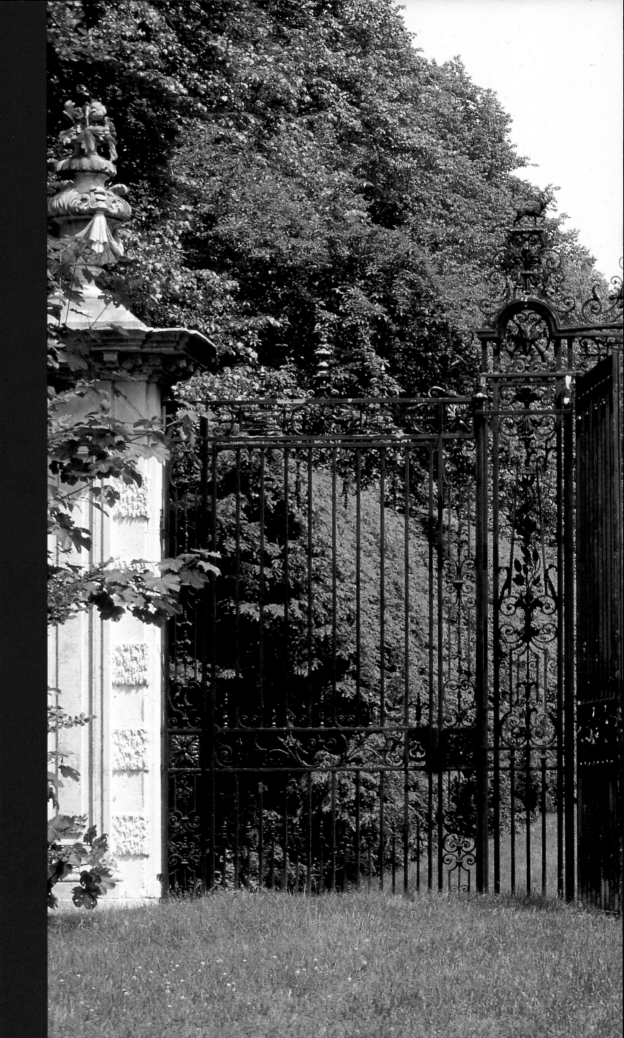

The only known indigenous gardens of the Americas are the *chinampas* of the Aztecs, which aroused the wonder of the Spanish conquistadors. Otherwise, the idea of the garden in America is a union between the available (or acclimatizable) vegetation and various fashions and tendencies imported from Europe. It is a "melting pot," sometimes confusing, of forms and citations.

The prototypes of colonial gardens are those that flank the plantations of Virginia and Louisiana, vast lawns crossed by boulevards of oaks. Only in the 1800s and 1900s did the resort residences of Newport, Rhode Island; Long Island, New York; and West Palm Beach, Florida, appear, and with them revivals of every sort.

At the same time, in the Caribbean Islands an attempt was made, without success, to tame the vegetation, which was so luxuriant that it could overtake every inch of space in a period as short as a season. But the variety of plants and bright hues of their flowers amply made up for the lack of order and symmetry.

It was only in South America that courtyard gardens were preferred to external ones. Especially in Venezuela and Ecuador, the interiors of stately dwellings offer pleasant and fragrant surprises.

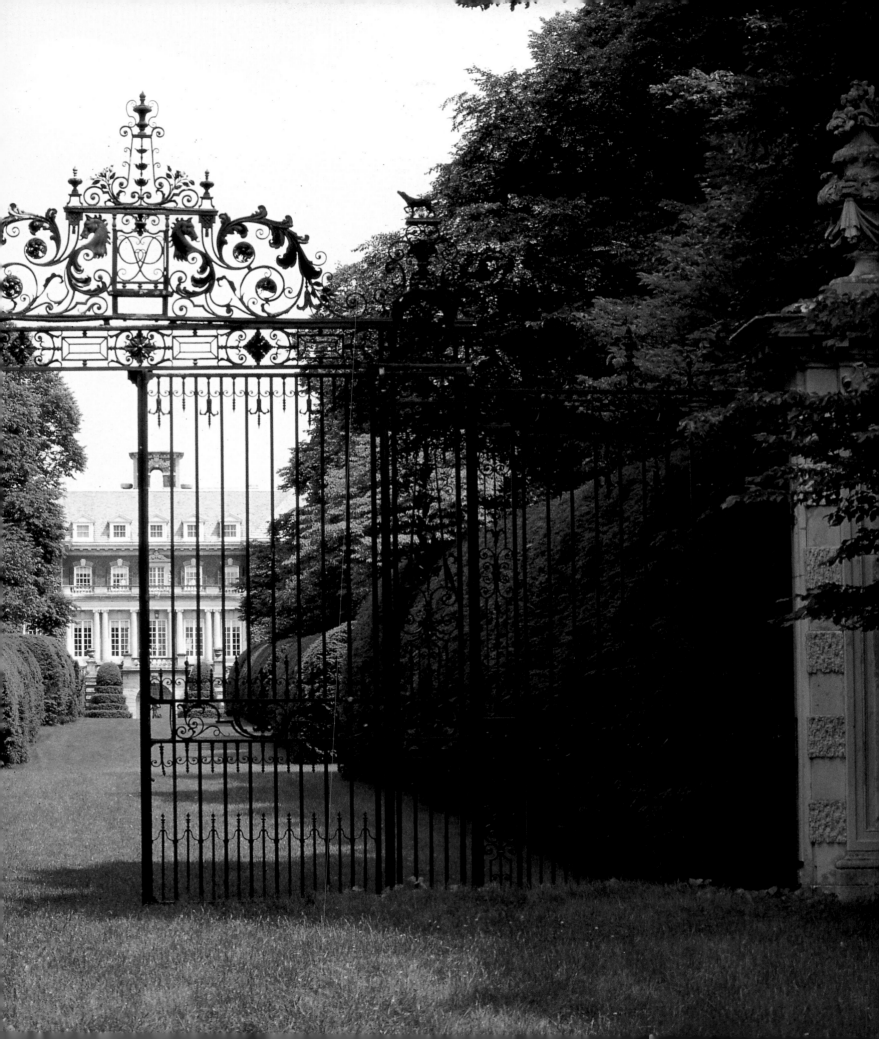

French-British Amenities

French colonists arrived in Canada in the 1600s, with the inception of trading in skins. Their settlements remained spartan until the end of the nineteenth century, so much so that they were relatively unconcerned when they were obliged to relinquish the colony to the English. Even now, in the field of architecture and, above all, in gardening, all references are Anglo-Saxon.

The name Canada itself evokes images of immense and boundless spaces where humanity has had to fight against nature and work hard to "domesticate" it. Not by chance are the first examples of gardens woods that were somewhat refined. In the middle of the nineteenth century, the landscape architect Andrew Jackson Downing published in the United States his *Treatise on the Theory and Practice of Landscape Gardening*, an erudite dissertation on the difference between the "beautiful" and the "picturesque." Thanks to such contributions, the Anglo-Saxon tradition of the romantic garden is widespread in North America.

In the end of the nineteenth and the beginning of the twentieth centuries, Montreal grew into an active and prosperous city. In the hands of its inhabitants was concentrated 70 percent of the Canadian economy, leading to general well-being and also to great wealth.

After the construction of the city arose the necessity of avoiding its chaotic life. Hence, rural vacation residences arose along the Saint Lawrence River. The major designers were architects Edward and William Maxwell, who succeeded in fusing experiences from the United States and Europe with local taste (and materials) to create the so-called Quebecois style. The new dwellings had to represent the economic and social success of the owners; the green spaces that surrounded them inevitably testified to their taste. In this way arose lawns alternating with groves of solitary trees as well as geometrically ordered gardens, an echo of a distant *ars topiaria*.

The gardens of Quebec are a tribute to the marvelous vegetation that characterizes that territory, tribute the descendants of the colonists wanted to pay to the New World by avoiding decisive cuts, deforestation, and any domination over the territory. Natural greenery and what is added fuse gently.

Preceding pages: Monumental gate leading to the Westbury Mansion on Long Island, in New York, dating to the beginning of the twentieth century.

Below: Window on the Chinese garden of Montreal.

Solitary stone bench on the banks of the Saint Lawrence River, site of vacation homes for many Montreal residents.

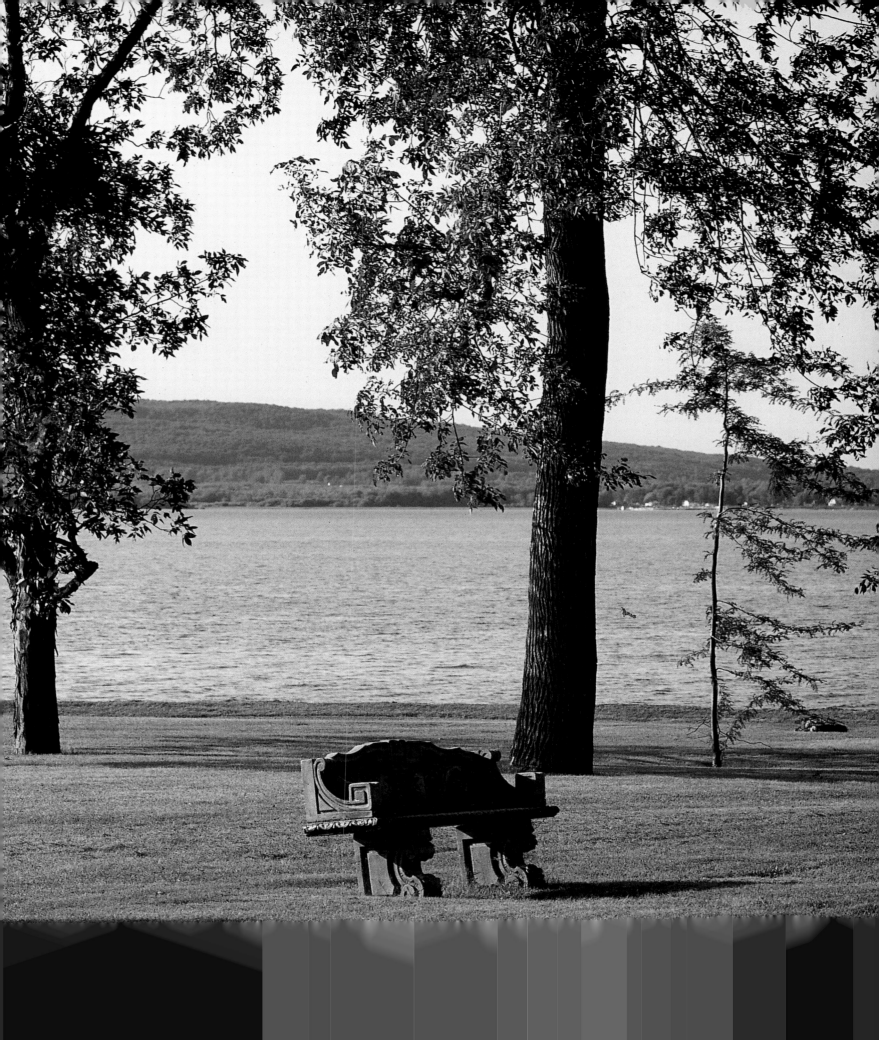

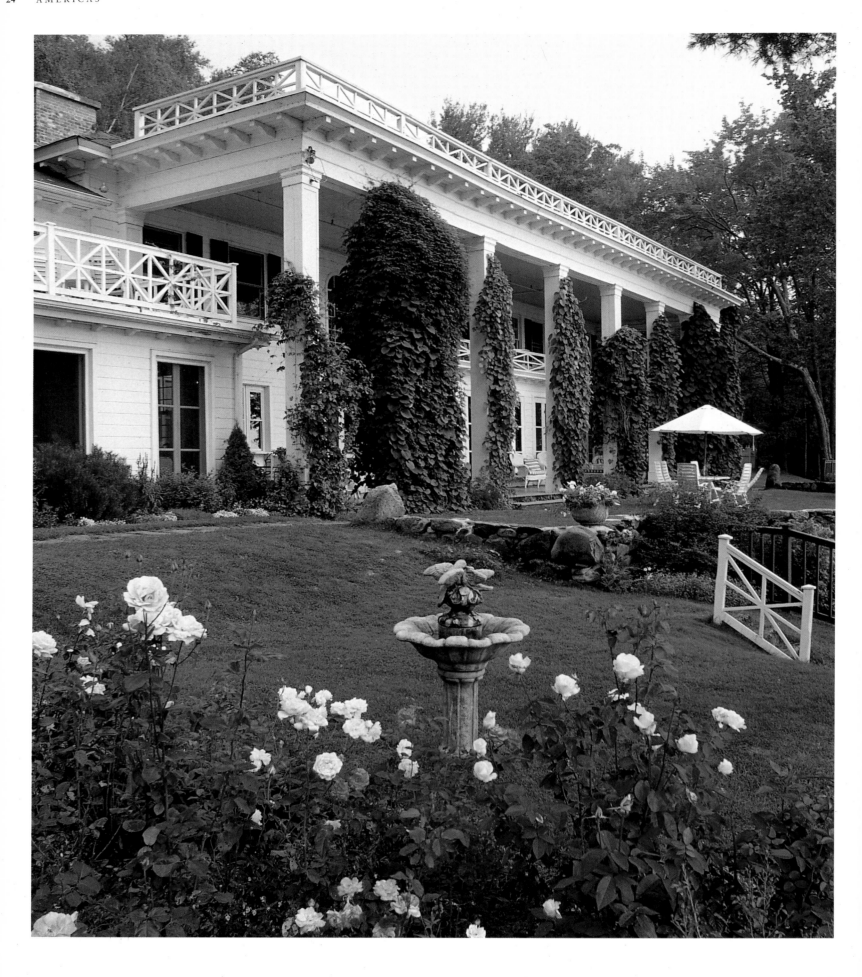

Opposite:
River front of Hovey
Manor with spacious
flowering garden.

Saint-Anne-de
Bellevue, not far
from Montreal, on
the Saint Lawrence
River. Houses there
have ample green
spaces with large
pools.

Left and above:
Wells and little
towers in the
gardens of Quebec.
The green spaces
are halfway
between geometry
and nature.

Polygonum amphibium

Hypericum sp

Anemone sp

Lupinus arcticus

FLOWERS AND PLANTS OF QUEBEC

As evinced by the maple leaf on the national flag, Canadian culture and tradition have always reserved a role of primary importance for ecology and the environment. The province of Quebec follows this tradition and, in homage to the heraldry of the former French monarchy, has adopted as its emblem the fleur de lis.

Situated in the extreme east of Canada, Quebec does not enjoy a climate particularly favorable to the development of vegetation. The northern part, regularly invaded by polar air masses, is occupied by Arctic tundra, dominated by musks and lichens mixed with vascular plants adapted to extremely low temperatures and conspicuous aridity; generally the latter present a particularly developed radical apparatus and a low aerial portion with small leathery leaves.

Despite the absence of trees, the flora is rich and varied; with the arrival of spring, when the snow and upper layer of the terrain melt, the earth is green, thanks to soft blankets of musk and silver green mats of lichens. *Dryas integrifolia, Lupinus arcticus, Silene acaulis,* saxifrage (*Saxifraga hirculus, S. cernua, S. rivularis, S. cae-* spitosa, and *S. nivalis*), and ericaceae (*Cassiope tetragona, Arctostaphylos alpina, Vaccinium uliginosum, Rhododendron lappiconicum,* and *Ledum decumbens*) flower colorfully, though fleetingly. Among the bushes, beyond ericaceae, are willows and birches of uncommon shrubby carriage, often dragging *Salix herbacea, S. polaris, S. pulchra, Betula nana,* and *B. glandulosa.*

In the swampier areas is a typical peaty vegetation composed of *Carex aquatilis, Eriophorum angustifolium, Caltha palustris* var. *arctica, Salix frutescens* var. *reducta, Betula nana* var. *exilis,* and diverse species of sphagnum. Found there as well are *Hippuris vulgaris,* commonly called

Hippuris vulgaris

Phisostegia sp

Roaming Salicacea

Rudbeckia sp

aquatic horsetail and nicknamed by the French *pin d'eau*, and the polygonacea *Polygonum amphibium*, a polymorphous species capable of adapting to the most varied environmental conditions.

At lower latitudes, the tundra becomes the taiga: a strip of forests of coniferous evergreens dominated by the white and black fir (*Picea glauca* and *Picea mariana*), the Norway silver spruce (*Picea glauca*), the gray pine or jack pine (*Pinus banksiana*), and the American tamarac (*Larix laricina*).

Still farther to the south, the boreal forest yields to the mixed temperate forest, where conifers are gradually replaced by the broad-leaf *Populus tremuloides*, *Betula papyrifera*, *Acer saccharum*, and *Tilia americana*. *Hypericum*, *Anemone*, *Rudbeckia*, and *Phisotegia* color the fields and undergrowth of these zones; among other interesting shrubs are the ericacea *Gaultheria procumbens*, or tea from Terra Nova, from which comes an essential oil used to scent food and, in medicine, as an antiseptic and antirheumatic.

Western Repertoire

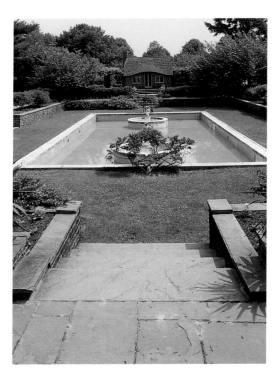

Of the original gardens created by the first English and Irish colonists in New England or planted by the Dutch in the former New Amsterdam (today New York), nothing remains except the memory. The oldest gardens still in existence are those of the tobacco plantations in Virginia, erected for the most part along the banks of the James River. Here are found, among others, the residences of presidents Washington and Jefferson; their models, for both the dwellings and the gardens, were either French or English. Moreover the conception of green space in the first colonies—that is, a small private paradise for the cultivation of flowers and vegetables—in the 1700s and 1800s began to disappear in favor of more cultured and mediated interpretations of the gardens of the Old World.

In the other great zone of plantations, Mississippi and Louisiana, life unfolded mostly along the shore of the great river, the source of wealth for commerce and an important and rapid route of communication. Here the cotton and sugar plantations produced a fortune for many colonists who flaunted their economic solidity with imposing neoclassical dwellings, often connected to the river by long shady alleys of oaks. Cultivated fields were joined to the living quarters and outbuildings by means of romantic parks. The trees were often selected for their capacity for shade, given the summer heat, and were surrounded by azaleas, camellias, and gardenias. It is easy to imagine Scarlett O'Hara scrutinizing the horizon and awaiting the sunset amid oaks, magnolias, and weeping willows.

After the period of the plantations, in the nineteenth and twentieth centuries resort homes became popular. In Newport, Rhode Island; Long Island, New York; and later in West Palm Beach, Miami, and Key West, Florida, arrived the country house era of great mansions with lovely romantic parks, which, unlike those overseas, had elements of symmetry (axes, little *parterres*, hedges, and so forth), which had long since lost favor in Europe. The landscape architects came from France, Italy, and Great Britain; the owners were big names in industry, construction, and finance. Only the stock-market crash of 1929 brought this phenomenon to a halt.

After that year, with few exceptions, the scale was reduced. Furthermore, styles based on antiquated revival forms lost their popularity, and new forms promoted by the modern movement spread along with a new way of relating to nature. Frank Lloyd Wright, with his houses in Chicago and, above all, with Fallingwater, built in 1936 in Pennsylvania, destroyed the barrier between construction and garden and advocated a new rapport with nature, one that was more direct, immediate, and interactive.

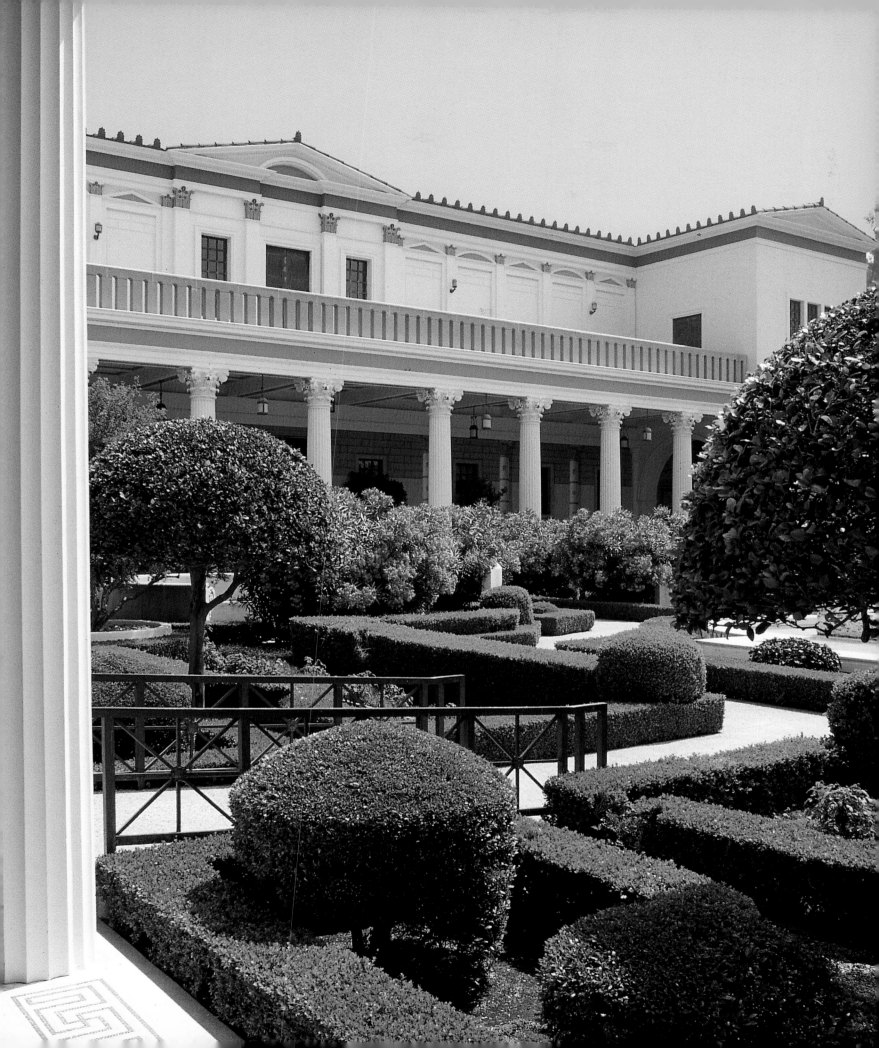

Vases, statues, and
pools at the Elms, an
imposing neoclassical
dwelling in Newport,
Rhode Island, realized
at the beginning of
the twentieth century.

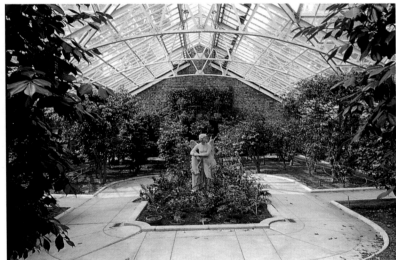

Coe Hall greenhouse,
organized like a real
garden with paths
and statues.

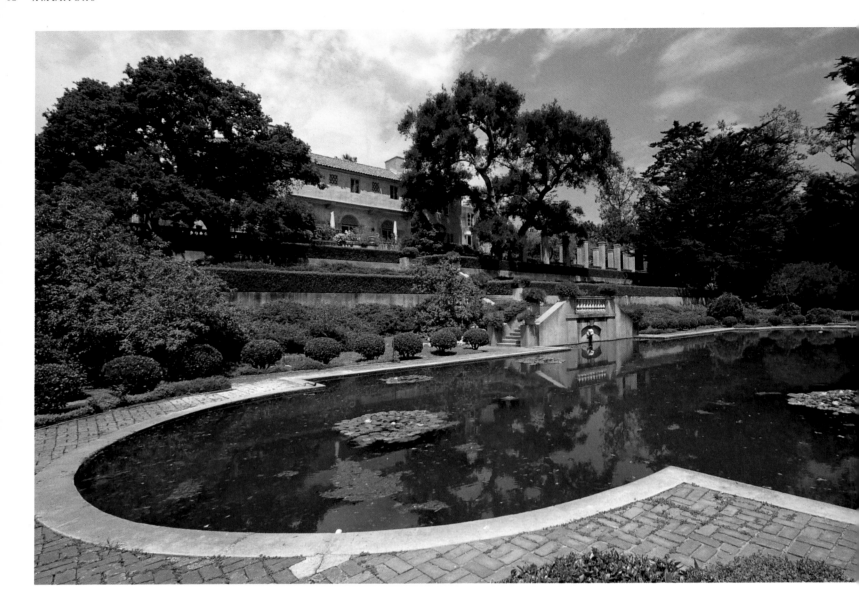

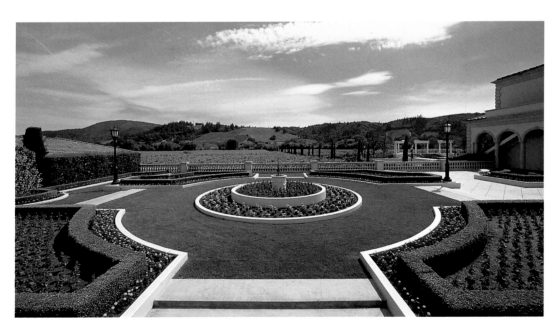

Garden next to a winery in Napa Valley, to the north of San Francisco, with grapevines in the background.

Below and bottom:
Lotusland, realized
for the Polish princess
Ganna Walska
around the 1940s.
Succulents grow
next to palms and
other plants in an
impressive medley.

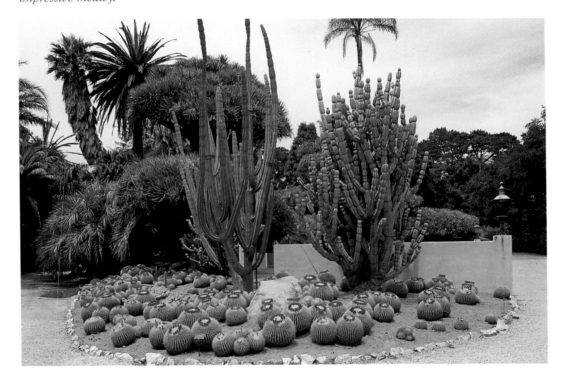

Long narrow terraces
at Val Verde in
Montecito, California,
the work of the
landscape architect
Lockwood de Forest,
which end in front of
a nymphaeum pool.

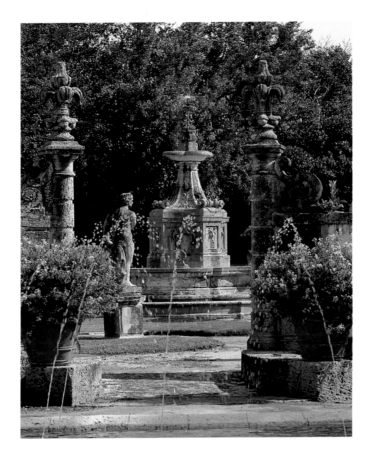

Vizcaya gardens, where stairways, amphitheaters, flowerbeds delineated by hedges, and multicolored plants alternate with statues and fountains, belvederes and nymphaeums.

Villa Vizcaya in Miami, Florida, one of the most noted dwellings in the United States. Its garden is an erudite re-creation of the Renaissance concept of the garden.

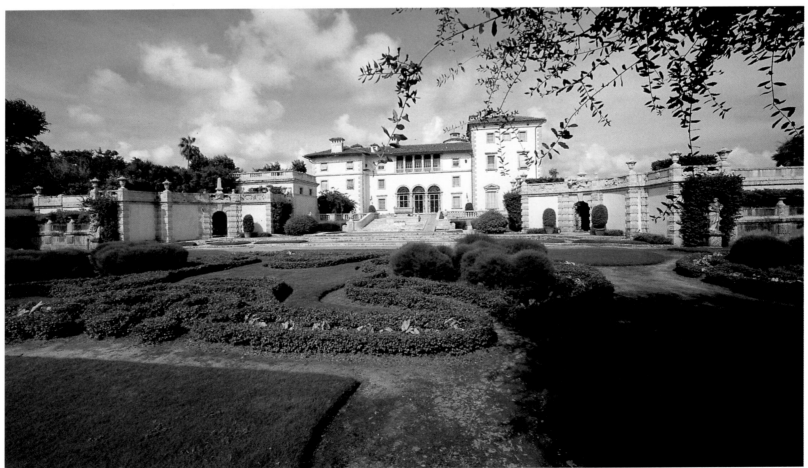

Principal parterre *of the Filoli Garden in San Francisco. In the center is a nymphaeum pool, and in the background a lookout tower.*

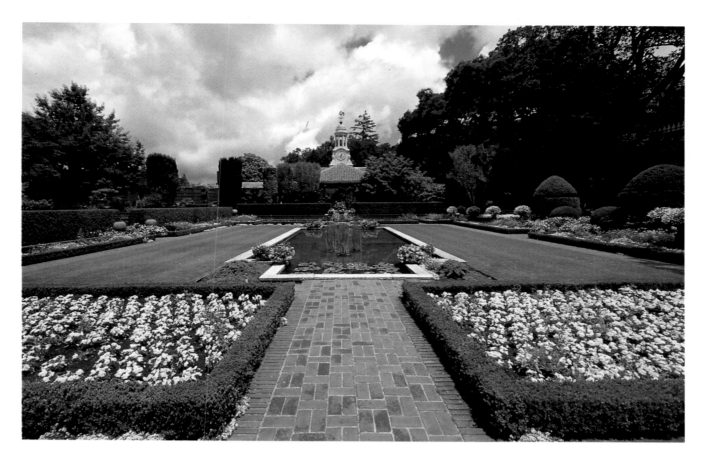

Stairway leading to the private garden of the little palace at Hearst Castle in San Simeon, California.

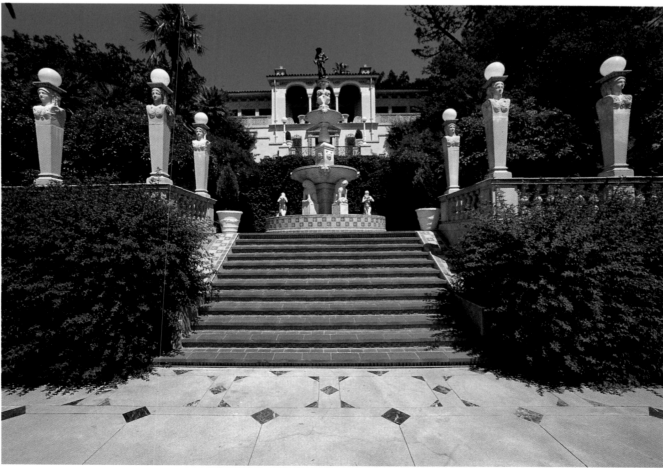

Grand pool in the center of the court at the J. Paul Getty Museum.

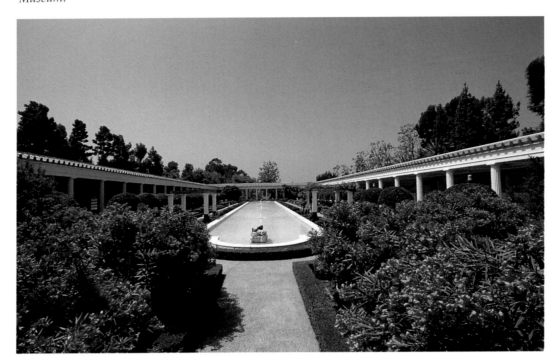

A contemporary garden in the classical style in Napa Valley.

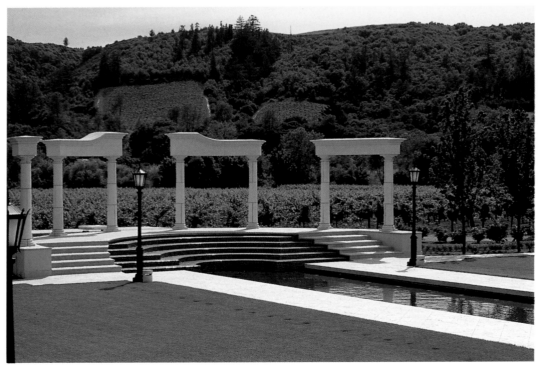

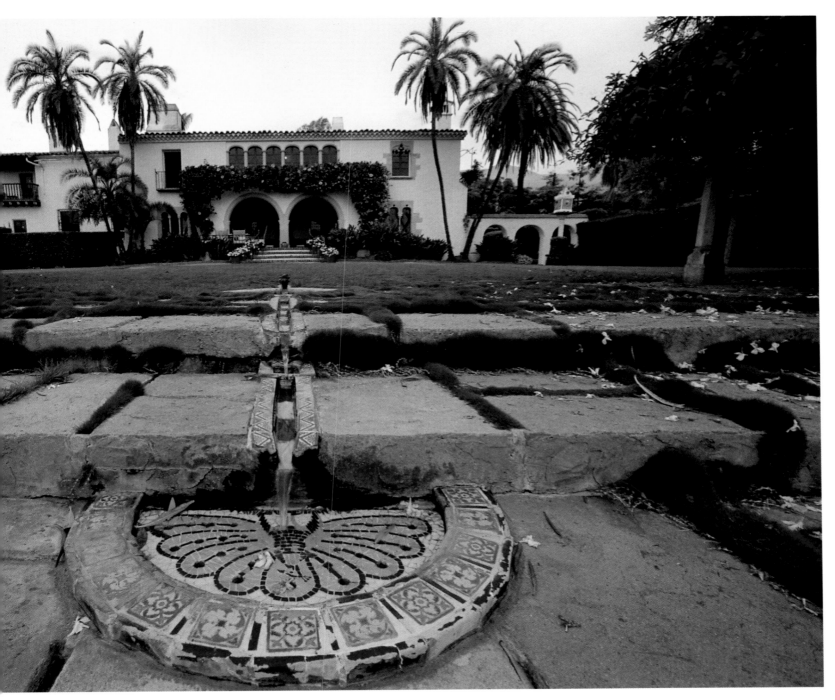

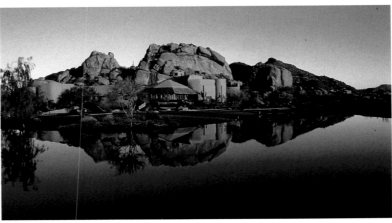

Grand mansion in Santa Barbara, with plays of water that recall Mediterranean gardens.

Lake at the center of the gardens at the Boulders resort in Arizona.

From the Aztecs to the Conquistadors

Mexico

The history of Mexican gardens begins with the *chinampas*, the floating islands of Lake Xochimilco, near Tenochtitlan. On these platforms the Aztecs cultivated flowers and vegetables long before the arrival of the Spanish. In the Aztec cultural heyday, corresponding roughly to the arrival of the Spanish, the tradition of such green spaces had evolved into grand aristocratic gardens.

The first chroniclers who arrived with the conquerors described the *chinampas* as rich with pools and plays of water, canals, gazebos, terraces, and stairways. Elaborate aqueducts distributed water to the various levels; in certain defined areas rare and wild animals were raised. The royal parks of Montezuma featured numerous rare plants and innumerable vegetables species. The style was vaguely "Babylonian," that is, sloping terraces supported by embankments, pillars, and grottoes reserved for the pleasure of the master. In Mexico City, where today stands the castle of Chapultepec, preserved by Emperor Ferdinand Joseph Maximilian during the Second Empire, was originally one of Montezuma's parks, which was destroyed to make space for the present elegant *parterres* in the French style.

With the settlement of the conquistadors Hispanic culture spread, and *haciendas* were embellished with ample patios with cactus, agave, and pomegranate; such spaces enlivened life in the *casco*, the main house, which awaited the winter transfer to the urban dwelling in Mexico City.

The garden open to the surrounding vegetation is a recent invention in Mexico. Only contemporary designs introduce traditional flora to a larger context related to the territory. But this is already a more international trend. The true Mexican gardens are the impenetrable and invisible places full of history like Cuernavaca or Puebla.

Echoes of the colonial baroque in the garden of the Quimiapán hacienda *outside Jalapa.*

A modern sculpture in the Kepenyes garden in Acapulco.

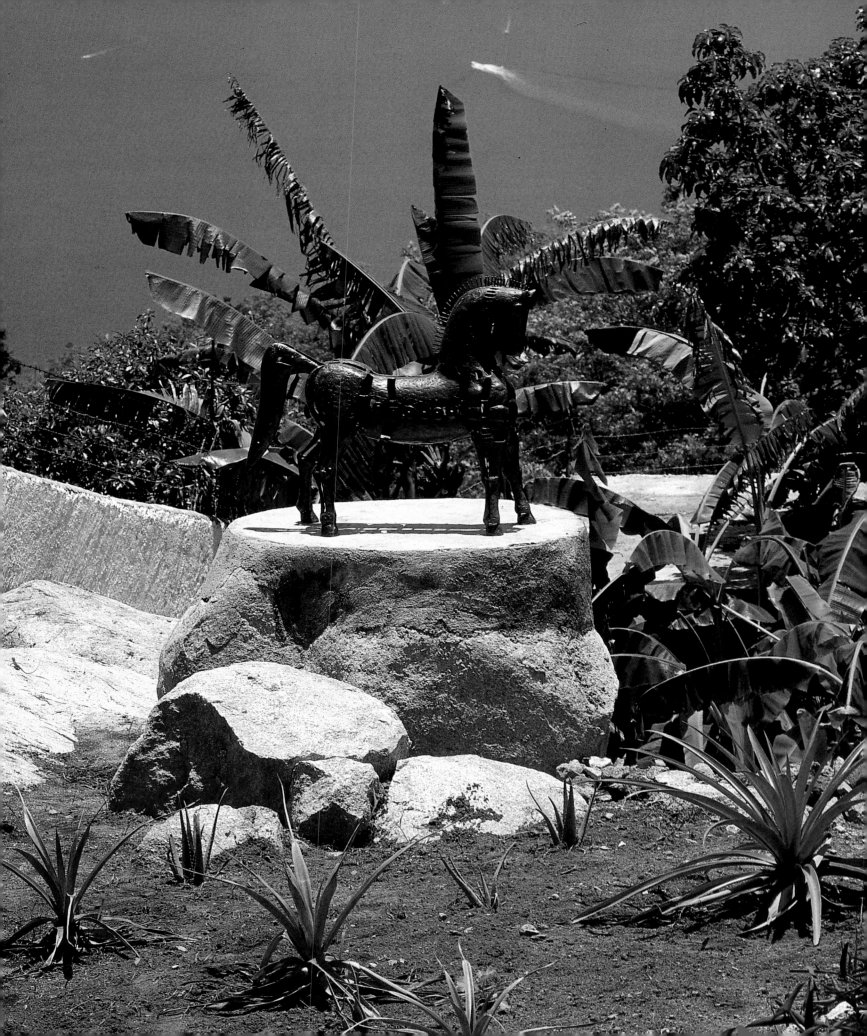

Pink dome emerging from the dense vegetation around Las Alamandas.

Vegetation in the village of Las Alamandas, to the south of Puerto Vallarta. The plant life changes as it approaches the sandy soil by the ocean.

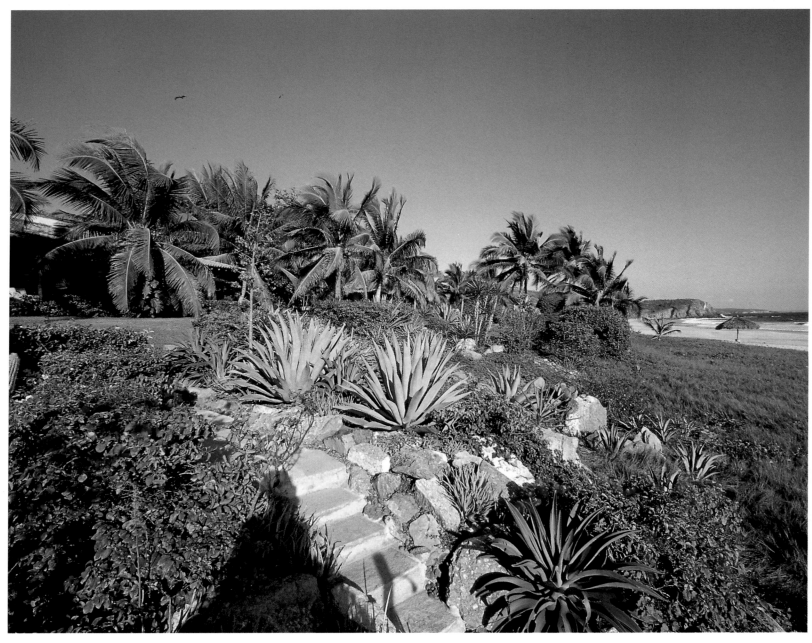

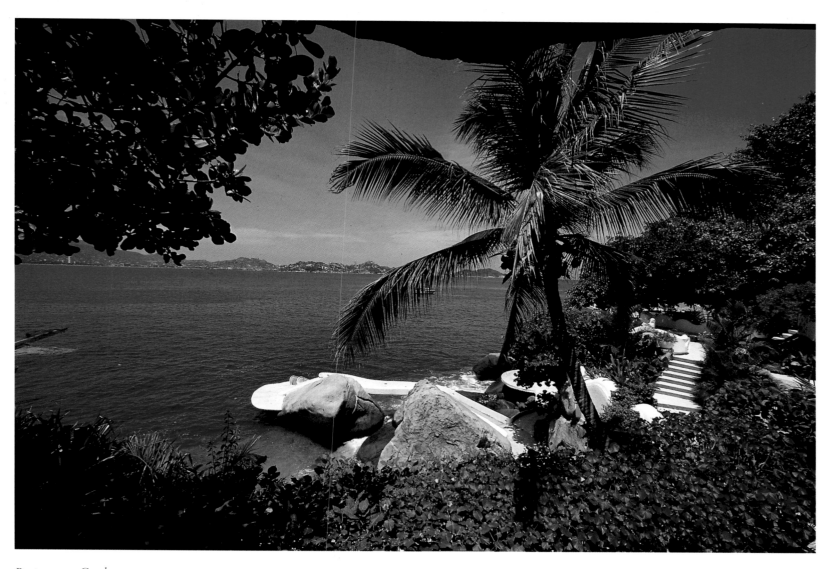

Portanuova Garden, terminating at water's edge with Acapulco in the background.

Village of El Tamarindo on the coast of Manzanillo.

Hacienda of San Juan Tlacatecpan in Teotihuacan, close to the Aztec ruins.

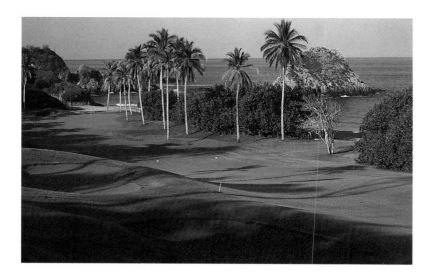

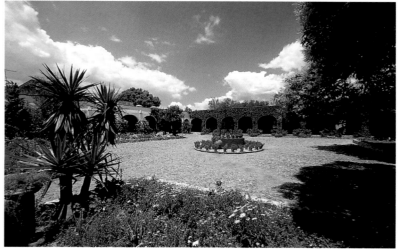

Caribbean Fascination

From Florida to the Yucatán to Venezuela, the myriad small islands known as the Greater and Lesser Antilles pass by Puerto Rico, Jamaica, Antigua, and the West Indies, where Columbus returned four times in search of a passage to the East. They form a wreath of immersed lands sharing a common climate of humid heat and periodic raging hurricanes. Very few residents can call themselves natives; most of them were brought from Africa in slavery or were colonists from Europe—France, England, Holland, or Denmark.

Thus the area is a melting pot of ethnic groups but also of cultures and artistic expression. It is difficult to speak of "Caribbean style" in these lands of slaves, adventurers, missionaries, revolutionaries, and planters of every color and race. Yet, thanks to the climate, the ubiquitous luxurious vegetation, and the constant presence of the sea, this potpourri of styles does have something in common, especially in the gardens.

In the Antilles even the most modest houses have green space with flowers, plants, medicinal herbs, and vegetables in abundance. Leafy trees are necessary for shade. Utilitarian gardens have spread out and evolved into gardens of pleasure with large clearings, coconut palm alleys, and tamarind trees. For the sugarcane planters—but also for planters of coffee, tobacco, sugar, and bananas—they are places dedicated to calm (and fleeting) moments of leisure.

So many different peoples have produced so many styles and so much greenery. The gardens of the Antilles are striking not for their stateliness or for the richness of their embellishments. They are spaces for living more than for admiring, where the climate and nature, more than in any other place, have been extremely generous with humankind.

Swimming pool at Castillo Serrales in Ponce, in the south of Puerto Rico.

Giant bell above the entrance to the garden of Parham Hill Plantation in Antigua. Palms frame the house.

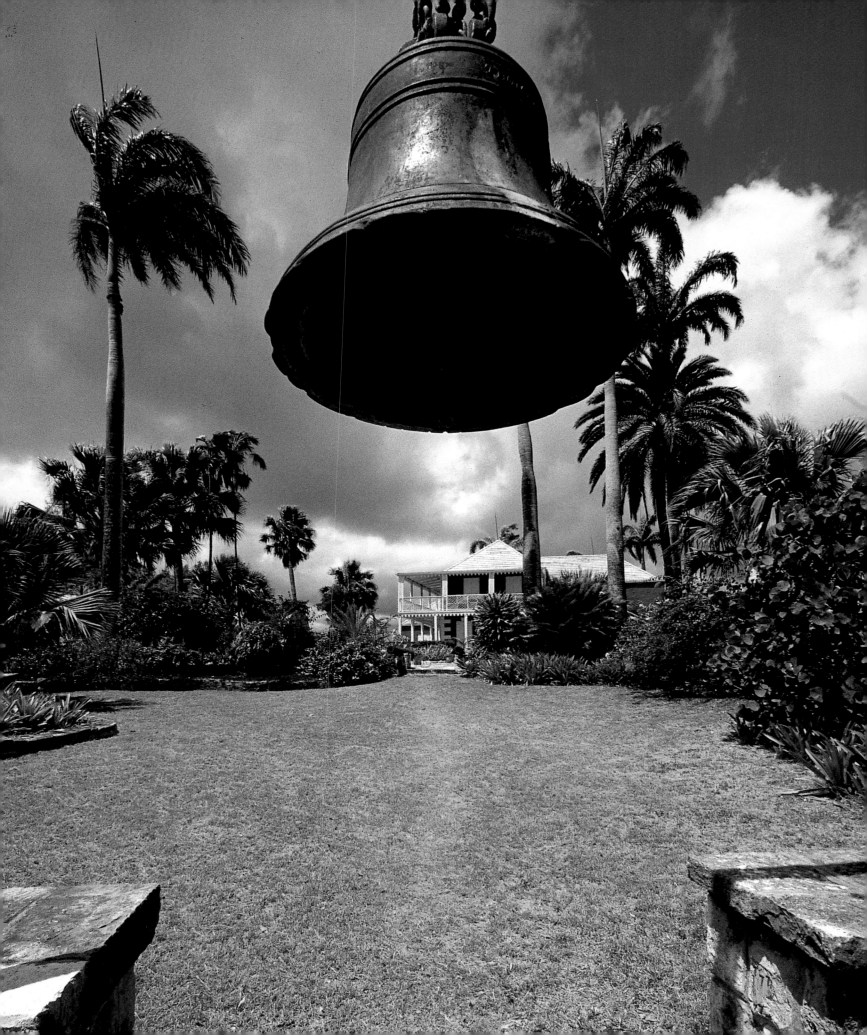

Water Wheel Garden
in Tobago with the
remains of a sugar
factory. The great
wheel provided
energy.

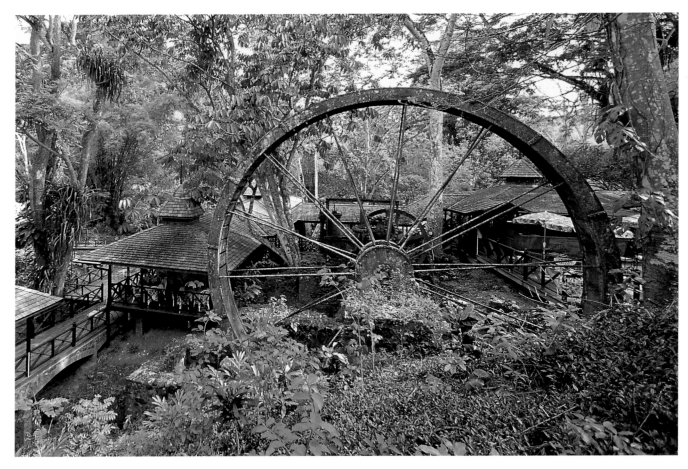

Remote corner of
the gardens at the
Rose Hall Great
House in Jamaica,
today transformed
into a hotel.

Agave and palm
forest surrounding
the bungalows
of the K Club in
Barbuda.

Saint James Club
in the north of
Antigua. The village
is separated from the
sea by a horse ring
and a palm grove.

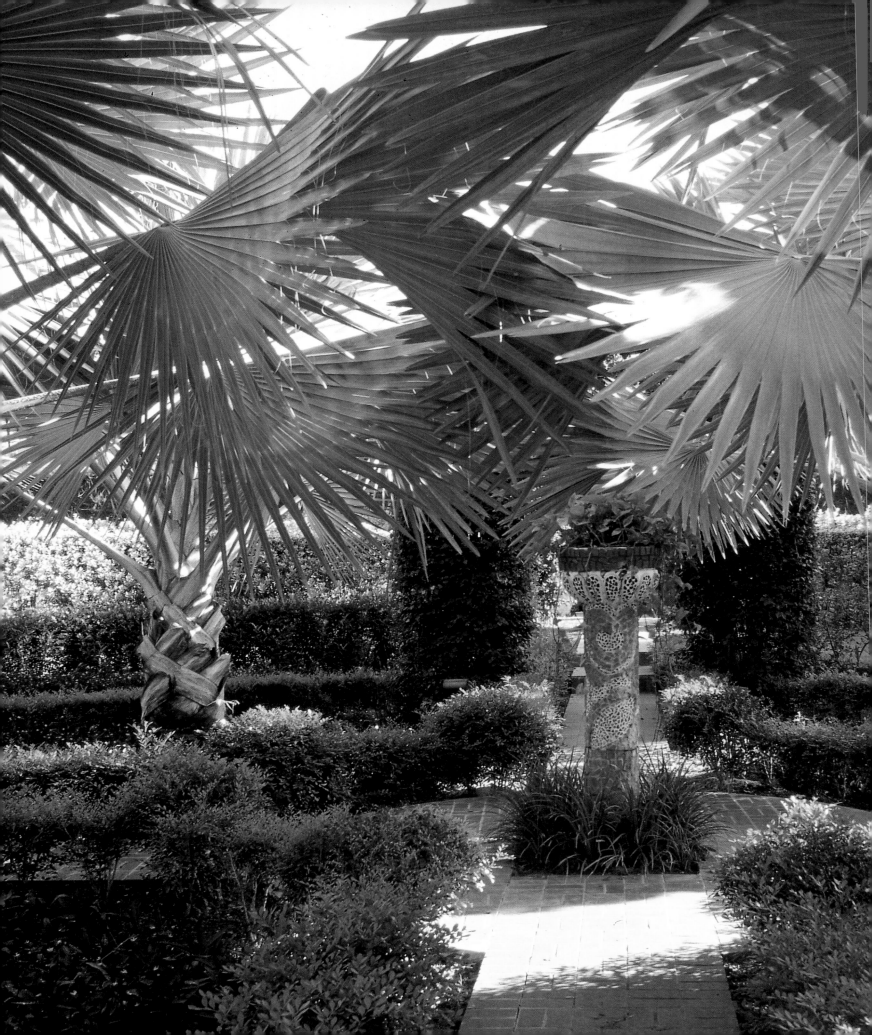

Palms, hedges, and
plays of water in
the garden of the
Half Moon Club
in Montego Bay,
Jamaica.

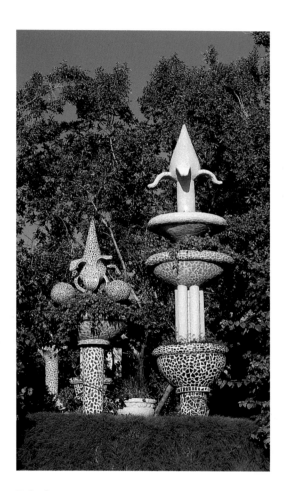

Polychrome ceramic
sculptures in the
gardens of the Half
Moon Club.

*Lake near the beach
of Montego Bay.*

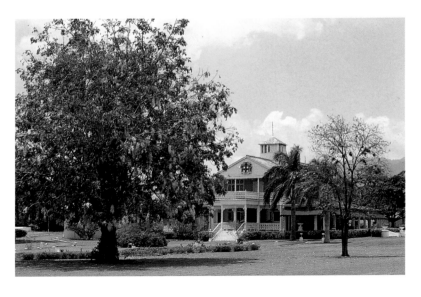

*Tall trees and ample
lawns around the
colonial villas near
Kingston, Jamaica.*

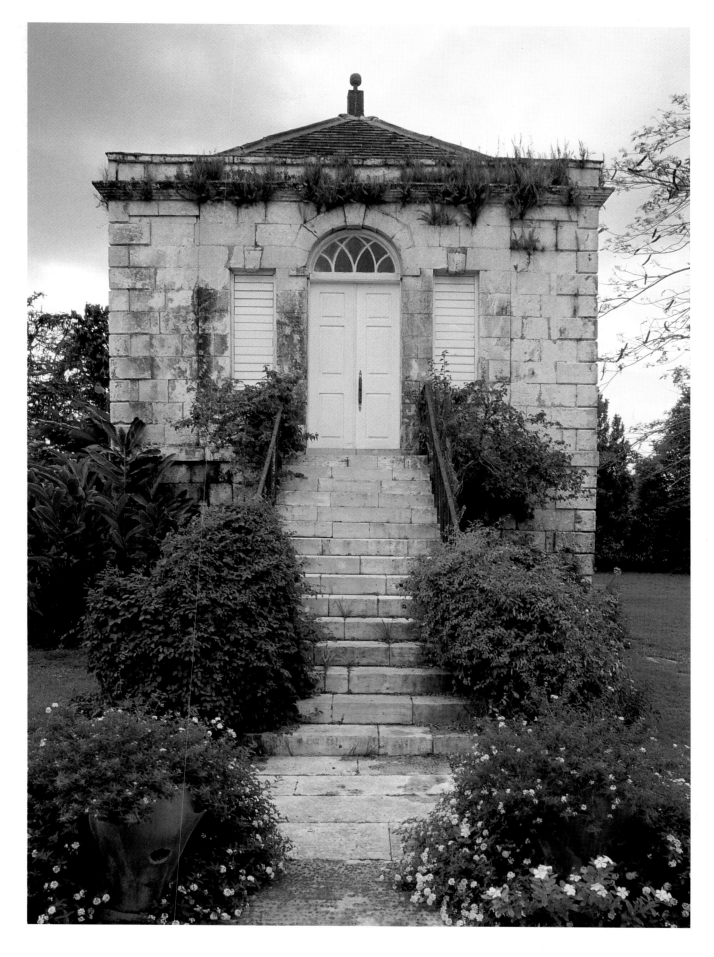

Outbuilding in the garden of the Rose Hall Great House in Jamaica.

Two examples of
Hibiscus sp

Two examples of
Hemerocallis sp

Solandra maxima

Brownia grandicaps *Russelia equisetifolia*

Bignonia fuchsioides

FLOWERS AND PLANTS OF THE CARIBBEAN

With about two hundred native species, the flora of Central America and the Caribbean Islands boasts extreme richness and variety. A tropical paradise for antonomasia, the Caribbean is characterized by a hot and humid climate with rainy summers and relatively dry winters, depending on local conditions.

The abundant precipitation that the northern winds bring to the Atlantic side favors the growth of luxurious tropical rain forest dominated by evergreen broad-leaf plants and an undergrowth rich in creepers, climbing palms, and ferns, as well as a great number of epiphyte bromeliaceae and orchideaceae.

Very common are the species of the *Plumeria* family with the name frangipani or "mayflower," with large leaves and fragrant white or red flowers, used in medicine for skin diseases or respiratory ailments. Typical of this zone, and widely cultivated as an ornamental plant, is an aracea with the characteristic spadix blossom, the *Monstera deliciosa,* an evergreen creeper that begins life as a climber; often, however, its trunk breaks, forcing it to transform itself into a sec-

ondary epiphyte bound to the terrain by long, elastic, and resistant roots.

A myriad of colorful flowers makes the rain forest a veritable botanic paradise: funnel-shaped *Hibiscus, Hemerocallis* of various colors, *Bignonia fuchsioides* with its characteristic hanging flowers, *Lantana camara* with its multicolored corymbs, and unusual *Hymenocallis* with its curious and fragrant floral crown. The graceful *Tropaeolum majus,* the so-called rose of Venezuela *Brownia grandicaps,* the scrophulariacea *Russelia equisetifolia,* the very elegant *Cleome,* and the climbing solonacea *Solondra maxima* are also in the rain forest. Indigenous to this area and located

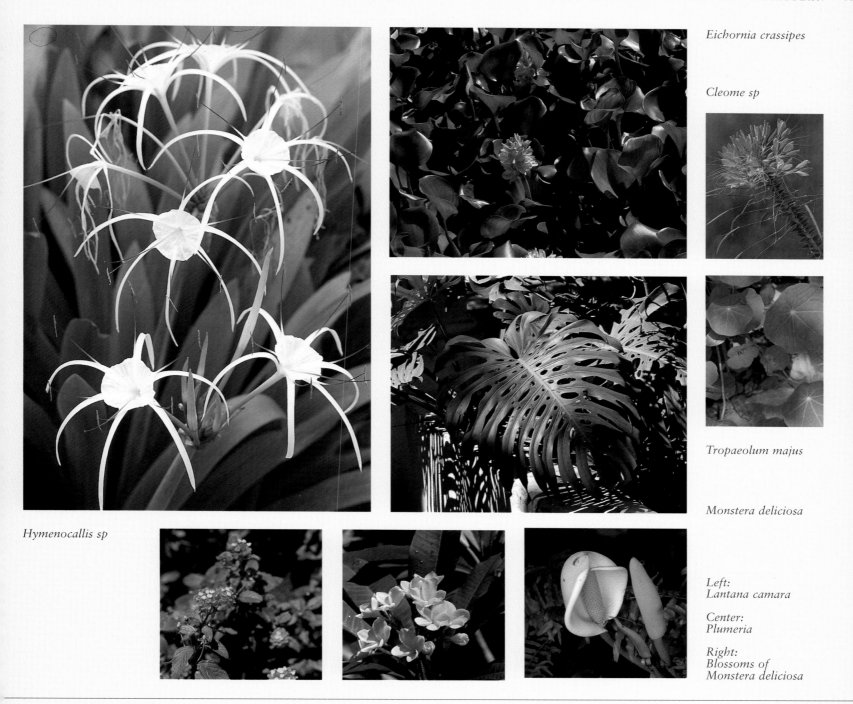

Eichornia crassipes

Cleome sp

Tropaeolum majus

Monstera deliciosa

Left:
Lantana camara

Center:
Plumeria

Right:
Blossoms of
Monstera deliciosa

Hymenocallis sp

throughout the tropical zones is the pontederiacea *Eichornia crassipes*, better known as the water hyacinth.

Originating from the submerging of two great mountain systems, the islands that emerge from the transparent waters of the Caribbean present, to a large extent, mountainous territory. At the highest altitudes are species like *Pinus occidentalis* and *Ilex, Lyonia,* and *Garrya*. In the regions protected from the northeastern winds, which, though they have similar temperatures, are characterized by a longer and drier winter season, shrubby formations of deciduous broad-leaf plants, formed by tall shrubs with broad crowns,

take the place of evergreen trees. There prosper unusual cactaceae, like *Epiphyllum hookeri* and *Hylocereus undatus*, which live clinging to other plants, following the example of common epiphytical bromeliaceae. Cactaceae of the genus *Cereus, Opuntia,* and *Agave* occupy the dry zones of these regions.

Finally, there are numerous beneficial species, including exotic fruits like the avocado *Persea gratissima*, the papaya *Carica papaya*, the pineapple *Ananassa sativa*, the cherimolia *Annona cherimola*, and the cashew *Anacardium occidentale*. Medicinal plants comprise the guaiac *Guaiacum officinale*, the symbol of Jamaica

with its beautiful blue flowers, which is used for the production of perfumed oil and a cure for rheumatism. An important forestal plant is the *Swietenia mahagoni*, a meliacea that yields precious mahogany. The cacao tree, *Teobroma cacao*, due to the curious phenomenon of caulifloria, develops its flowers and fruit directly on the stalk.

In the Patio-Gardens

Venezuela

Time is an elastic concept in Venezuela. Outside Caracas, throughout the *llanos*, the boundless prairies, is a reality that goes back to the Spanish conquest of the sixteenth century. Here *hatos*, great farms that extend as far as the eye can see, are still populated by herdsmen who ride all day in the pastures. The South American rhythms of Caracas and Maracaibo are far away; haste is a useless extravagance. In these places concepts like environmental impact are academic abstractions, as is that of the garden.

The Venezuelan garden, in fact, does not exist—at least in the French, Italian, or English styles. Instead is the traditional patio-courtyard: closed within domestic walls, it can supply privacy and coolness on summer days. Small and large, these spaces are always very green, with a well and a fountain. They are found in the *haciendas* of the Andean slopes, above all in Mérida, but also in the homes of the oil magnates of Maracaibo, in the colonial residences of Coro and Valencia, and in the dwellings of the intelligentsia of Caracas. Everywhere an integral part of the rich house or palace, the patio-courtyard represents an oasis of relaxation.

Small but lush porticoed courtyard with a stone well in the center of historic Mérida.

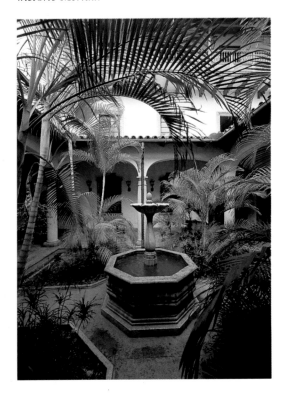

Grassy Venezuelan courtyard with an ample portico and a well.

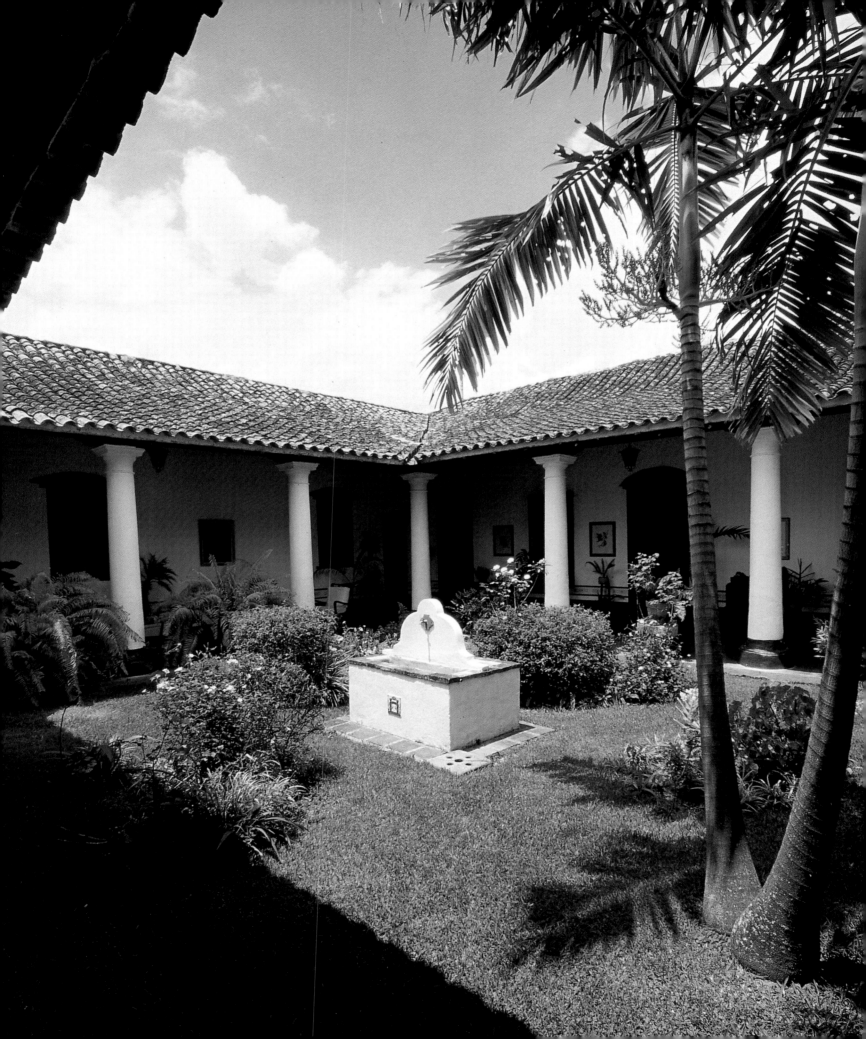

Interior court of La Isla in Mérida, with the mountains of the Sierra Nevada in the background.

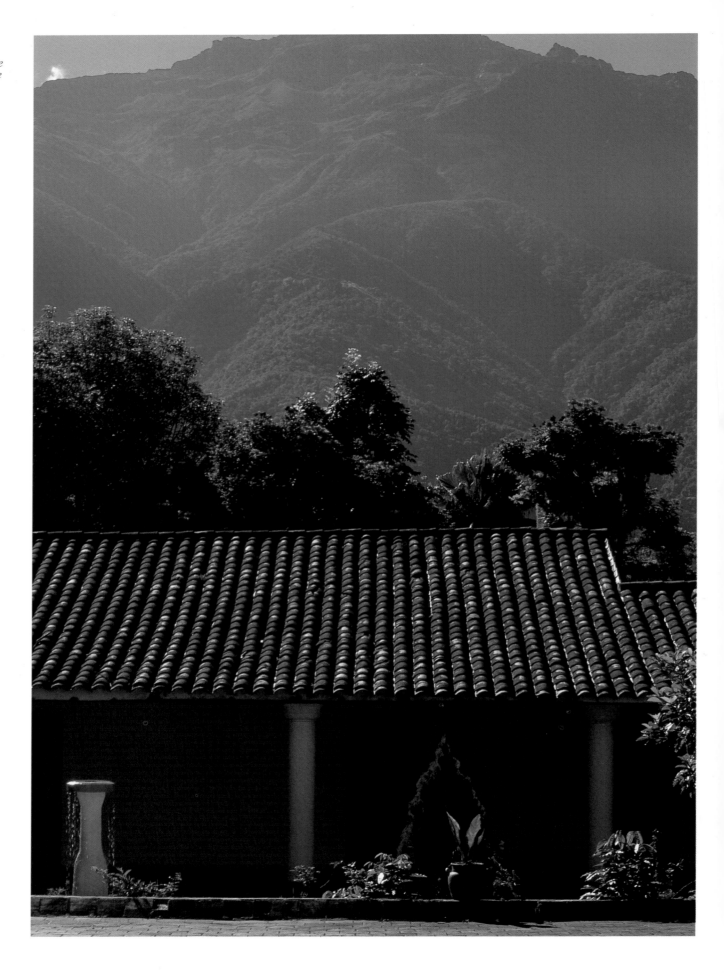

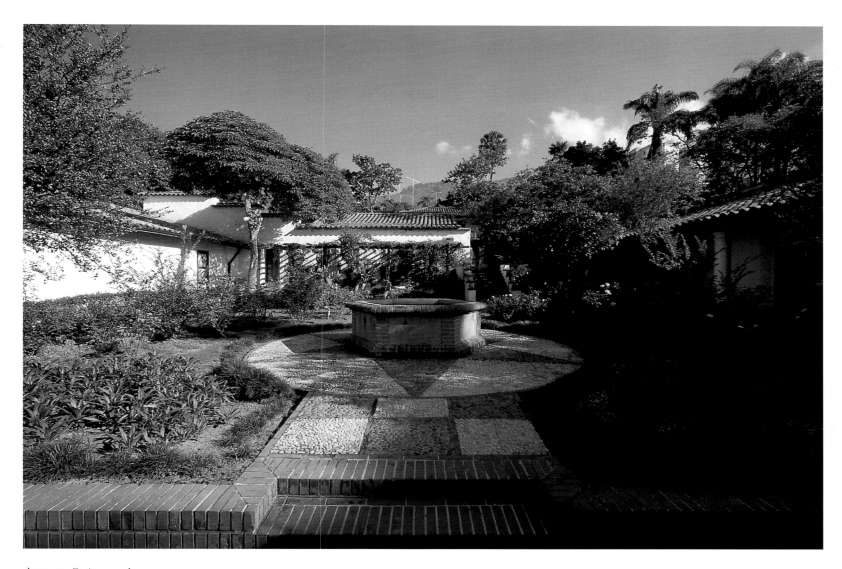

*Arranco Quinta and
its lush garden on the
approach to Caracas.*

*Courtyard of the La
Victoria hacienda in
Mérida, a plantation
that has been
transformed into
a coffee museum.*

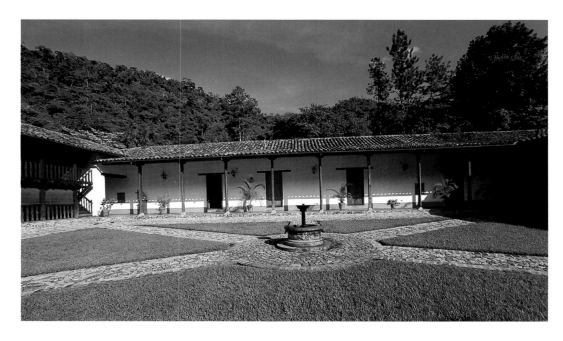

At the Foot of Cotopaxi

A curious image of Ecuador emerges from the path of the volcanoes, a green valley to the south of Quito, or from the Panamerican Highway, which runs through the Andes and links all of South America. Luxurious vegetation frames broad cultivated clearings that stand before snow-covered peaks; on particularly clear days, Cotopaxi, at more than nineteen thousand feet one of the highest volcanoes in the world, is visible. All around are the *haciendas* of the *encomenderos*, the fiduciaries of the Spanish crown who, immediately after colonization, began to cultivate the best lands to produce bananas, sugarcane, cacao, and rice. The style of the buildings is a pleasing union of Spanish colonial baroque and the indigenous tradition, especially in regard to decorations and colors. Spacious terraces connect the interiors of the main houses with the surrounding vegetation.

The green spaces are for the most part located alongside the *haciendas*. They are usually open, even though introduced by gates that might assume a monumental form. Mown lawns alternate with paved areas with fountains and wells. The style is simple, echoing Spanish experiences, since it is nature and the landscape that create the fascination of these places. Yet humanity resists taming nature, allowing it to engender the "picturesqueness" of a spot. The result is certain to be impressive.

Balustrade and stairs in a secret garden in Ecuador.

Lawn before the Avelina hacienda in Lasso. The tall trees hide cultivated fields.

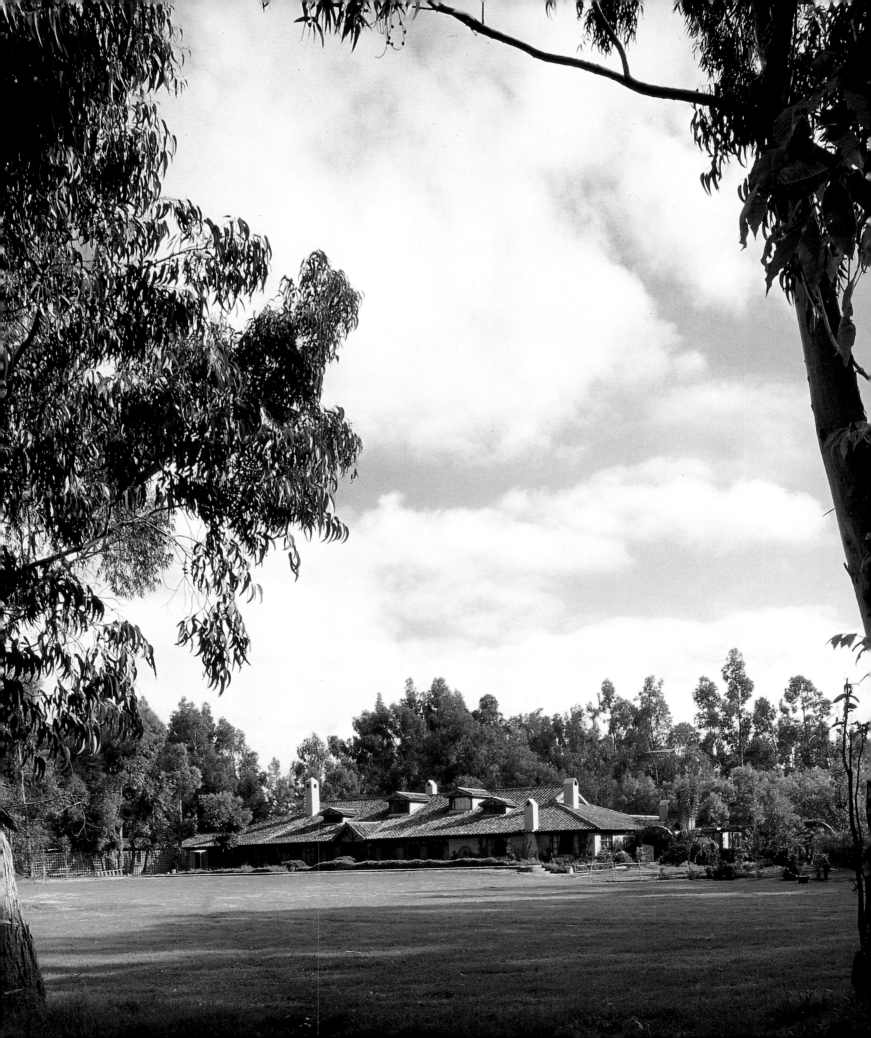

Garden front of the
Pinsaquí hacienda,
near Otavalo. A
spacious terrace with
flowered borders and
trees faces the valley
below.

Terrace of the
Chillo Jijón
hacienda, *with
a stone fountain
at the center
and a surrounding
balustrade.*

*Elegant volcanic
stone well with ample
volutes in the center
of the garden of the
La Herreria hacienda,
not far from Quito.*

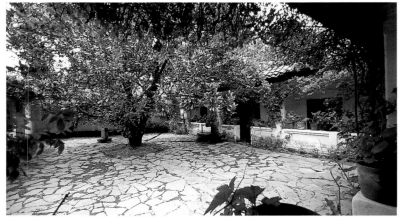

*Private interior
courtyard with leafy
trees at La Herreria.*

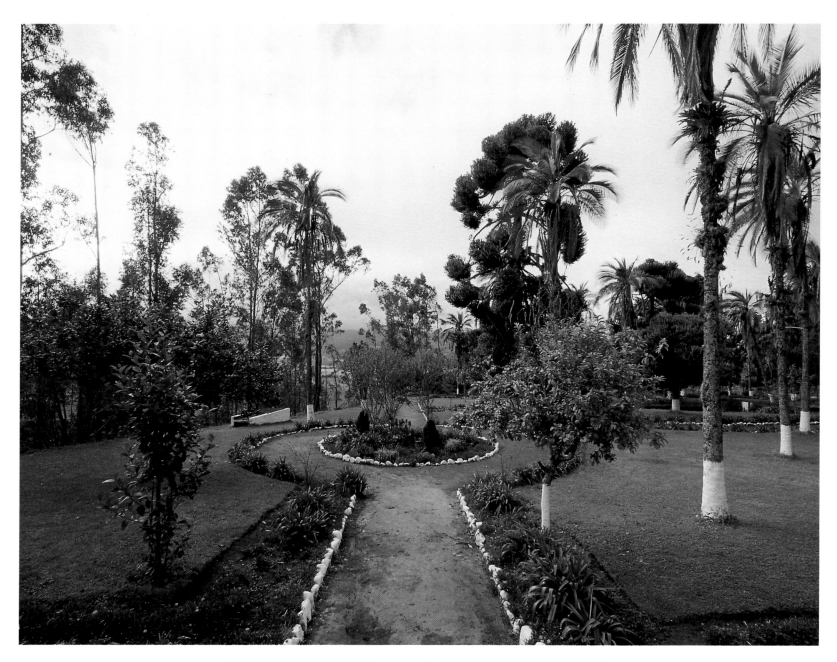

Simple garden characterized by an allée on axis with a round flowerbed.

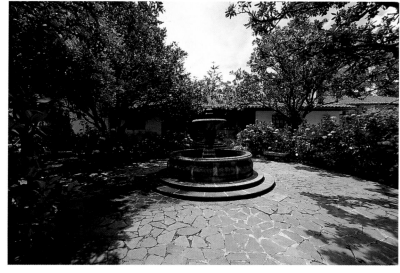

A well and fountain typical of those that often characterize Ecuadorian private gardens.

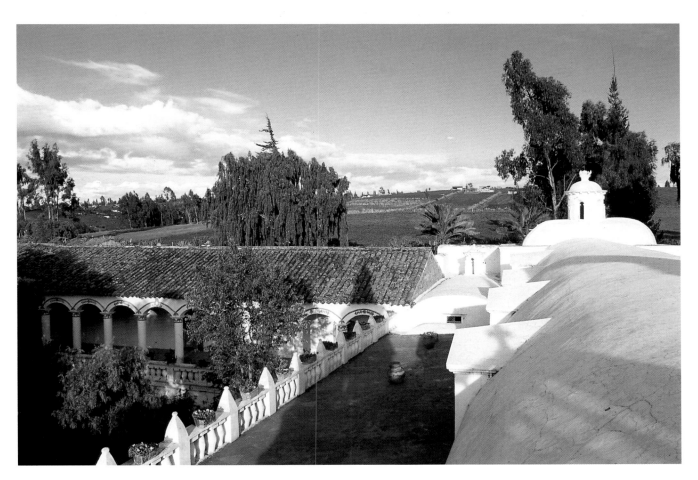

Porticoes, terraces, and cultivated green spaces in an impressive composition.

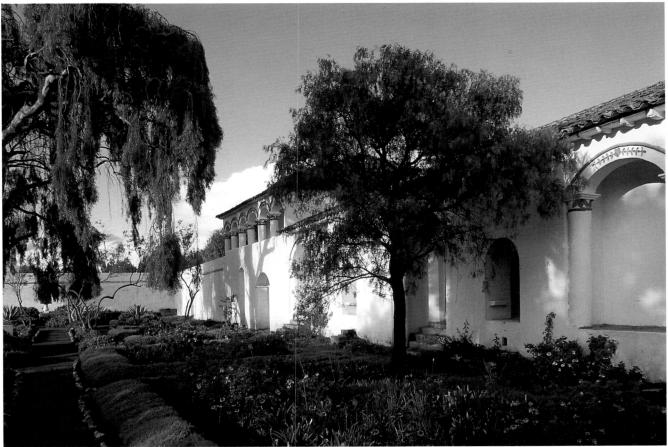

Small garden in an old convent.

The Fragrance of Coffee

When Napoleon invaded Portugal in 1808, Dom João IV fled to the overseas territories and settled in Rio de Janeiro. The coming of the monarch greatly stimulated the economy of Brazil. The borders were opened; foreign ships were welcomed in the ports; schools, universities, and publishing houses were founded; and industries, new commerce, and companies were born, permitting economic and cultural life to become strongly established.

Toward the end of the nineteenth century two new developments generated further economic growth: the birth of the lucrative rubber industry and the new project to cultivate coffee. Immediately afterward arose great *fazendas* where these products were collected, worked, and shipped. Next to the elegant dwellings was found space for gardens.

The colonists were in general cultured and often held European degrees. Hence they knew and were fascinated by the tendencies that were spreading in the Old World. The green spaces they realized both imitate—greatly simplified—the gardens of Europe and exploit the local vegetation. Long alleys of palms frame the beautiful facades of the stately houses, which are embellished by simple decorations and flanked by vast enclosures that delineate areas for horses and livestock.

Earth, the source of life and wealth, assumed immense value for these colonists. A garden would ornament it best, creating a sort of farm-garden where the division between productive and recreation areas is rather evanescent.

Terrace in front of the São Fernando fazenda *in Vassouras.*

Paddock between the street and the main house of the São Luis da Boa Sorte fazenda *in Vassouras.*

ESTRADA
Rio-São Paulo
28·95

Fazenda *on the Rio de Janeiro–São Paulo road near Itaguaí. An allée of palms is cut into the surrounding vegetation.*

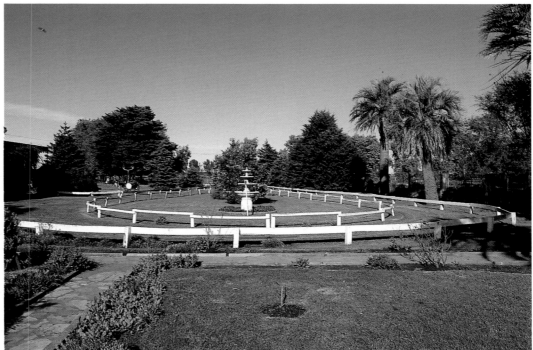

Simple fountain at the center of a circular area on the approach to the main dwelling.

In the Pampas, Amid the Gauchos

Miles separate the street gates from the dwellings of the *estancias* scattered throughout the *pampas*. Little city-gardens where the rhythm of life is still tied to the changing of the seasons and to the pace of agricultural tasks characterize these great complexes.

The story of the gardens is parallel to that of the colonization of these lands forever belonging to the *indios*, who, until the nineteenth century, defended it strenuously. The first colonial estates arose in the north of Argentina beginning in the 1500s and the first half of the 1600s. They were located near the coast on plots of land along the Paraná River and called *suertes de tierra*. It was only later that the phenomenon spread to the surrounding plains, which were more fertile but made communications difficult.

Today the fascination of the *pampas* is conserved almost intact with boundless fields of cereals and pastures and the grand farms that punctuate them. The passage from cultivated field to designed greenery is gradual, progressive, and embracing, without conclusion, as if the latter were an offspring of productive territories. The main house is above all a directional center, the fulcrum of a business establishment more than a residence or resort.

Amid green fields, windmills, and herds of cattle arise ample and simple gardens, elegant oases of tranquillity that relate the main dwelling to the farm areas. Handmade articles—gates, pools, and fountains—still borrow from the Spanish colonial baroque repertoire, when they are not a miniature copy of the Patio of the Acequía of the Generalife at the Alhambra. Such nostalgia humanizes the infinite solitude of this generous land.

Small statues recalling fantastical creatures at the entrance to an important residence.

Opposite:
Copy of the Patio of the Generalife at the Alhambra in the gardens of the Acelain estancia in Tandil.

Overleaf:
Vast English-style park with a pleasant lake surrounding the La Favorita di Acelain estancia.

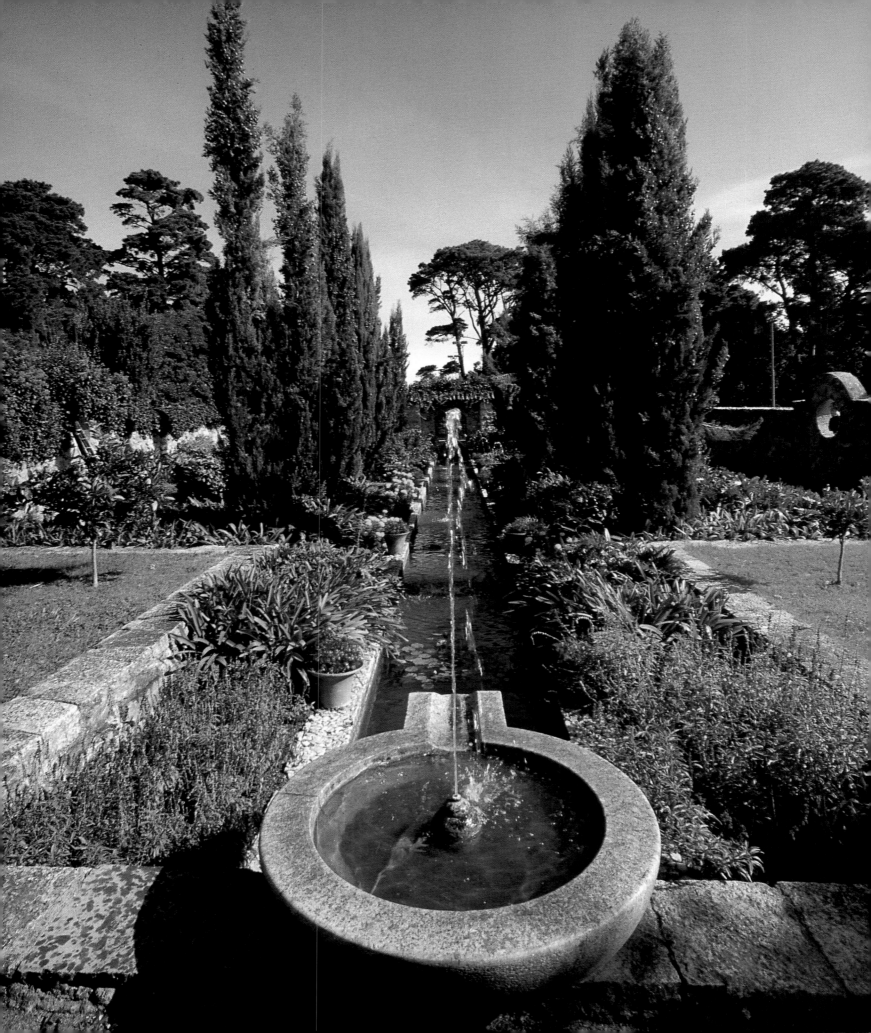

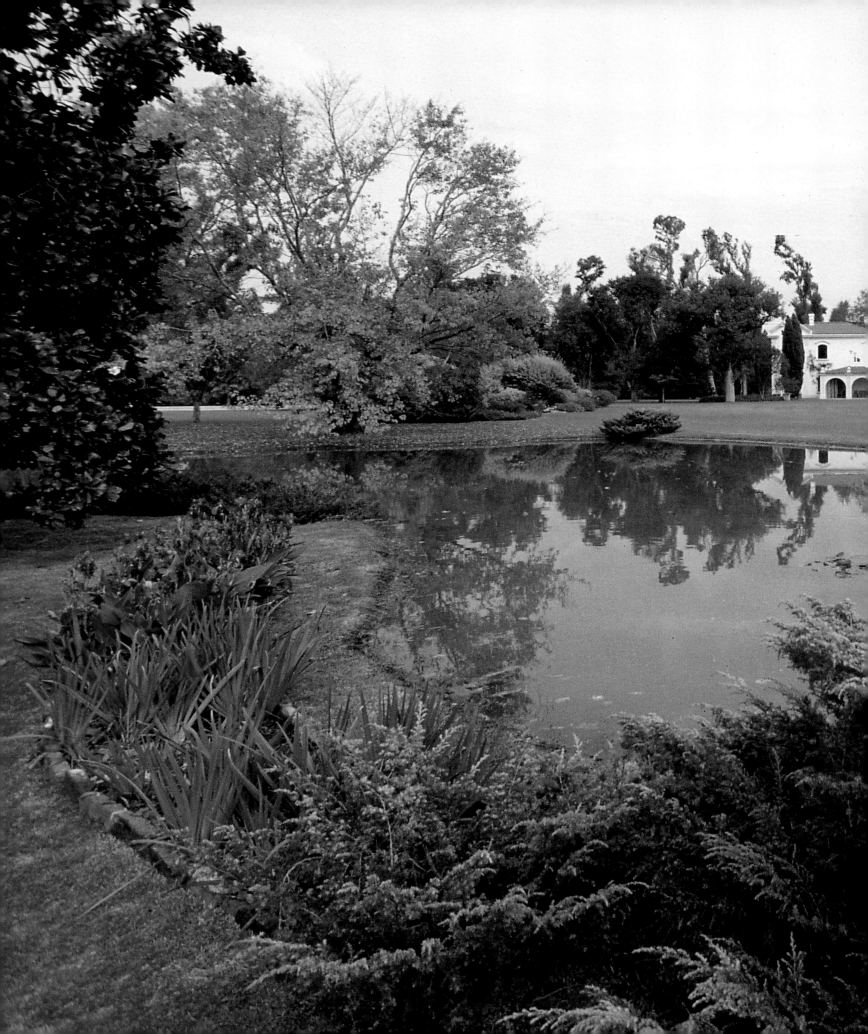

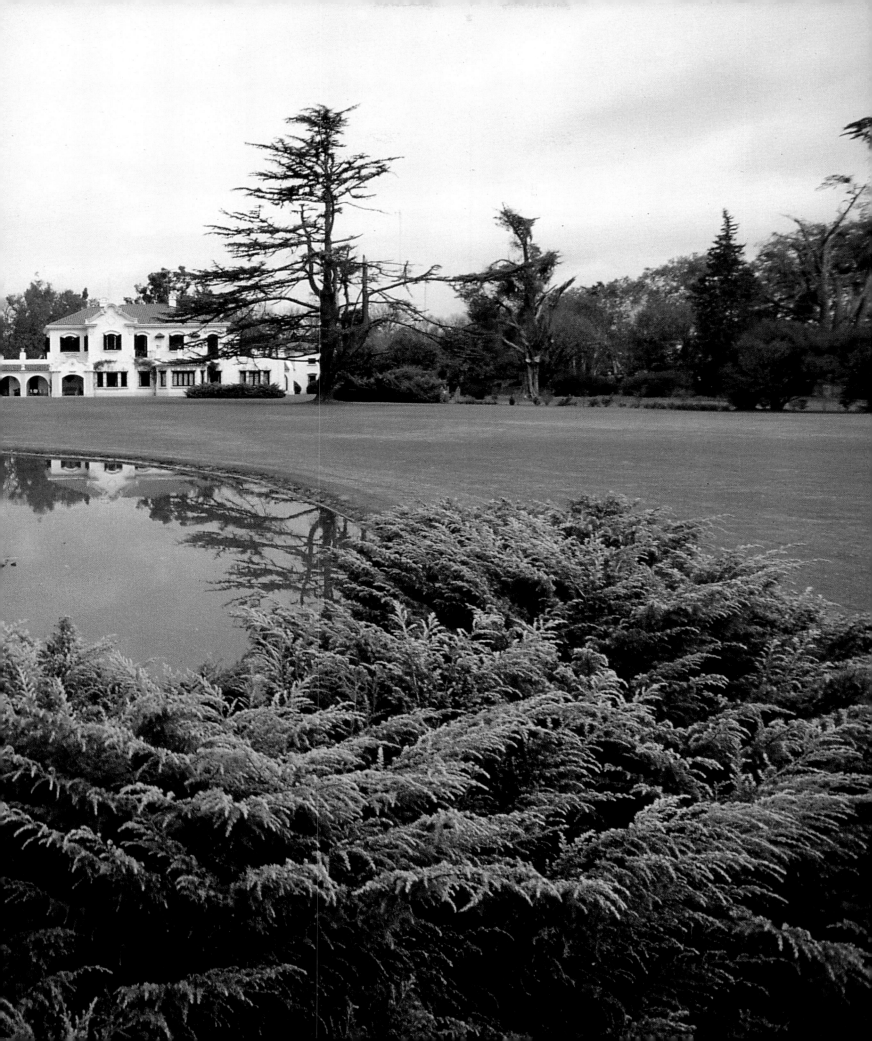

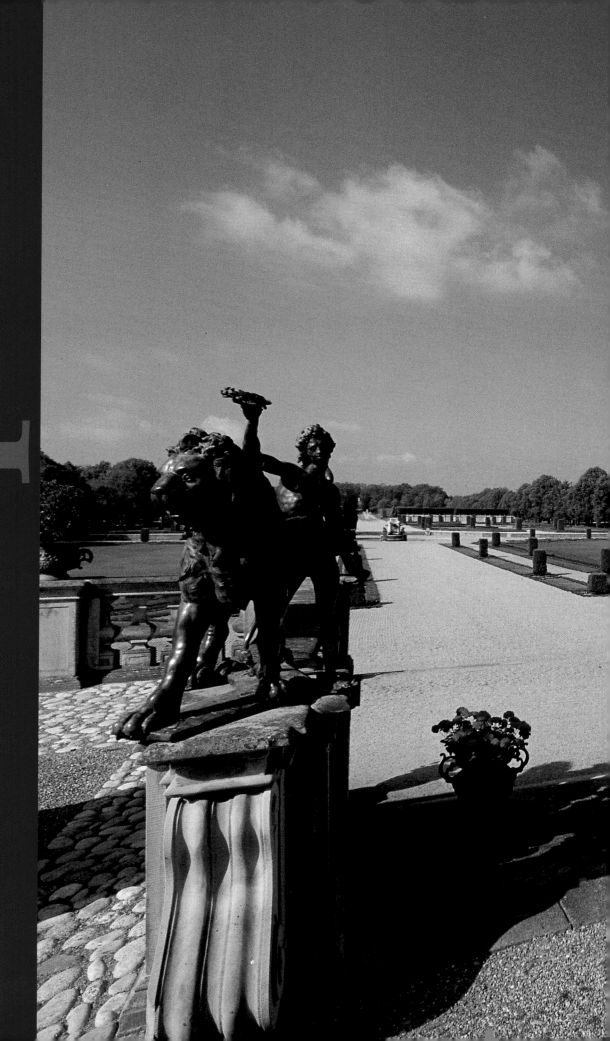

In fifteenth-century Europe, the Western garden regained its course after medieval times. At that time Florentine humanism had recently discovered the classicism of imperial Rome, and the Arabs were settled in Andalusia, where they disseminated their knowledge of hydraulics.

The migration of artists and landscape architects everywhere contributed to the germination of the idea of the garden. First in Great Britain, then in Holland and in France, green spaces assumed more and more importance, until the turning point in the 1600s. Versailles created a standard for the most beautiful and largest garden that could be realized. Paradoxically this great accomplishment would bring about the negation of geometric order and the exaltation of the "natural" garden of romantic parks.

The European garden would from the sixteenth century on provide a guide for the rest of the world. The only exceptions were the Near East and the countries under the influence of China and Japan, which have themselves at certain moments exported their own traditions to the West.

Europe

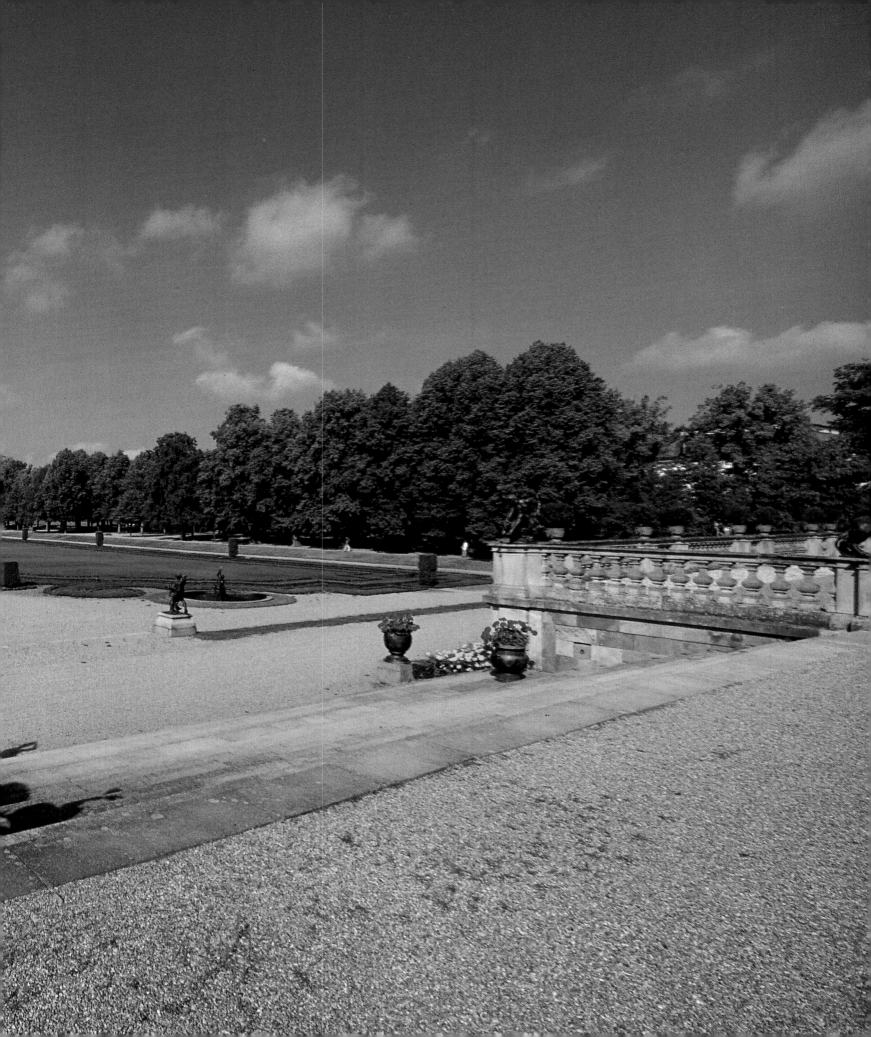

Original Landscapes

At the end of the 1400s the Tudor dynasty settled in Great Britain. This family placed great importance on the development of the garden, which emerged from walled courtyards and medieval cloisters to form knotted *parterres* with geometric hedges of rosemary and thyme, long stretches of gravel, and multicolored flowers. This style, still spartan in the 1600s, was gradually ennobled by innovations imported from Holland and France, but it was above all through French landscape architects that the Renaissance garden and then the baroque garden were re-created in the British Isles; the transmission of garden styles was unusual because France was at the time Great Britain's antagonist in colonial politics and commerce in the East and West Indies.

The subsequent landscaping movement was born in opposition to the French baroque, continental and inimical. The new course of the garden was inspired by intellectuals and philosophers supported by landowners and politicians who required a national style to represent British culture and power creatively. Seventeenth-century landscape painting, in particular that of Claude Lorrain and Nicolas Poussin, greatly influenced the new course. The intellectuals began to spread the new landscape credo, which held that natural nature is more beautiful than—and morally preferable to—its artificial substitute. The landscape architects were instructed to follow the *genius loci*, study local typology, views, and flora instead of violating the terrain and imposing "barbarous" geometrical forms.

At first baroque symmetry was softened and observation points created and decentralized, with no axes. Natural elements such as woods, streams, and lakes were exploited. The myth of Arcadia was resuscitated in poetry inspired by the works of Horace and Virgil. At the same time grottoes, small woods, and statues of mythological characters appeared in gardens.

Gardens and parks became tableaux, seemingly natural but in reality meticulously designed. The British style of landscape and romantic garden rapidly spread to the rest of Europe, sometimes adding to and sometimes replacing what was there, causing the disappearance of numerous impressive *parterres*.

Preceding pages: Grand parterre *of the royal gardens of Drottningholm in Stockholm.*

Below: The park at Melbourne Hall in Great Britain.

Rigorous and austere symmetry in the garden at Kildare Manor in Ireland.

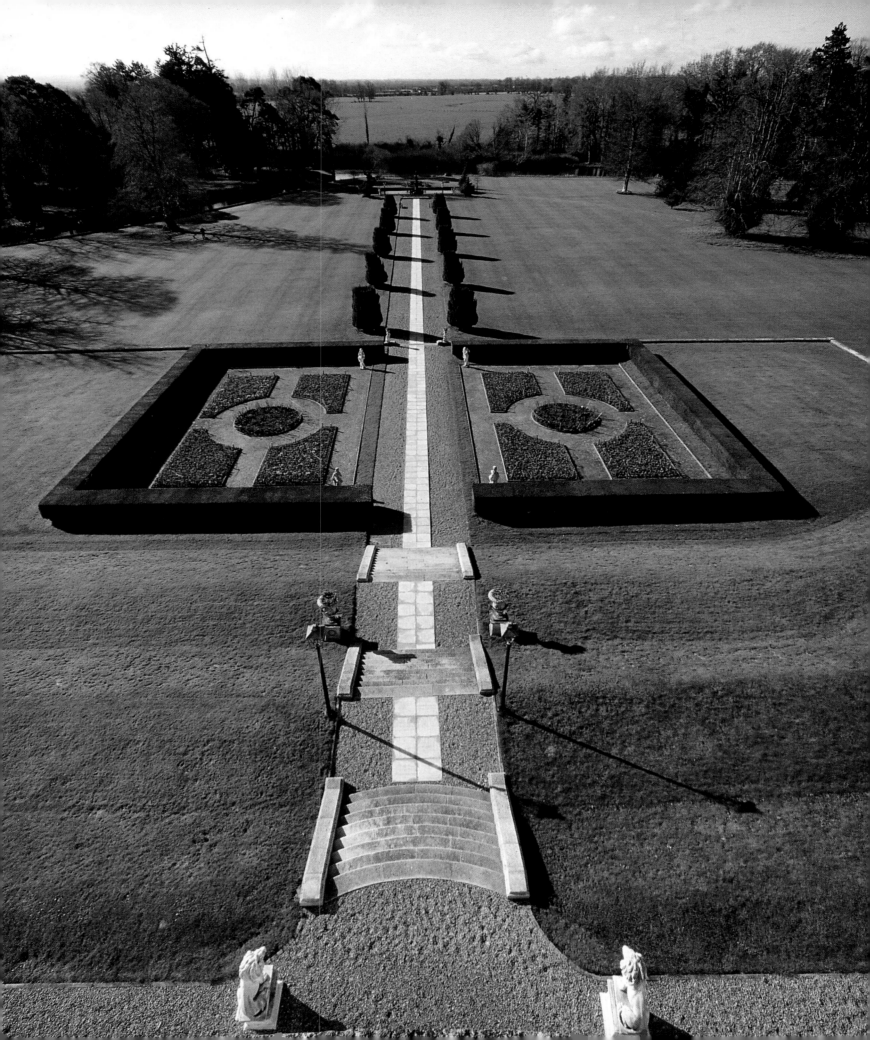

*Symmetrical composition
reinforced by steps and
fountains. Such an
arrangement is typical
of Anglo-Saxon gardens
of the 1600s and 1700s.*

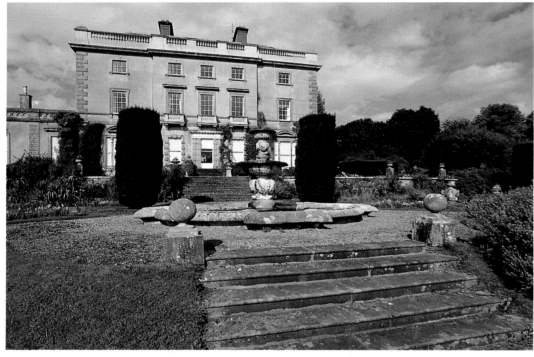

*A goblet surmounted
by an eagle on the
vast lawn of the
Powerscourt garden
in Enniskerry, Ireland.*

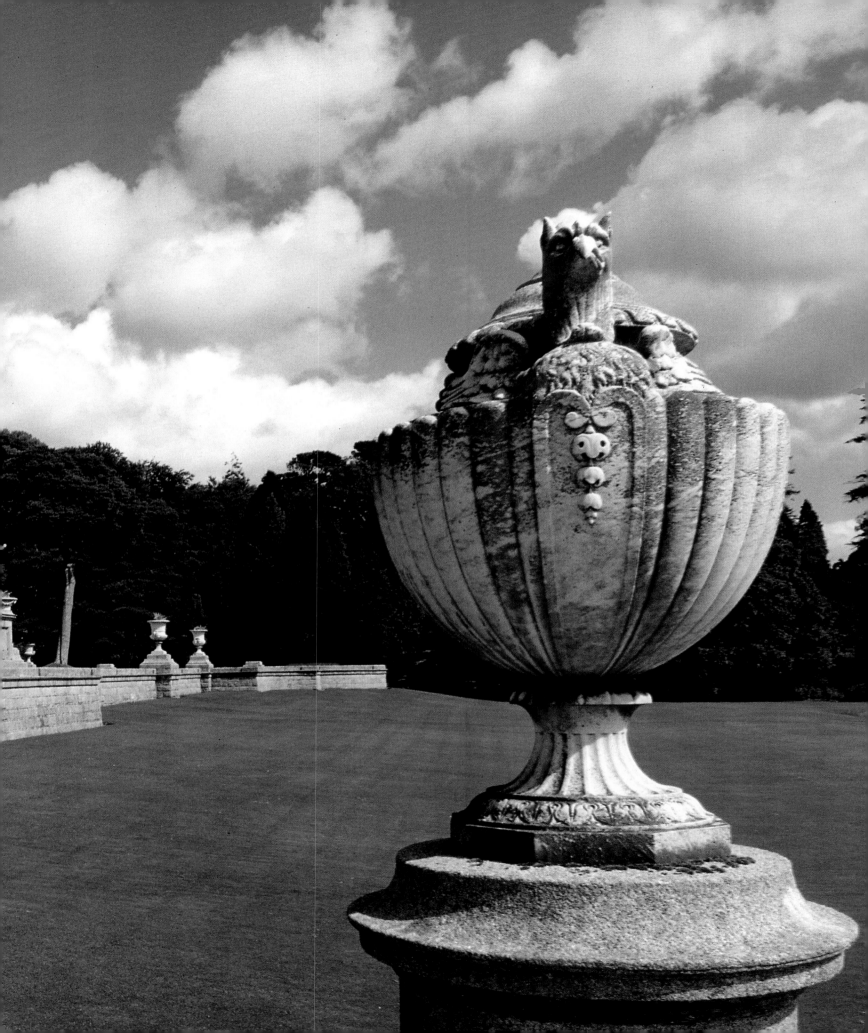

Small private garden of a formal residence. Many important dwellings in Ireland maintain such enclosed gardens, which contrast with the surrounding parks.

Glen Grant Park in Aberdeen, Scotland, recently restored to its eighteenth-century form.

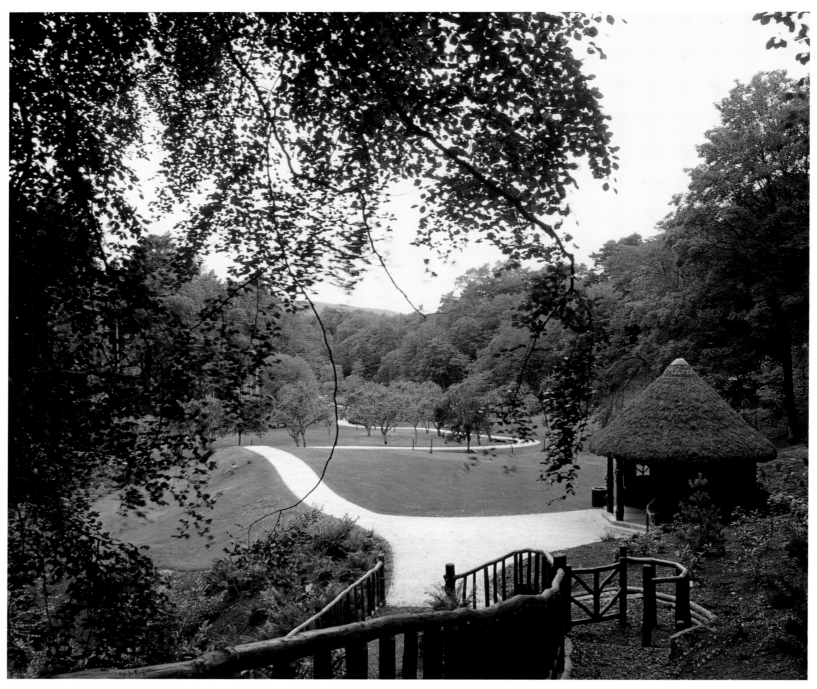

Right and below: Two of the grand parterres that compose the formal gardens of Blenheim Palace in Oxford. One is composed of volutes in boxes, the other of pools and fountains.

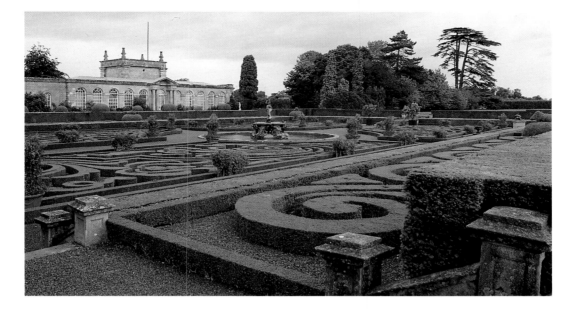

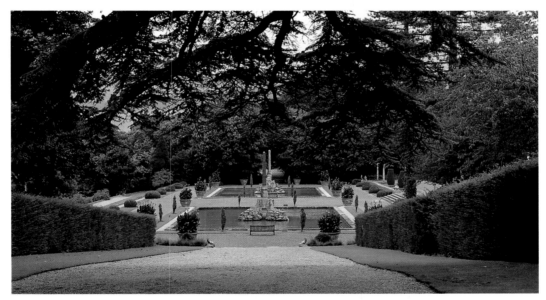

The gardens of Chard, in Great Britain, which demonstrate the compromises made during the gradual passage from formal gardens to romantic parks.

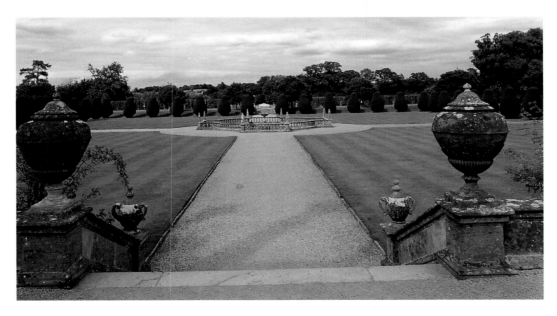

Scandinavian Surprises

Sweden

The history of Swedish gardens is quite recent. The climate had long hindered the spread of the garden tradition, although monastic *hortus conclusus*, particularly those of the Cistercians, were not lacking. In the first half of the seventeenth century, Dutch and French precedents were imported for the first time, and soon any lost time was recuperated. In effect, it was as if there had been strong resistance to importing what the Swedish considered only an extravagant fashion; in many cases there was, at the least, indifference. However, with the advent of the baroque era and the new dialogue between the European courts, it seemed to the Swedish sovereigns indispensable to conform to the tendencies of Central Europe.

In 1637, Simon de la Vallée, a noted landscape architect, arrived from the Netherlands and immediately initiated his professional activity; he was followed by the French garden designer André Mollet, who brought the French style, with its taste for grand dimensions, its oversized *parterres*—always diverse—and its rigid axial patterns, which incorporated the palaces themselves. The garden and the residence became in this way an indivisible unit that brought such realizations closer to those of the rest of the continent.

The most significant example is Drottningholm. In the seventeenth century a large "natural" area was installed next to the immense baroque *parterre* in front of the palace, coinciding with the development of the romantic garden in Great Britain. In 1753, the court architect, Carl Frederik Adelkrantz, added a Chinese pavilion, noted for its refined exterior decorations. In the same period the garden at the royal residence in Ulriksdal was remodeled; many romantic landscaped areas were added.

Since that time, Swedish traditions have followed the changing styles. Green spaces have been regularly updated, so while they are relatively young they are nevertheless ample and variegated.

Painted wooden tent in the center of Haga Park, on the outskirts of Stockholm.

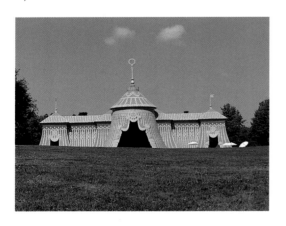

Simple and elegant parterre behind the dwelling of Julita, not far from Stockholm.

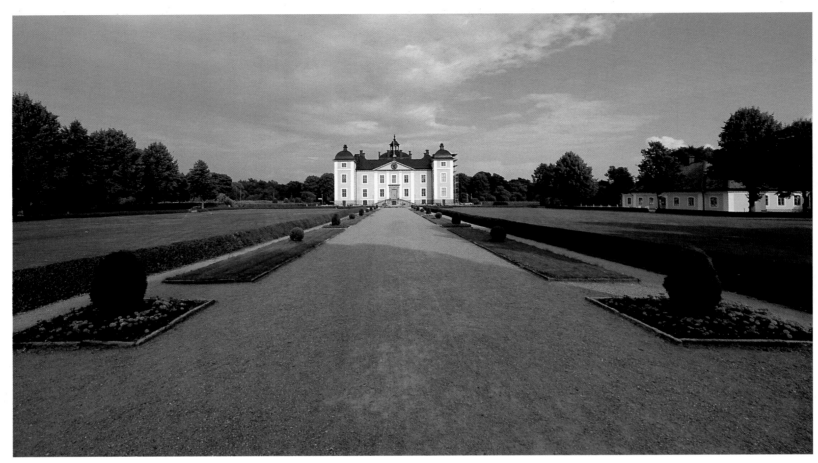

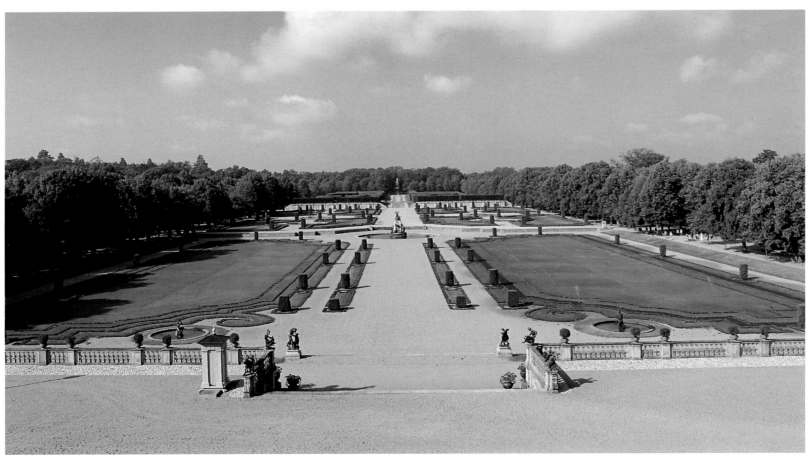

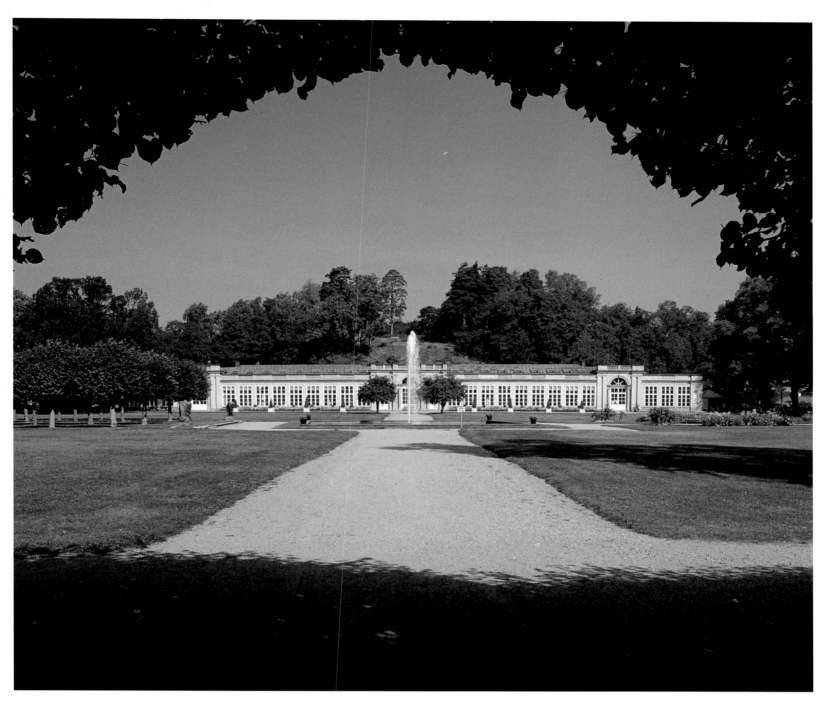

Opposite top:
The castle of Stroms-
holm, not far from
Lake Mälaren, with
its long boulevard.

Opposite bottom:
Baroque parterre in
the seventeenth-
century gardens of
Drottningholm. The
royal residence, just
a few miles from
Stockholm, is sited on
a watercourse and
surrounded by a park.

The winter garden
at Ulriksdal, another
important royal
residence, built on a
body of water about
an hour by boat from
Stockholm.

Sculpted hedges
between the residence
and the orchard at
Sandemar.

Peucedanum palustre

Calluna vulgaris

FLOWERS AND PLANTS OF SCANDINAVIA

During the last Ice Age, the Scandinavian peninsula was entirely covered by ice, and a good number of its indigenous vegetal species migrated toward the south. Only after conditions became more favorable—ten thousand years ago—did many of them return to their place of origin, but still today the northern regions shelter a lesser number of species than the southern areas. Thus historical reasons, combined with the difficult climatic and edaphic conditions, are at the root of

the limited vegetal variety of this area. Winters without light, summers without dusk, and low temperatures are the prohibitive conditions to which the vegetation of these latitudes has had to adapt.

In the northernmost part and in the alpine strip of the Scandinavian mountains, the favorable season for plant growth is very limited. These zones, which have an Arctic climate, shelter a typical vegetal formation: tundra. Here prosper musks, lichens, herbs, and sparse low bushes, including *Empetrum nigrum,* the berries *Vaccinium myrtillus* and *V. uliginosum, Diapensia lapponica, Ranunculus pygmaeus, Dryas octo-*

petala, and *Saxifraga stellaris.* Other species that take advantage of the brief boreal summer are the *Oxyria digyna,* the heather *Calluna vulgaris,* and the bearberries *Arctostaphylos uva-ursi,* which are often associated with lichens of the *Cetraria* and *Cladonia* types. Other plants that can thrive in such inhospitable territories are the lichen *Haematomma ventosum,* the reed *Juncus trifidus,* and the climbing azalea *Loiseleuria procumbens.*

In the east, polar air masses from northern Eurasia bring frigid winters, while summers—in relation to the latitude—are relatively hot. In the boreal region of Scandinavia, the kingdom of the taiga, the forest of coniferous evergreens is dom-

Oxyria digyna

*Arctostaphylos
uva-ursi associated
with lichens*

Loiseleuria procumbens

inated by the Norway spruce *Picea excelsa* and the Scotch pine *Pinus sylvestris*. Deforested or burned areas are rapidly colonized by a species typical of these regions, the lanuginous birch *Betula pubescens,* which constitutes veritable woodlands on the mountains beyond the coniferous strip. Another species of birch, *Betula pendula*, is present only in the southern part of the region.

Above the subalpine birches is vegetation composed primarily of herbaceous plants, including the wild geranium *Geranium sylvaticum*, the aconite *Aconitum septentrionale*, the wolf's bane *Trollius europaeus*, the sow-thistle *Lactuca alpina*, the cloudberry *Rubus chamaemorus*, and the buttercup of the glaciers *Ranunculus glacialis*.

In the southern part of the boreal region various species of broad-leaf plants appear sporadically: ash trees, oaks, elms, maples, aspens, and lindens. Peat bogs and swampy zones, which are rich in musks, sedges, and other species like *Potentilla palustris, Utricularia intermedia,* and the umbellifer *Peucedanum palustre,* alternate with these forests. Willow groves with *Salix triandra* and *S. daphnoides* and alder groves with *Alnus incana* and *A. glutinosa* grow in the more humid terrain.

Beyond the Scandinavian mountains to the west, an area with a climate of cool summers and "mild" winters—due to the influence of the Atlantic—are mixed deciduous forests dominated by oaks and birches and, even if of anthropic origin, "Atlantic" moors rich in grasses and other herbaceous plants. Beeches and oak and hornbeam forests, identical to those of Central Europe, characterize the vegetation of the southeastern part of Scandinavia.

Castle Gardens

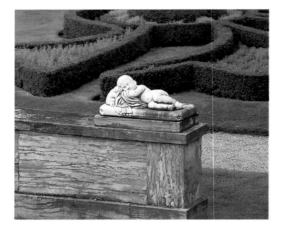

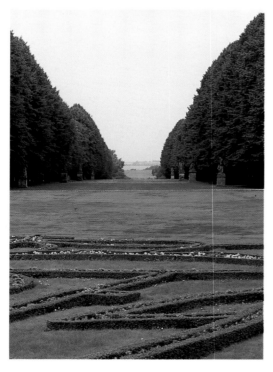

In the sixteenth century, austere and isolated Danish castles gradually opened out to the countryside; at the same time gardens appeared, often connected to the castles by drawbridges. *Parterres* were placed alongside the moats, which since then have been transformed into pleasant and innocuous lakes. The style was always formal, with boxwood and hornbeam hedges in addition to pavilions, chapels, gazebos, and the numerous rose gardens favored by the climate— certainly not Mediterranean but milder than that of nearby Scandinavia.

The creator of the Danish style, if it can be referred to in that way, was Frederick IV, who as a youth traveled throughout Europe learning about landscapes in the diverse styles that were burgeoning at the end of the seventeenth century. In the first half of the following century, the king first concerned himself with the garden next to Frederikberg Palace in Copenhagen—designed by Cornelius Krieger, the principal Danish landscape architect—and then that of Fredensborg. The latter was built to commemorate the peace treaty with Sweden; it was finished by Krieger in 1720. Krieger's gardens were typically baroque, composed of rigid geometric forms using high hedges concealing ample flowered *parterres*.

The Anglo-Saxon romantic garden was adopted in Denmark only slowly, so many of the most beautiful baroque gardens have been preserved. Today woods and lakes alternate with the airy *broderie*, and great axial vistas, believed to be the province of the French, attract attention.

Above and left: The garden of Fredensborg, a grand residence near Hillerød. A long allée of trees starting at the parterre *in front of the dwelling creates an impressive vista.*

The Jensen's Gaard private urban garden in Copenhagen, constructed at the end of the nineteenth century and maintained by the family.

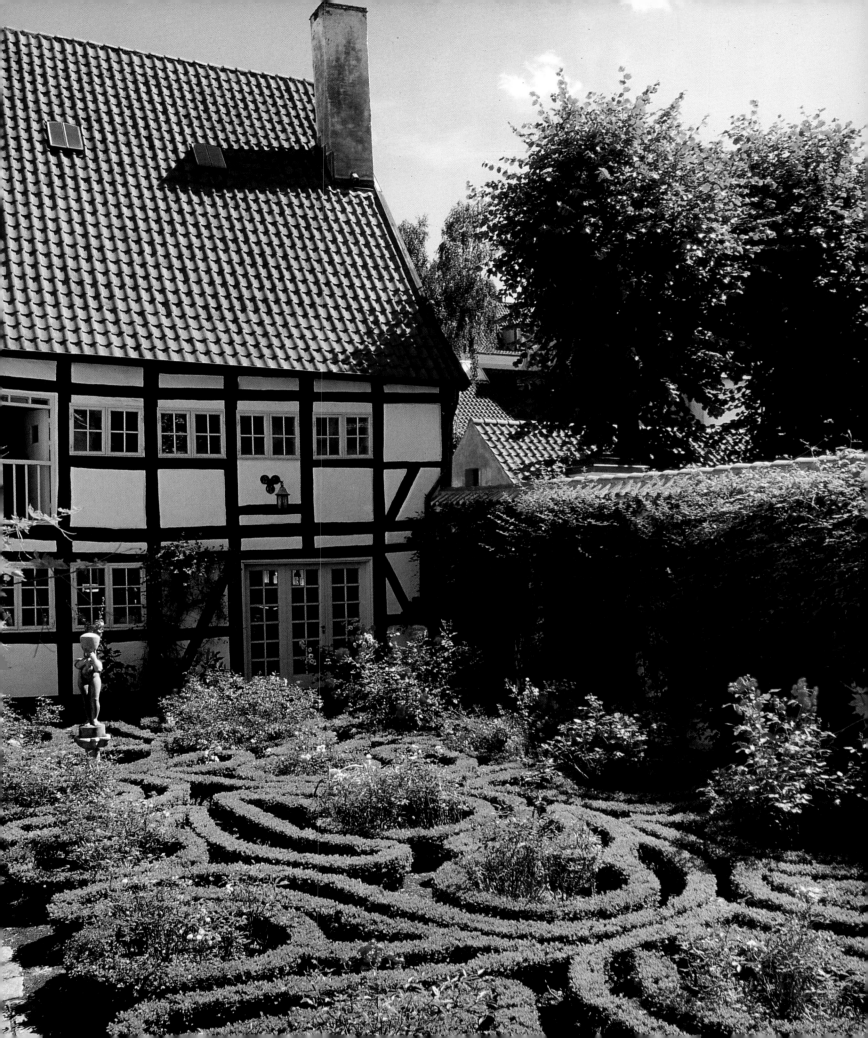

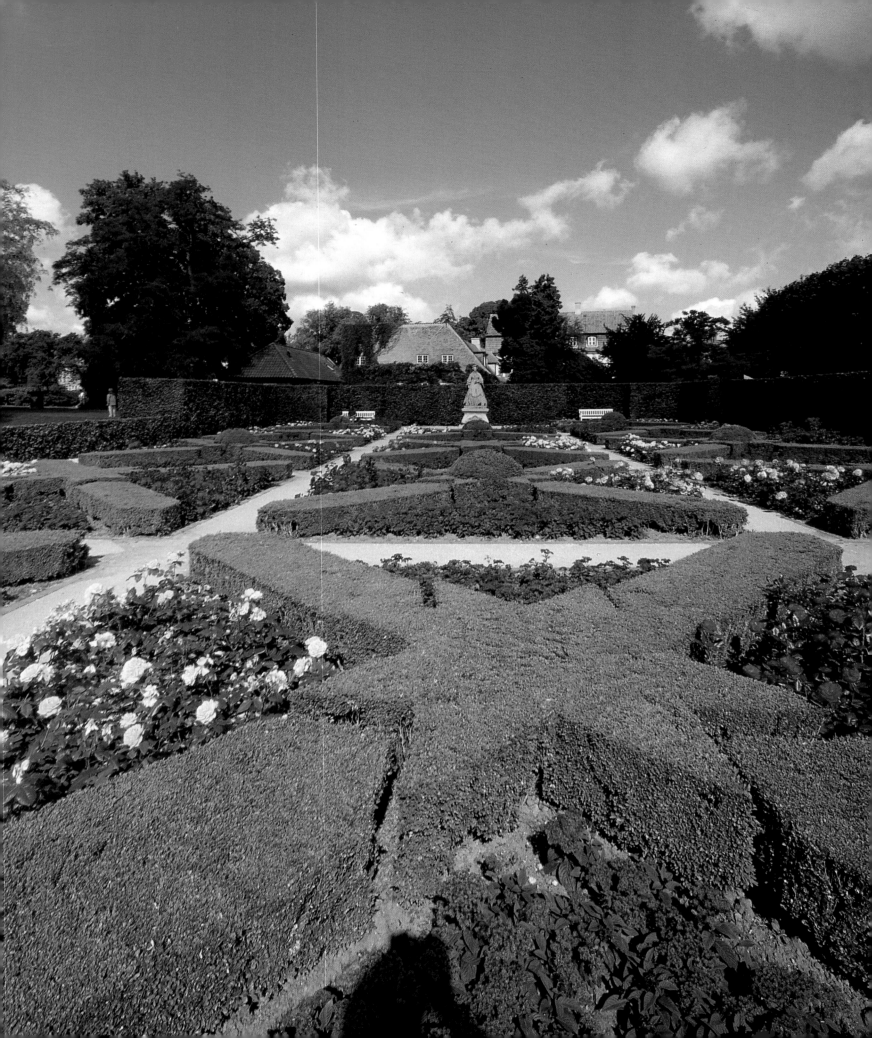

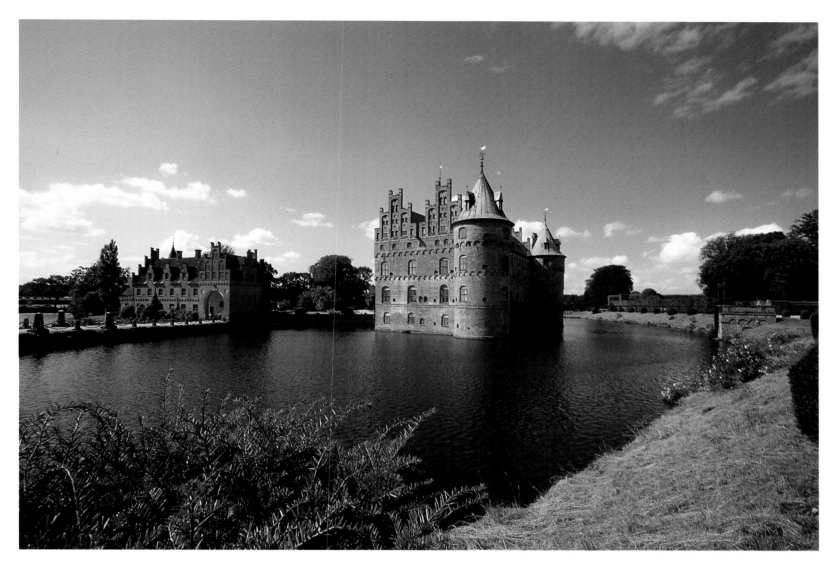

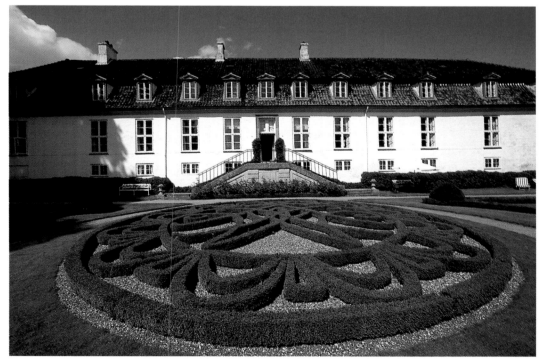

The Renaissance castle of Egeskov in Svendborg. An ample romantic park with a marked geometric quality was added halfway through the eighteenth century.

The Glorup Castle in Svendborg, where a formal flowerbed with volutes formed of hedges faces a romantic park.

Opposite:
Gardens flanking the Rosenborg Castle in Copenhagen. Spacious flowerbeds are defined by hedges in the shape of Xs and bloom from spring to fall.

Flemish Scenes

Low Countries

A white bench behind a colorful flowerbed. The myriad colorful flowers in gardens of the Low Countries almost testify to the victory of humankind over the sea.

*Opposite:
The garden of Annevoire in Belgium, which for the most part maintains the form created in 1770 by its designer and owner, Charles-Alexis of Montpellier, a wealthy blacksmith who had traveled throughout Europe.*

The interest in gardens in this area of northern Europe, which comprises Belgium, Holland, and Luxembourg, is relatively young. The common history of these countries is distinguished by a continuous struggle to defend themselves from the sea; perhaps for this reason has there been a noteworthy interest in flora.

In 1577, a botanical garden was founded in Leiden, only thirty-two years after that of Padua; it was one of the first in Europe. Less than fifty years later, in 1614, the Dutch gardener Crispin Van de Pass the Younger published his *Hortus Floridus*, a herbarium containing every garden flower and illustrated with numerous xylographs; the plants are divided into climatic groups and by periods of flowering. At the same time, "tulip mania" spread and became a great commercial success.

Rural residences on the *polders*, in spite of their turrets, were tranquil and aristocratic oases of pleasure. After a century of war with the Spanish occupiers in the first half of the seventeenth century, Holland became independent and began to expand. The 1600s represented a golden age that coincided with the burgeoning of the arts and with a substantial increase in construction. Midcentury, the Danish garden assumed a precise personality: formal and embellished with *ars topiaria* virtuosity and with numerous statues and fountains. Each *parterre* presented a different design even though it was part of a rigorously symmetrical single project; each was a coherent realization with different botanical species and independent personalities. In this period, the Danish style was studied by English and French landscape architects as well as by those of czarist Russia. Colonies such as Brazil, South Africa, and Indonesia also acquired the tradition. It was only in the second half of the eighteenth century that this process was inverted and the picturesque garden was imported from Great Britain. Moats around castles were maintained as decoration or for fishing, emphasizing the tight relationship between these countries and the water.

When, in the middle of the nineteenth century, Belgium gained its independence, a noticeable colonial expansion was undertaken that enriched the bourgeoisie to such an extent that it was able to compete with the glitter and magnificence of the ancient nobility. In this period residences and castles enjoyed renewed splendor; gardens and parks were restored, often in the romantic style. Today the fascination still lies in the union between Italian classicism, Anglo-Saxon naturalness, and the Nordic propensity for dignity and solemn austerity.

Eymerick Castle in Heeze, Holland. Behind an austere facade hides a formal courtyard rich in Renaissance features.

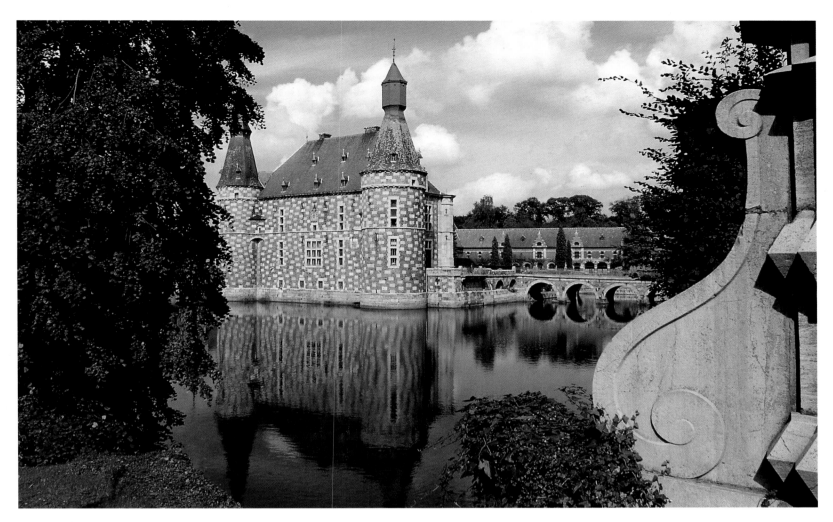

*Jehay-Bodegnée
Castle in Belgium.
The sixteenth-
century structure is
surrounded by water
and a luxurious park.*

*Long pool connecting
the far ends of the
eighteenth-century
Freyr garden in
Dinant, Belgium. The
green space between
the castle and the hill
is embellished with
numerous potted
orange trees.*

*A double stairway
in the Freyr garden,
which leads to a
terrace delimited
by tall hedges. The
rococo pavilion in
the background,
decorated by Moretti,
is on axis with the
entrance to the castle.*

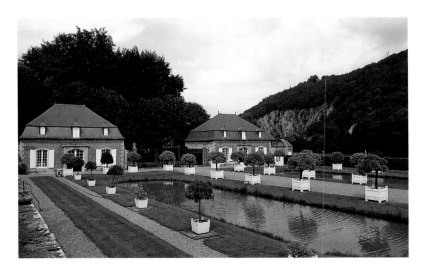

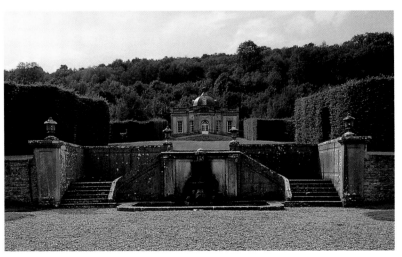

Where the Sun Never Sets

Below:
The grounds of a
castle outside Paris.
Many such castles
were built in the
seventeenth and
eighteenth centuries;
although fortified and
featuring towers and
moats, the structures
were simply vacation
residences with
spacious parks for
members of the court.

Opposite:
Beaumesnil Castle on
the Eure River. The
moat is now a pool
and the bastions
house flowered
parterres.

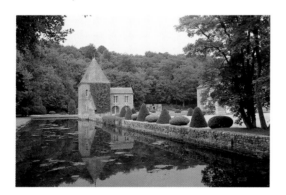

France, along with Italy and Great Britain, has been seminal in the history of the Western garden. The French tradition formed the link between Italian formality and British naturalness. French gardens amplified earlier designs, exaggerating their dimensions, rationalizing even more their layout, exhausting their expressive possibilities, and provoking, in the end, a total and absolute resistance to anything architectural in a green space.

The Italian garden truly arrived in France after the marriage of Catherine de' Medici and Henry II. Florentine lords contributed significantly to the spread of the new style, mainly by sending their gardeners. French landscape architects acquired such experience gradually and personalized the garden in France by introducing new elements such as *cabinets de verdure*, "green rooms" with architecture of pruned hedges. The *parterre*, already present in the Italian tradition, assumed altogether new meanings and dimensions. It became the reflection of architecture on nature, initiated a dialogue between garden and building, and was above all designed to be seen from the principal floor of the residence. Its forms were an infinite number of combinations of squares, circles, ovals, and volutes.

In the mid-1600s Louis XIV, the Sun King, an expert in botany and a passionate collector, took the throne. He initiated the most felicitous period of the French garden. André Le Nôtre was capable of translating into garden form the king's desire to express total dominion of humankind over nature. This concept, already proposed by the gardens of humanism and the Italian Renaissance, was enormously elevated. Le Nôtre, after designing Vaux-le-Vicomte, dedicated himself to Versailles, surely one of the vastest existing French gardens. To symbolize that there were no limits on the aspirations of the king, the green space was opened to the world; it was intended to be the center of the world, unraveling around axes ordered by the cardinal points.

In the rest of Europe, Versailles was above all form; for Louis XIV and France it was tangible testimony to the splendor of the kingdom, the stability of the monarchy, and the absolute and uncontested power of its lord. But it was also testimony of a period of pomp and triumph without equal. From then on every sovereign wanted a Versailles, but no one was able to realize anything comparable. The fashion of geometric forms waned and all Europe converted to the romantic park, but France remained faithful to the grandeur that had made its gardens famous throughout the world.

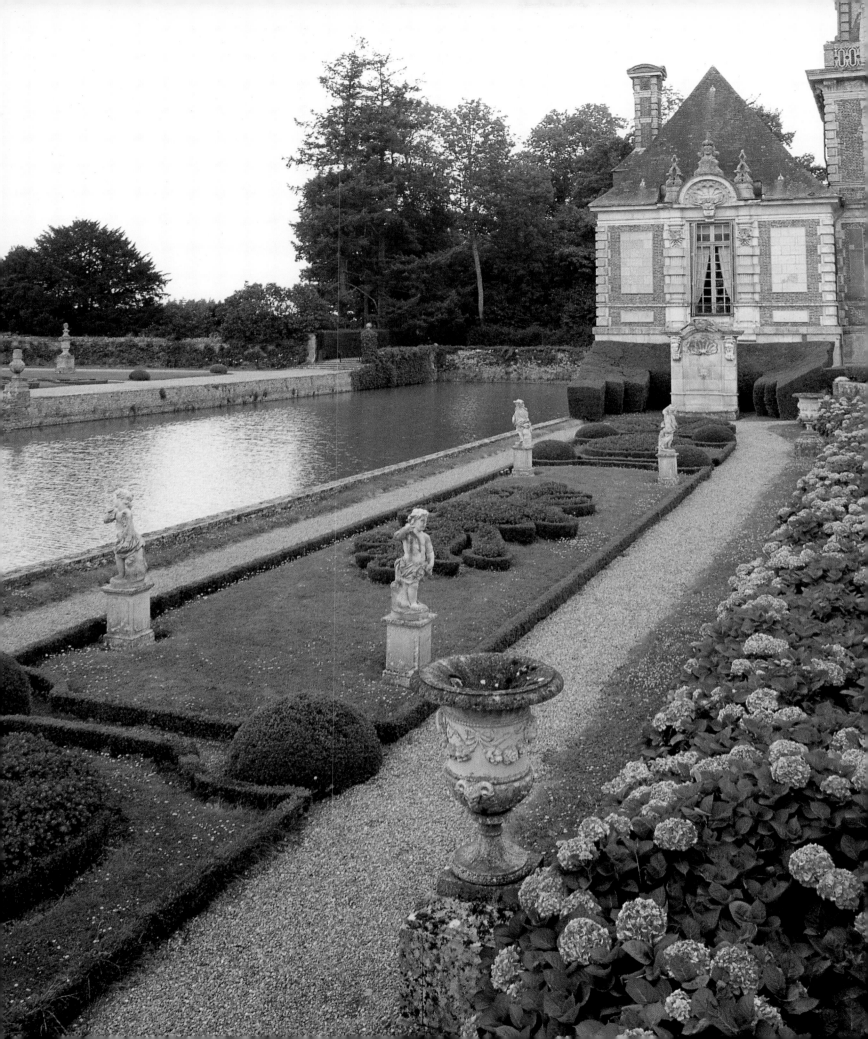

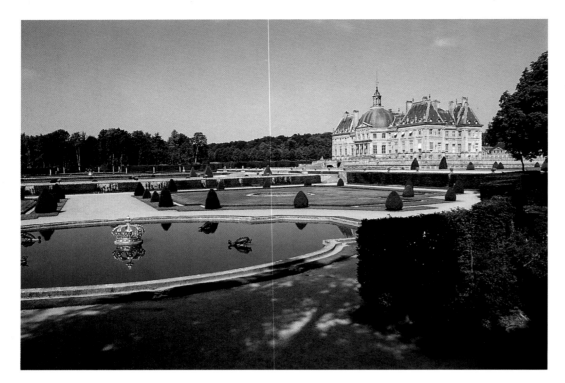

The gardens of Vaux-le-Vicomte on the Ile de France. André Le Nôtre's first great project, realized between 1656 and 1661, was commissioned by Nicolas Fouquet, the minister of finance for Louis XIV.

The gardens of Fontainebleau, near Paris, another important design by André Le Nôtre. The site was the property of the crown as early as the twelfth century.

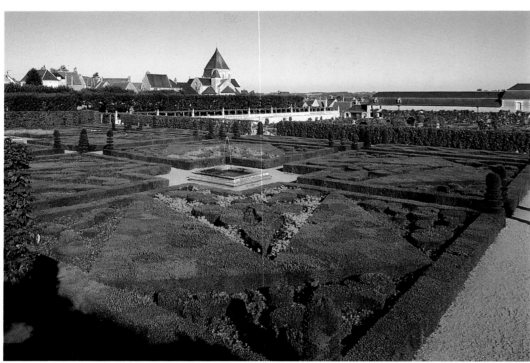

The garden of Villandry in the Loire Valley, which owes its originality to the geometric forms of the vegetable gardens.

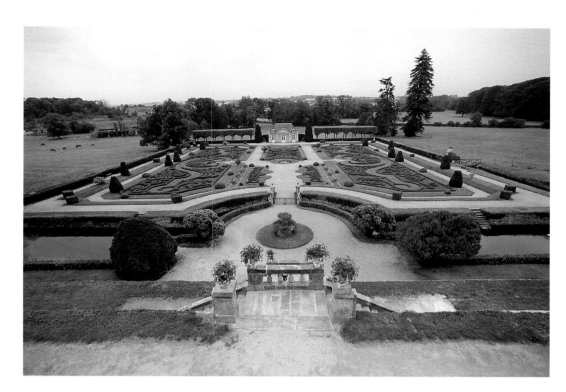

The parterre *at Sassy, in the Orne region, an example of the French baroque.*

Overleaf:
The gardens of Versailles, André Le Nôtre's masterpiece.

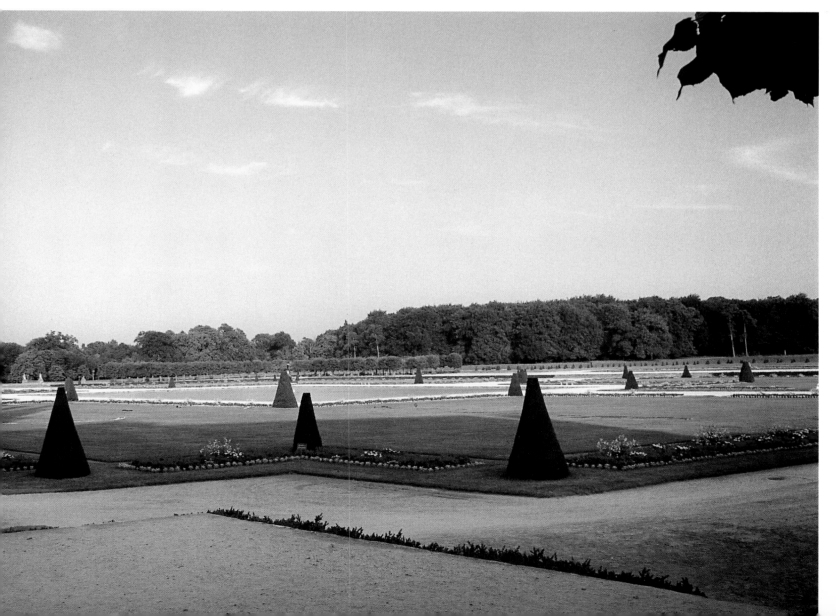

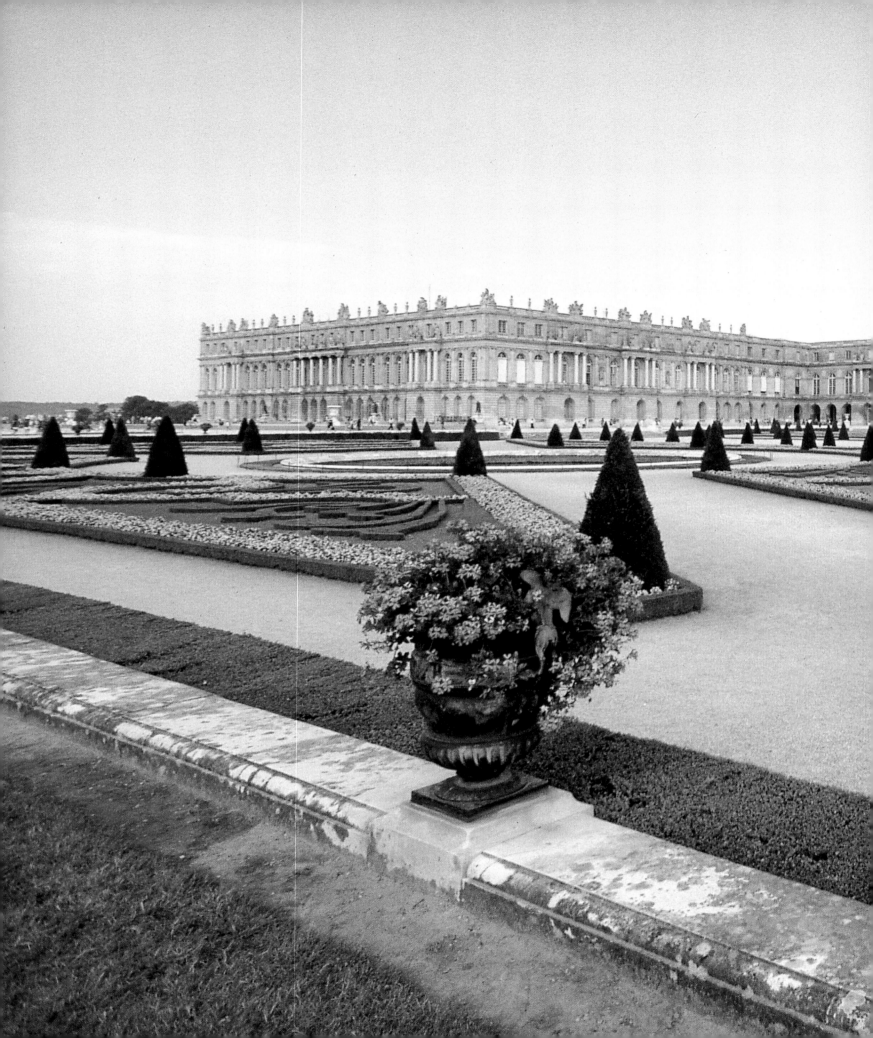

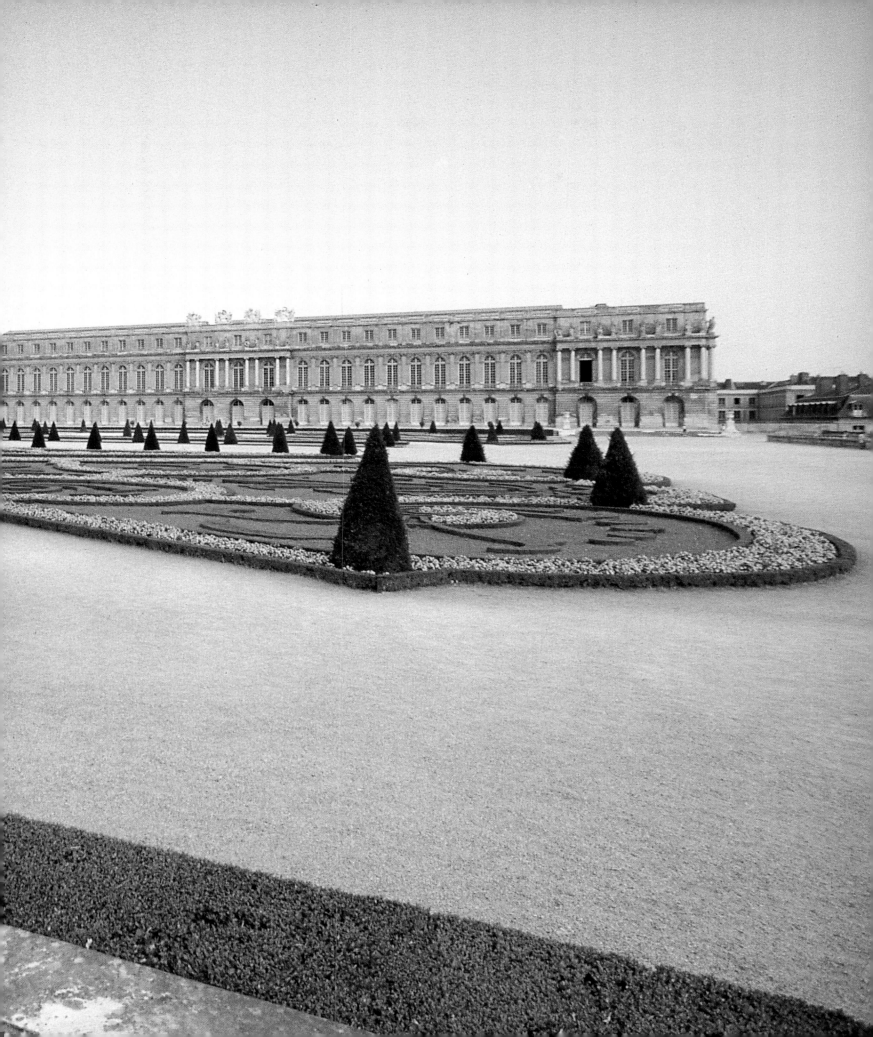

Valleys in Bloom

Flower-covered facade. In the Alps the concept of the garden broadens to encompass eccentric creations.

In the inaccessible valleys of Switzerland, castles and sturdy houses alternate with elegant baroque residences, making its cantons a sampling of fortified architecture. The climate—particularly cold in winter—the various religions, and the geography have favored the need for secrecy and also a certain diffidence toward foreigners and foreign culture.

In the medieval period, the diocesan headquarters and the grand monasteries were active cultural centers. Certain families entered the political scene, creating centers of power that were based in the newly founded hamlets. The feudal system favored the birth of numerous castles—almost two thousand—which were used for protocol and as manifestations of the acquired power and dominion over the territory. They were also important for the control of the region and, in case of attack, could serve as bulwarks of defense. In fact, even castles used as stately residences preserved martial elements such as merlons, parapet walks, towers, corbels, moats, and drawbridges.

Thus for sociopolitical reasons as well as for climatic and geographical ones, Switzerland has never been a garden country. Renaissance styles and ideals could not reach the valleys, so the medieval tradition of modest kitchen gardens with vegetables, planted in the courtyards of castles and monasteries, was maintained. The few baroque gardens, realized under French influence, were transformed into romantic parks in the nineteenth century and are now almost part of the surrounding woods.

In the twentieth century, Renaissance and baroque revivals, never perfectly realized with the vegetation of the country, have alternated with more innovative gardens that take advantage of the climate. This type of adaptation has defined the Swiss way with green spaces, a tradition that is spreading with a certain degree of success.

A contemporary garden in Switzerland; many such gardens include landscaping and, often, works of art.

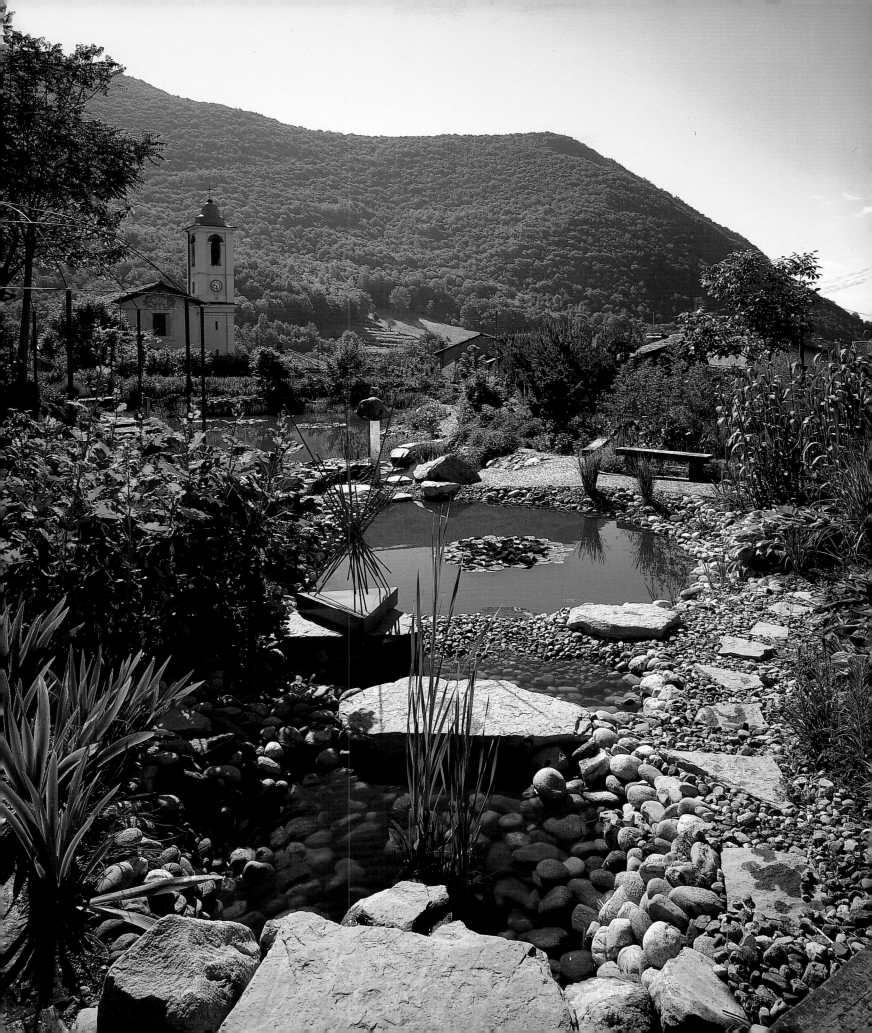

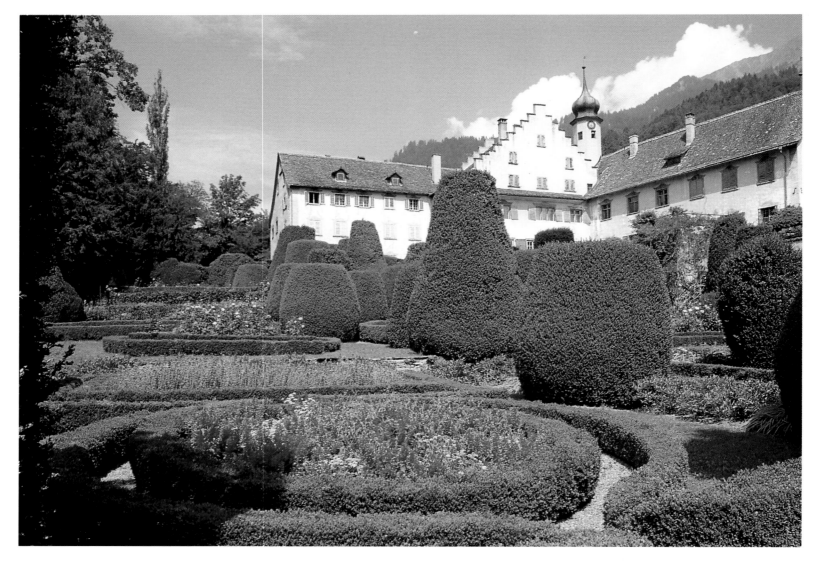

The austere castle of
Bothmar, in Malans,
and its walled garden.

Geometric vineyard
designs surrounding
an old tower used as
a stately residence.

The De Lenzbourg
gardens in Vogelshus,
which climb a hill
to offer to the house
a view of the multi-
colored hedges.

An eccentric gazebo
characteristic of the
structures built in
many Swiss gardens.

Teutonic Classicism

In the middle of the sixteenth century the Italian Renaissance garden arrived in Germany; in that and the following century was realized the best example of this tradition on German soil: the Hortus Palatinus of Solomon de Caus in Heidelberg. Resting on steep terraces and following a rigorous axial geometry, this space effectively illustrated the fascination and beauty of analogous gardens from Tuscany and Lazio.

The Thirty Years War, initiated in 1620, led to the disappearance of local gardeners who had been trained during long periods abroad. In the meantime developed the French baroque style, based on the model of Versailles, which would reappear in the gardens of the second half of the century. Dutch and, especially in the south, Italian traditions were also influential.

In German gardens the search for leisure and intimacy is evident. Grand perspectives on the countryside disappeared, boundless *parterres* were divided into various private spaces, and numerous eclectic garden edifices, from tea rooms to pagodas to Chinese pavilions, were built. Fruit trees and geometric *parterres* alternated with areas of natural vegetation. These trends characterized the German rococo garden, which in the first half of the eighteenth century became more elegant and refined and less representational. The most striking example is Sanssouci at Potsdam, near Berlin. The garden, "without worries," as its name suggests, was dedicated to pleasure and leisure.

The step from the rococo to the romantic and landscaped park was brief. In the second half of the eighteenth century the Wörlitz park was begun, the first of a long series of designs featuring ruins and other classical and exotic citations, such as grottoes, temples, and pyramids. Yet many great rococo sites were preserved and exist today.

The romantic park of Bad Muskau, designed and built by noted travel writer Prince Herman Pückler-Muskau from 1816 on. The scholar infused the gardens with knowledge acquired during his European trips.

Sanssouci in Potsdam, outside of Berlin, a vast complex of buildings and green spaces commissioned by the royal house of Prussia.

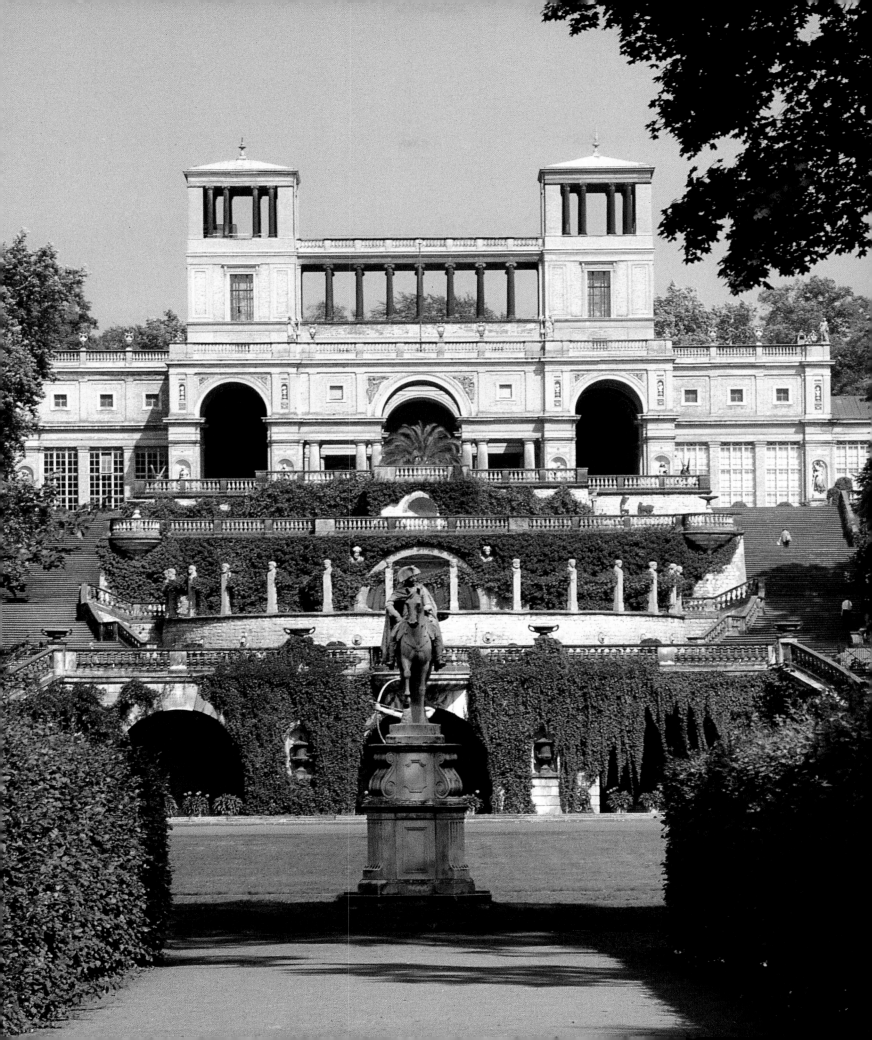

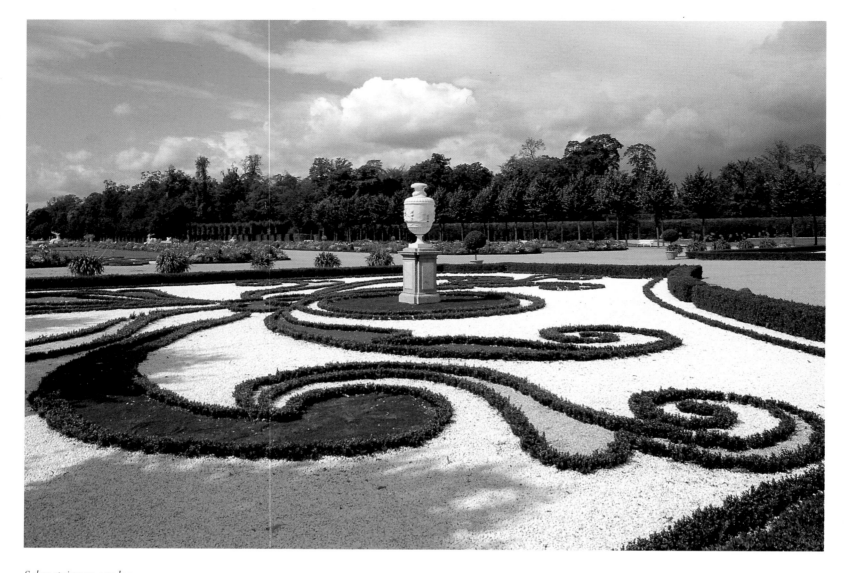

*Schwetzingen garden
in Heidelberg, with
volutes defining the*
parterre.

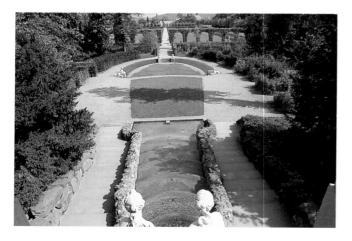

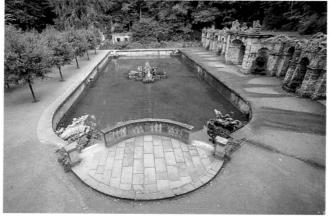

*Far left:
A "chain of water"
in the Schwetzingen
garden, which extends
to the semicircle that
closes the perspective.*

*Left:
The garden of
the Eremitage in
Bayreuth, located
between two
eighteenth-century
castles and designed
starting in 1736.*

The spacious terrace of the Nordkirchen garden, separated from the residence by an imposing stairway.

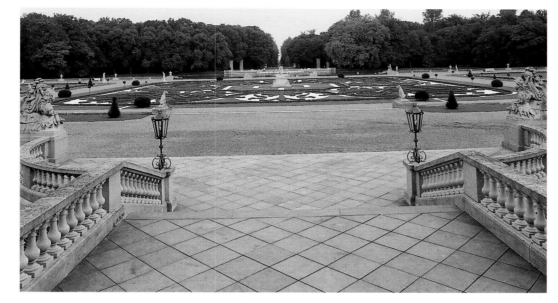

The approach to the Residenz at Ludwigsburg, simple in composition but producing an exceptional perspective.

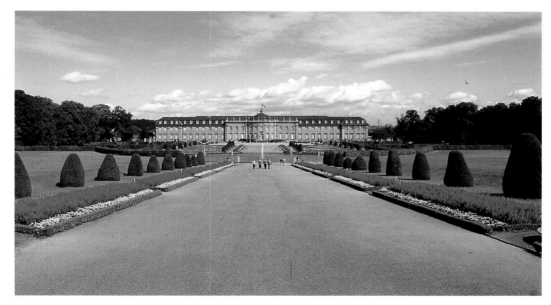

A parterre *half hidden in the garden of the Residenz at Ludwigsburg.*

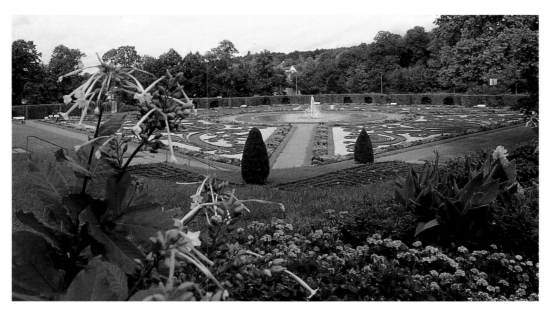

Baroque Divertissements

In the seventeenth and eighteenth centuries, members of the wealthiest families of Austria, Hungary, Poland, Bohemia, Moldavia, and Slovakia acquired the habit of making a pilgrimage to Italy in search of classicism. Returning to their countries, such individuals contributed to rendering their own cultural and artistic expressions more sophisticated and transformed themselves into enlightened proprietors. The virtual absence of natural barriers between these lands permitted an exchange of artists and ideas to the extent that the architectural taste had as early as the 1400s become that of the rest of Europe, although certain peculiarities tied to local traditions were preserved.

Like other European regions in the 1500s, especially from 1550 on, Bohemia and Moravia saw the spread of Italian Renaissance gardens. Unfortunately, during the Turkish invasion many gardens of that period were destroyed, and the surviving ones were later modified to recall French fashion. The first city to be exposed to the new styles was Vienna, where Holy Roman Emperor Leopold I at the end of the seventeenth century commanded a palace that would have been larger than Versailles. He decided against the project when it turned out to be too costly.

In imperial Russia—which had a political situation similar to that of Central Europe and participated in the exchange of artists—the French examples were taken as models. At the end of the 1700s the czars replaced the grand baroque gardens that had arisen with romantic parks embellished with temples, arches, obelisks, aqueducts, urns, sarcophaguses, and ruins, which made them encyclopedias of classical architecture. In the 1800s it was the nouveaux riches who constructed country houses; bankers, industrialists, and merchants competed to display their economic power with the purchase of grand farms. To show their taste and culture, they initiated a kind of rivalry, which attracted—for financial reasons—the best landscape architects of the time.

The ancestral coat of arms at the Edelény garden in Hungary.

Schloss Heilbrunn and its park, which were commissioned in the 1620s by the archbishop of Salzburg, Markus *Sittikus von Hohenems and feature hidden water games, including a table that sprays water over the diners.*

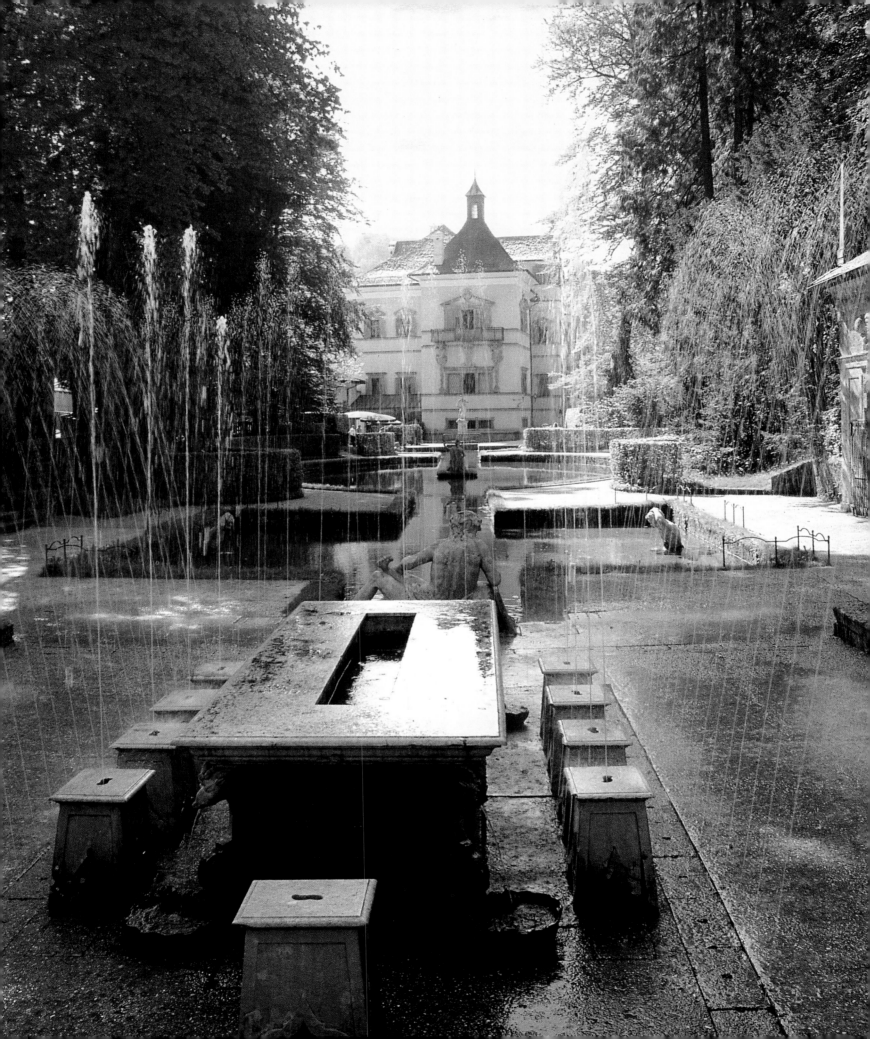

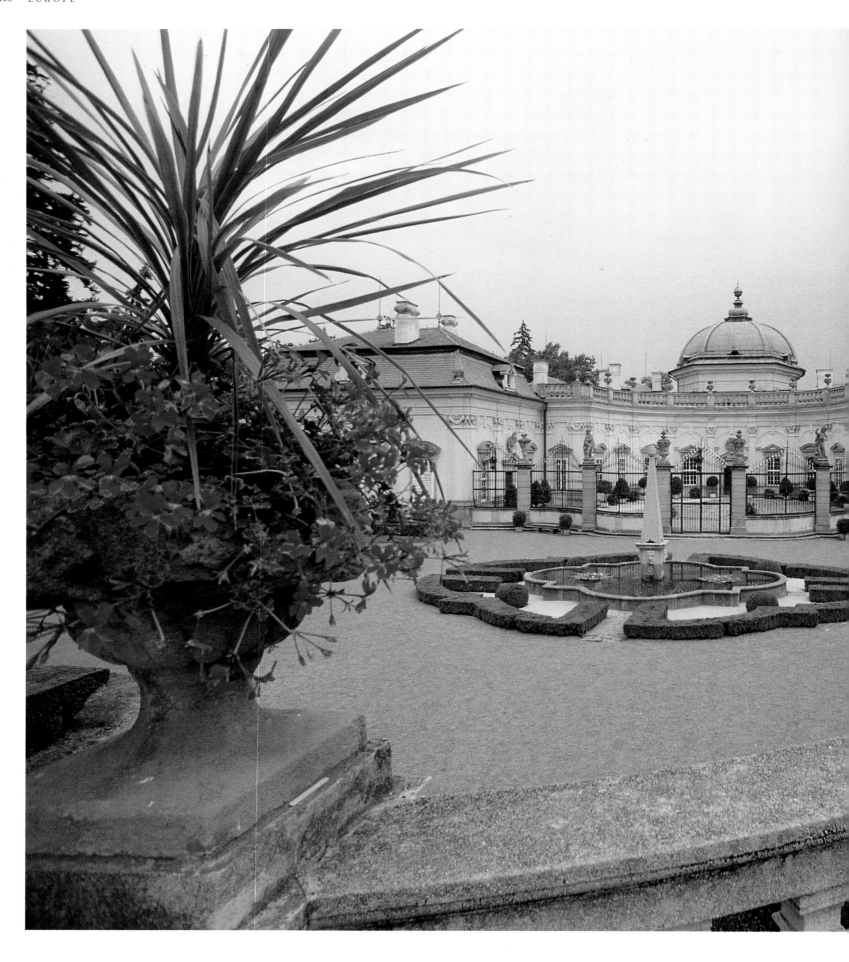

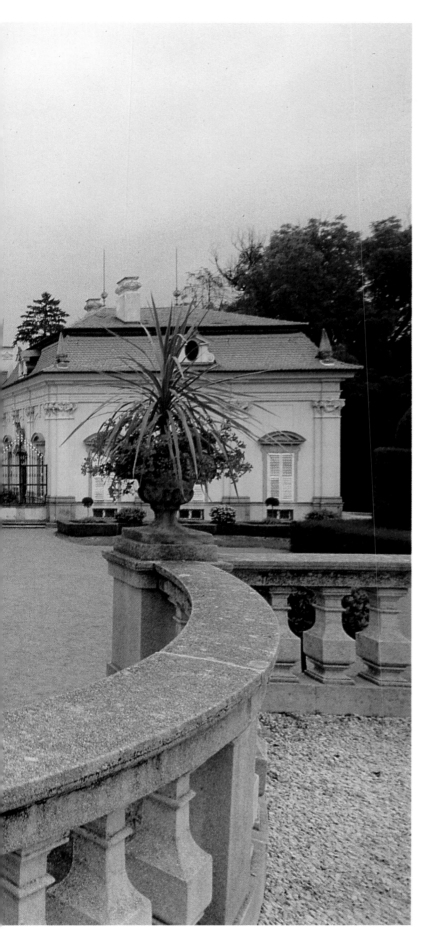

Buchlovice, a baroque garden in the Czech Republic. Italian in design and execution, it was created in the late 1600s by the landscape architect Domenico Martinelli.

The Renaissance castle of Ambra, near Innsbruck, the summer residence of Archduke Ferdinand II. In his time the castle featured a small formal garden; the romantic park was added in later years.

The estate of Veltrusy, built starting in 1698, about twenty miles north of Prague. The flowered parterre unites the villa and the park.

The gardens of the Kromeriz Castle in the Czech Republic, just outside the city of Kromeriz. Realized in the 1600s and 1700s, the gardens have a typically baroque setting; the romantic park was added in the nineteenth century.

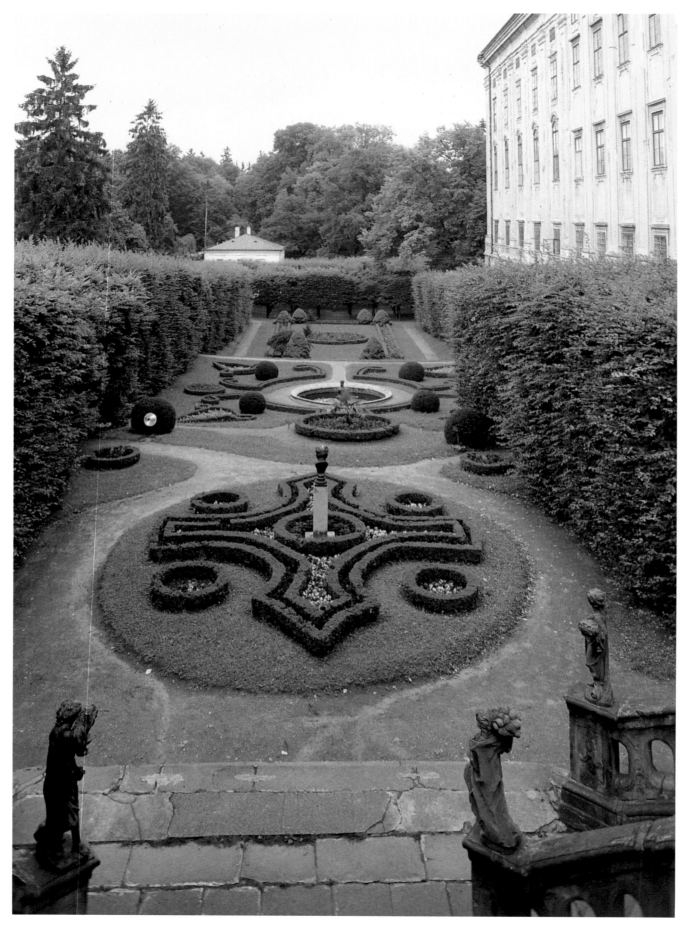

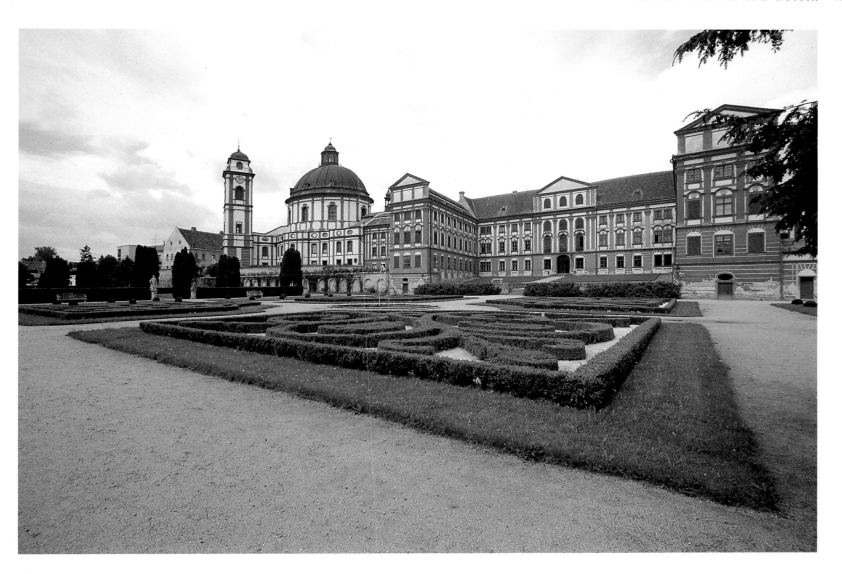

The Jaromerice gardens near Trebic, in the Czech Republic. On a huge terrace are rectangular flowerbeds with volutes of low hedges.

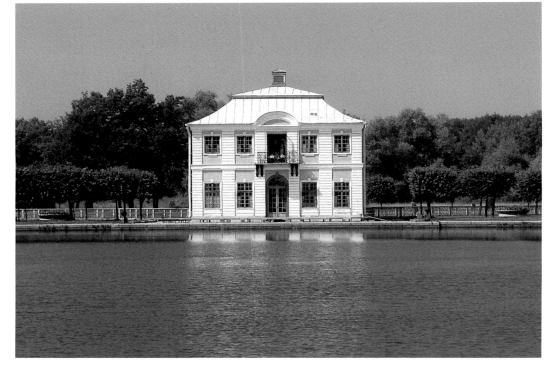

*Left:
Casino on the lake, part of the summer residence of the czars in Saint Petersburg.*

*Overleaf:
The park of Lednice, near Valtice.*

Oriental Inventions

Though long united in history, the Iberian peninsula is composed of two countries that have maintained their distinct identities. Spain offers not only the history of the European garden but above all evidence of the encounter between Europe and Islam. By the tenth century the Omayyadis from the Near East had already created gardens in the patios of mosques as well as in those of palaces. Moreover, in Spain the architecture of the Italian Renaissance fused with the Mudéjar style (the style of the Muslims who remained loyal to their religion after the Reformation), with the decoration of the plateresque, with the local baroque (also called the Churrigueresque), and with neoclassicism in an impressive synthesis of forms. This architecture had a formidable influence on gardens. The Arab culture is expressed perhaps more strongly, with patios full of citrus trees, flowers, and other ornamental plants irrigated by small canals and fountains. The European tradition, more open to the countryside but nevertheless true to the rules of geometry and symmetry, finds a *modus vivendi* with the decidedly Mediterranean surrounding vegetation.

Portugal received only echoes of Islamic art. A strong tradition of monastic gardens existed in the region. In the 1500s, gardens were also used to enhance palaces; new colonies in Brazil and the East Indies revitalized the economy and led to such new construction. Most characteristic of Portuguese green spaces are *azulejos*, ceramic tiles derived from Islamic art of the 1400s. The earliest tiles were bichromatic—white and blue—but gradually they attained a refined polychromy. The Renaissance culture of Portugal is represented in gardens more than in architecture. For example, in the Quinta da Bacalhõa in Vila Fresca—commanded by the viceroy of the Indies Alfonso de Albuquerque—the geometric forms of the boxwood recall the Medici gardens of Florence. The Iberian peninsula, a complex area, is a happy and miraculously preserved mixture of cultures, peoples, and traditions.

Below:
A bas-relief bust over the entrance to a garden in Catalonia, Spain.

Bottom:
The late-seventeenth-century nymphaeum of the Palacio de Fronteira in Lisbon, Portugal, renowned for its azulejos.

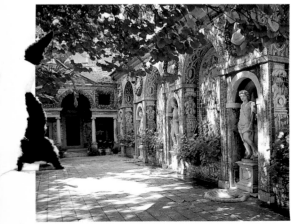

The formal garden of the royal summer residence of Queluz, not far from Lisbon, designed for the future king Pedro III by Jean-Baptiste Robillon.

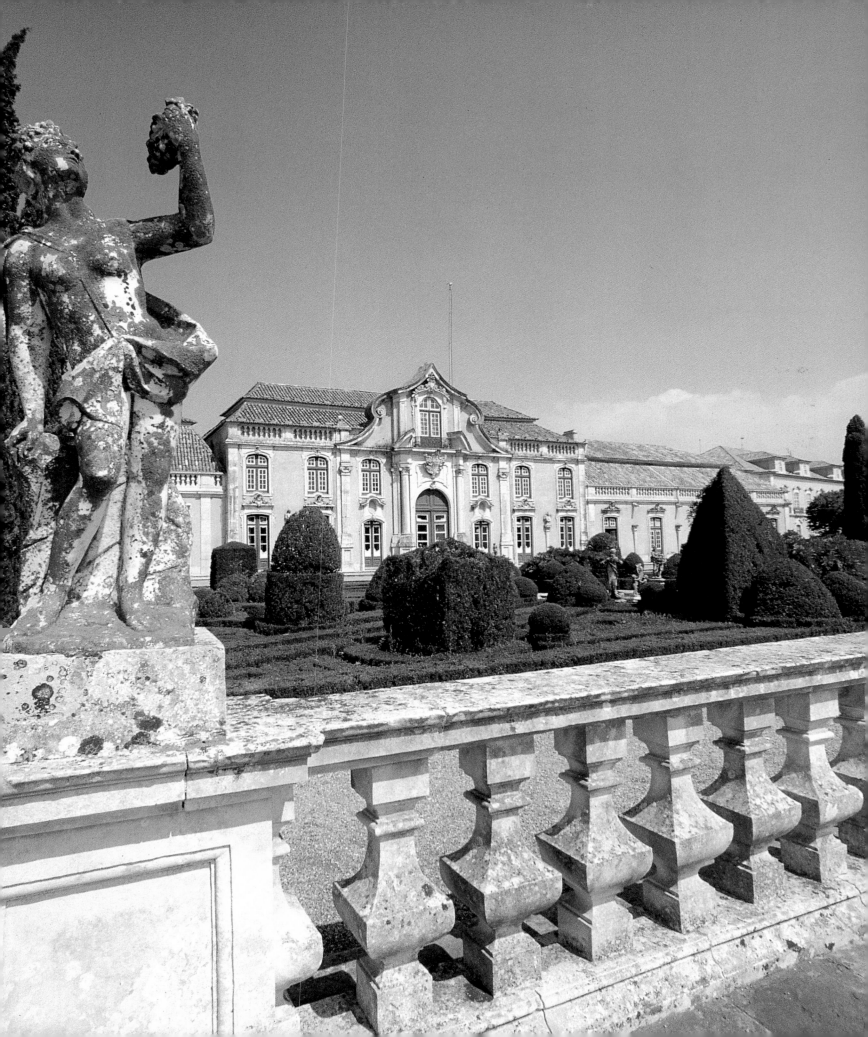

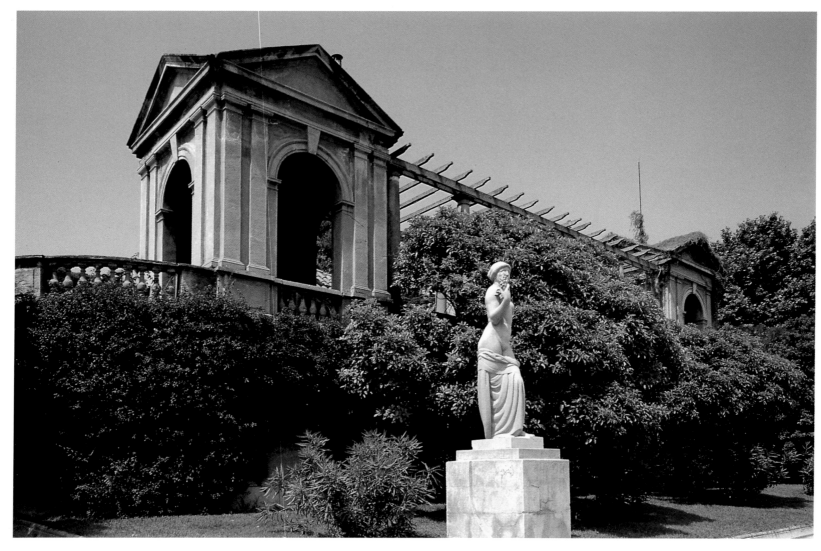

Pergola connecting
two masonry gazebos
along the enclosure
walls of the garden
of the Palau de
Pedralbes in
Barcelona.

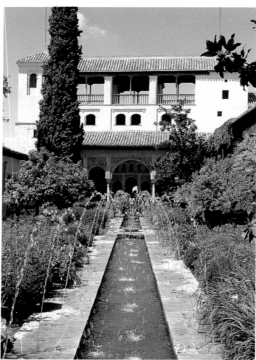

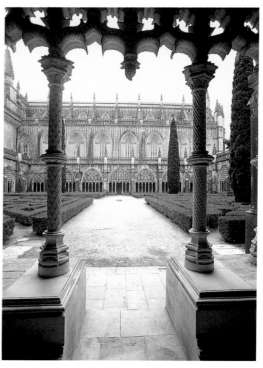

Right:
The Patio of the
Generalife at the
Alhambra in Granada,
Spain. The pool is
almost forty meters
long and is flanked
by a great number
of small fountains.

Far right:
The Mosterio de
Santa Maria da
Vitória di Batalha
in Portugal, where
a fifteenth-century
monastery garden
is preserved.

The Casa dos Biscainos in the center of Braga, Portugal. The walled garden encloses innumerable botanical species.

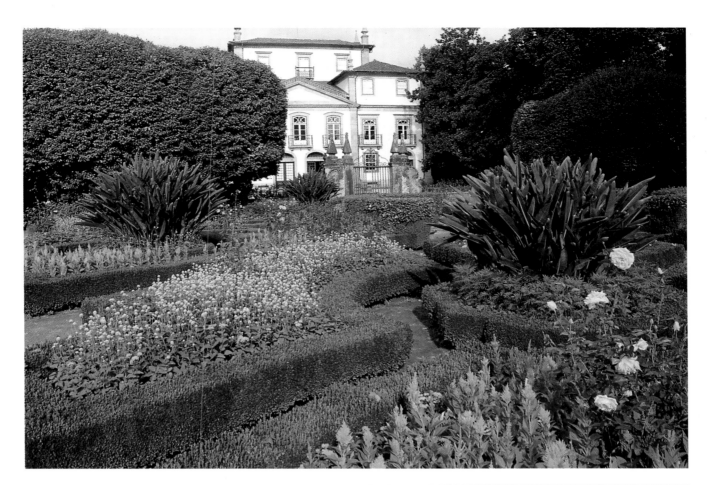

The courtyard of the Quinta da Bacalhōa, not far from Setúbal, Portugal, enclosing a formal garden of low hedges tracing a geometric scheme.

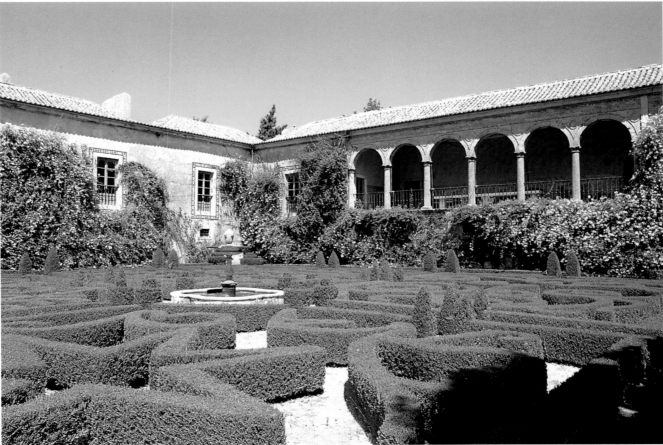

Knightly Gardens

A Mediterranean center, Malta is a kaleidoscope of forms and styles where the entanglements of history have led to original and unusual forms. From Valletta to Rabat to Mdina, in the houses of the Knights Hospitallers, were small enclosed flowering gardens, almost *hortus conclusus*, but originating from Arab influences rather than from medieval times. Malta was, in fact, Phoenician, Roman, Arab, Norman, and then knightly; Napoleon followed and finally the English. Malta is thus a true seaport in every sense, where traces of imperial Roman gardens are still found. All the nations that conquered the island enjoyed the particularly favorable climate. It is not fertile—it is arid and rocky—but fruits grow in abundance nevertheless, especially citrus trees, which were taken there by the Arabs to embellish their gardens.

In 1530, Emperor Charles V ceded the island to the knights, who governed it until 1798. The knights, who frequently traveled internationally, brought European traditions to Malta—above all the baroque, which found maximum expression in the Parisio garden, still private property and in excellent condition. The English brought to Malta their concept of the landscaped garden. The terrain, however, did not permit luxurious Yorkshire lawns or the leafy trees that formed romantic woods, so there are few examples of this style.

Malta is interesting not for trees or multicolored flowers but for its forms and history. A succession of events, along with its position, has made it a crossroads between East and West, Christianity and Islam, Europe and Africa. Its gardens cannot help but reflect its history.

An intimate garden in Naxxar, for generations the property of Parisio nobles, in which an Italian influence is easily recognizable.

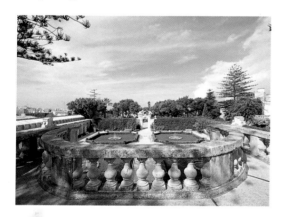

Terraces, stairways, and leafy trees in a Maltese garden, characteristic of the island's green spaces, which were often inspired by English colonists.

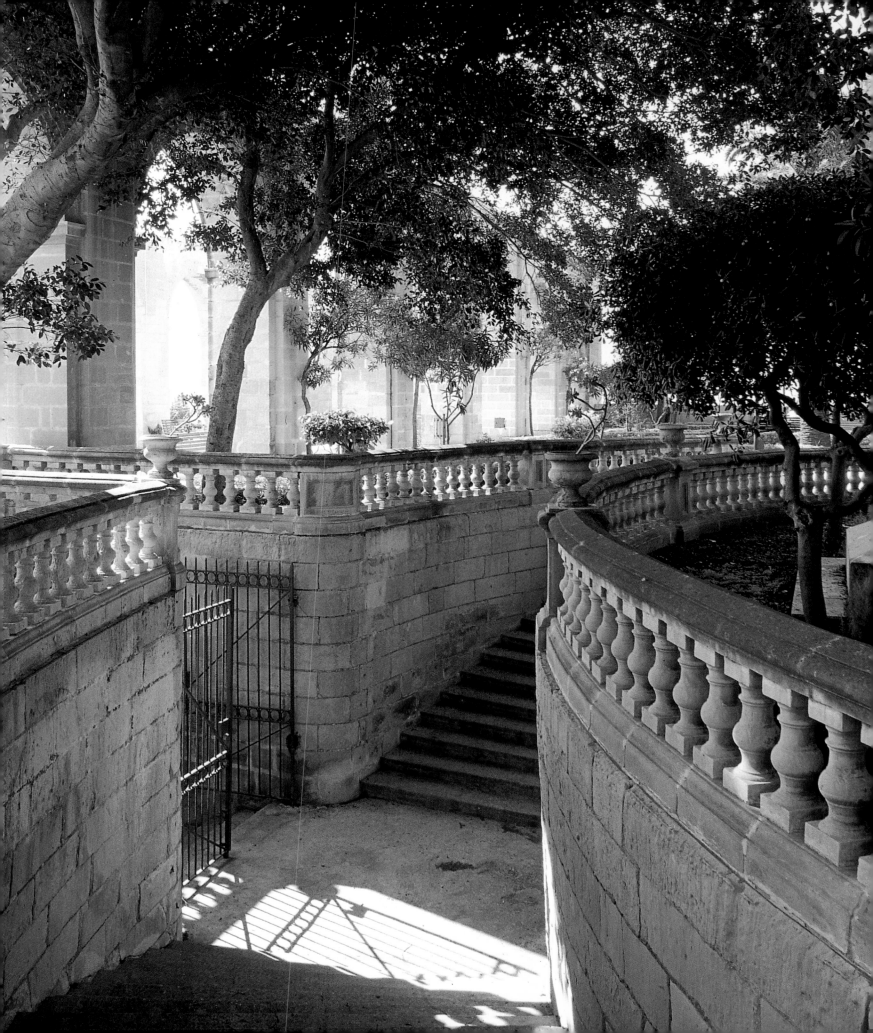

The Argotti garden in Valletta, one of Malta's largest and most impressive, which is rife with various species of succulents.

The Argotti garden, which occupies a part of the city's bastions and appears as an oasis against the yellow ochre of the buildings.

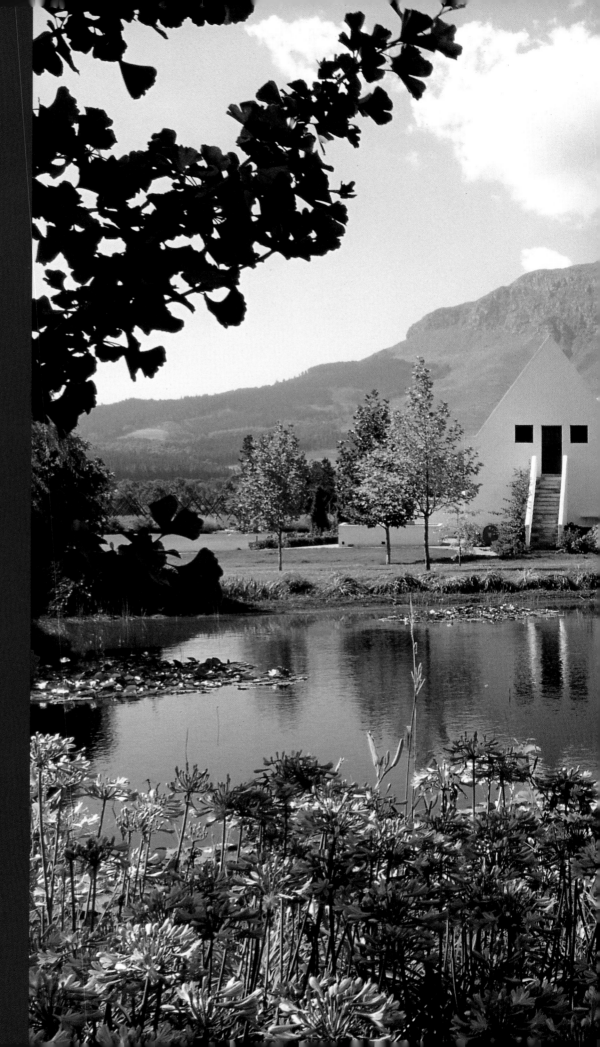

frica, though a cradle of humankind, does not have its own indigenous tradition of designed green spaces. The gardens of Africa were for the most part inspired by the merchants and colonists who came there at various times, the Arabs and then the Europeans.

On the Mediterranean coast, Arab influences are very evident, and gardens bearing an Arab stamp exist today. In the heart of Africa—south of the Sahara Desert—the character and plant life of the African landscape are particularly strong and define any natural or created garden.

In South Africa the climate and vegetation recall Europe; some of the most beautiful gardens of the continent are in this region. The open green spaces, often among grapevines and on plantations, provide a strong contrast to the closed and secret gardens of Northern Africa.

Africa

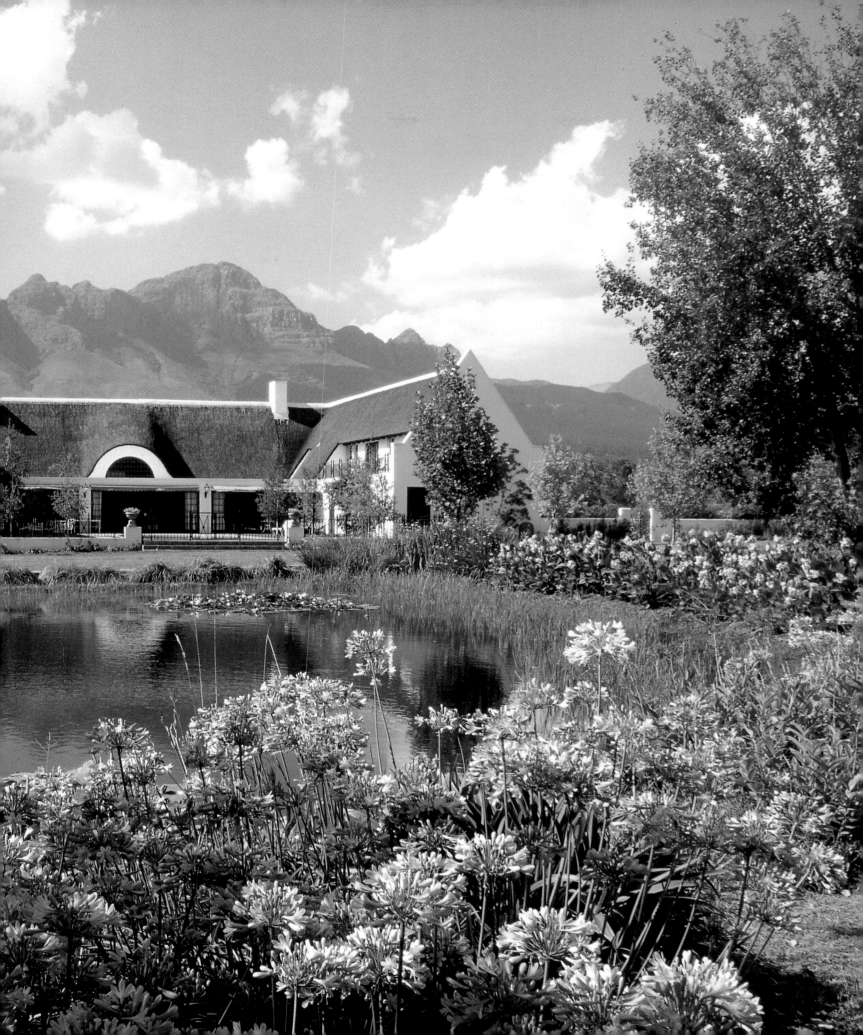

Floating Garden

Madeira

The "island of the woodsman"—it was named Madeira by its Portuguese discoverer, Infante Dom Henrique, known as "the Navigator"—is small and mountainous with a mild, springlike climate year round. Excellent wines (grapevines were imported from Cyprus and Crete as early as the fifteenth century), lush vegetation, and famous visitors from Christopher Columbus to Winston Churchill have made this little Portuguese archipelago a haven for beautiful architecture and gardens. Its well-being derived from the sale of prestigious wines, a trade begun by the English during their brief period of domination; in addition, the island was an obligatory stopover for ships coming from Africa and the Indies, which allowed European culture, particularly Portuguese and British, to spread. The resulting gardens are original unions between nature and designed greenery.

Portuguese *quintas*, stately houses that recall their counterparts in the Old World, still exist today. Flanking these seventeenth- and eighteenth-century residences are resorts, primarily of Anglo-Saxon inspiration, which appeared at the beginning of the nineteenth century. At the same time arose indigenous dwellings that to a certain extent resemble northern European architecture. These houses, for the most part quite modest and rather small, are characterized by their use of color. Gardens bring together Portuguese *azulejos* and Anglo-Saxon romantic parks, recalling as well formal Italian Renaissance gardens.

Thus the style of Madeira is an eclectic one, whose only African influence is the climate. The mixture of forms and colors makes of the landscape a kind of floating garden in which architecture and gardens reveal Madeira's history.

Preceding pages:
The New Vergelegen farm, near Stellenbosch, South Africa.

Below:
The roof-gardens of the village of Quinta Splendida, not far from Funchal.

The Quinta do Palheiro garden, where rare plants have been imported by the owners.

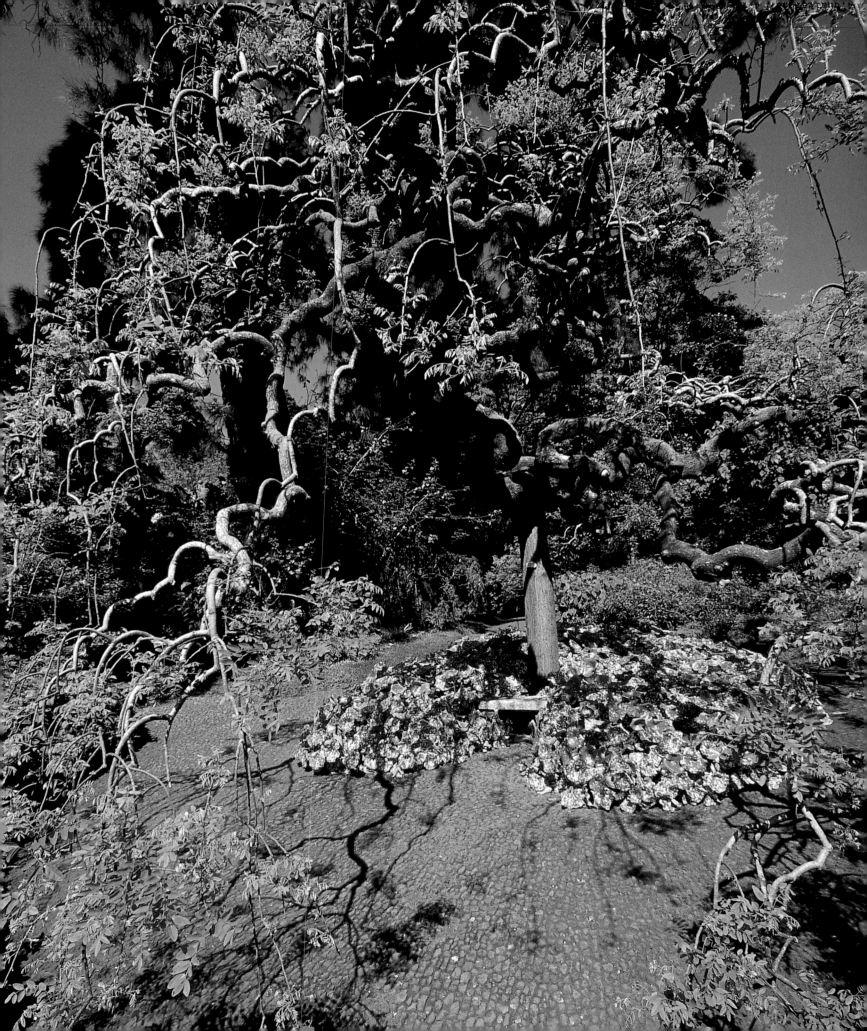

Villa Berardo, which
is surrounded by
luxuriant vegetation
that descends the
slope of the hill.

An "ethnic" area
in the Berardo park
where sculptures
and other elements
refer to the cultures
of other continents.

The main house of
Quinta Splendida,
erected on a
promontory in the
middle of the
nineteenth century.

The large garden next
to the main house
of Quinta Splendida,
where a resort has
been established. The
architectural style
and furnishings recall
the culture and art
of the island.

Luxurious vegetation characteristic of the mild climate and Anglo-Saxon floral tradition of Madeira.

The courtyard of a stately home in the center of Funchal. Many such residences are embellished with green spaces.

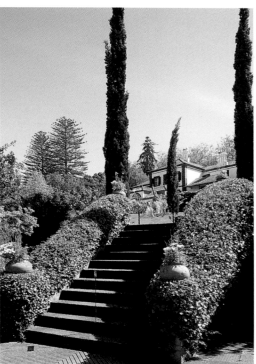

Right and far right: The Quinta do Palheiro park, realized at the beginning of the nineteenth century. Vast landscaped areas alternate with small parterres, themselves bordered by hedges and bushes and reached via short flights of steps.

Aeonium sp

Agave

Fruit of the Phoenix
canariensis

Opuntia ficus indica

Callistemon sp

FLOWERS AND PLANTS
OF MADEIRA

Near the Moroccan coast emerges the geographic-botanical region Macronesia, formed by the archipelagos of the Canaries, Azores, Capo Verde, and Madeira; it is considered by some the last fragment of ancient Atlantis. The region is characterized by a rich and luxuriant landscape and by unique vegetation; while a number of the plants belong to the Mediterranean area, many are found only on these islands. Between 1,300 and 4,000 feet, in fact, in a section of the con-

densation zone called "the fogs," is a singular evergreen forest with laurel-shaped plants, mostly *Laurus canariensis, Prunus lusitanica, Persea indica,* and other shiny leathery-leaf species, which shade an underbrush rich in ferns, musks, and epiphyte lichens. Left over from the extensive forests that gave Madeira its name, these formations are today limited to small areas along the northern mountainsides. At the lower altitudes on the mountains—areas tending to be more arid—grows a xerophytic euphorbiaceous vegetation including the succulent *Euphorbia canariensis,* agaves, the well-known palm *Phoenix canariensis,* and various species of the

Aeonium type. Of particular significance is the rare native plant *Dracaena draco.*

Beyond the laurel-leaf woods is a temperate undergrowth of evergreen shrubs: dominant are *Ilex canariensis, Erica arborea, Arbutus canariensis, Myrica faya,* and *Vaccinium maderense.* Farther toward the north the vegetation thins out in favor of semideserts with sparse bushes of such genista-like plants as *Spartocytisus supranubium, Thymus caespitius, Aira praecox,* and *Echium bourgeanum,* characterized by gigantic dark red spikes.

The vegetation of the area was profoundly transformed by humankind and is currently

Orchideaceae

defined more by cultivated species than by native plants. Among the few indigenous bushes along the coast are *Myrtus communis, Juniperus phoenicea, Olea europea* var. *oleaster, Sideroxylon marmulano, Jasminum odoratissimum, Genista virgata,* and *Salix canariensis.* As for cultivated plants, certain American species have found particularly favorable conditions: *Agave americana, Aloe arborescens,* and the Indian fig *Opuntia ficus indica.*

On the southern mountains, up to an altitude of about 2,300 feet, crops have completely replaced the original vegetation. Figs, medlar trees, grapevines, citrus trees, and sugarcane are cultivated. Over 2,300 feet grow such tropical fruits as papaya, mangoes, and maracuja. Instead of the laurel forests are cluster-pine forests, often accompanied by *Ulex europaeus* and *Cytisus scoparius.* On the northern side, from sea level up to 2,600 feet, grapevines, which produce the world-famous wine, dominate the vegetation.

Madeira is likewise varied in its flowers: *Callistemon* with unusual blossoms, azaleas, fuchsias, begonias, bougainvilleas, and—from the rich garden of Quinta da Boa Vista—splendid orchids.

Plays of Water and Sand

Northwestern Africa

Below:
The palm groves of the oasis of Beni Isguen, Algeria. The dwellings and their dense vegetation are enclosed by high walls.

Bottom:
Forbes park in Tangier, in the north of Morocco.

In the cities of Northwestern Africa the portals of the residences of viziers, courtesans, and wealthy merchants open unexpectedly off the narrow streets of the *casbah*. Extremely simple exterior facades contrast with golden carved-wood ceilings, polychrome stucco, enameled ceramics, and, above all, fragrant and luxurious gardens enhanced by fountains and plays of water. Such perfumed patios introduce a world unimaginable in the chaotic city life, and it is the most anonymous facades that conceal the greatest surprises.

As early as the sixteenth century, Morocco was distinguished as the relatively fertile strip of land between the Atlantic and the desert. At that time Portugal and then Spain ruled the area; in the seventeenth and eighteenth centuries, a kingdom was reestablished, which continued until the period of French rule at the beginning of the twentieth century. Water has always been a precious commodity in Morocco, and near every city arise large containers for collecting rainwater, often surrounded by actual parks of citrus and olive trees. In Marrakech is one of the most beautiful examples of this type of architecture.

Yet Northwestern Africa is also known for its oases, an early reference for the concept of the garden. These desert springs create small yet lush green spaces composed of palms and citrus trees. In the oasis of Gardaïa in Algeria, for example, a *palmerie* (palm garden) grows at the doors to the city, as do pomegranates and figs. The irrigation water comes from a well three hundred feet deep. In the shade of the oasis are the summer residences of rich merchants. These houses, always disposed around a patio and girded by high walls, provide shelter for family life amid the surrounding gardens.

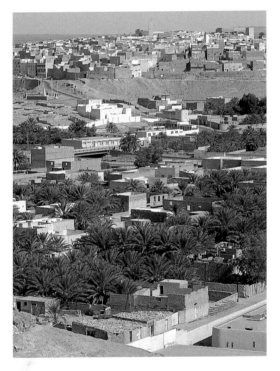

The courtyard of the Palais du Bardo in Algiers, formerly a stately residence and today a museum.

Surrounding the fountain and central paved area are flowerbeds with tall trees and plants.

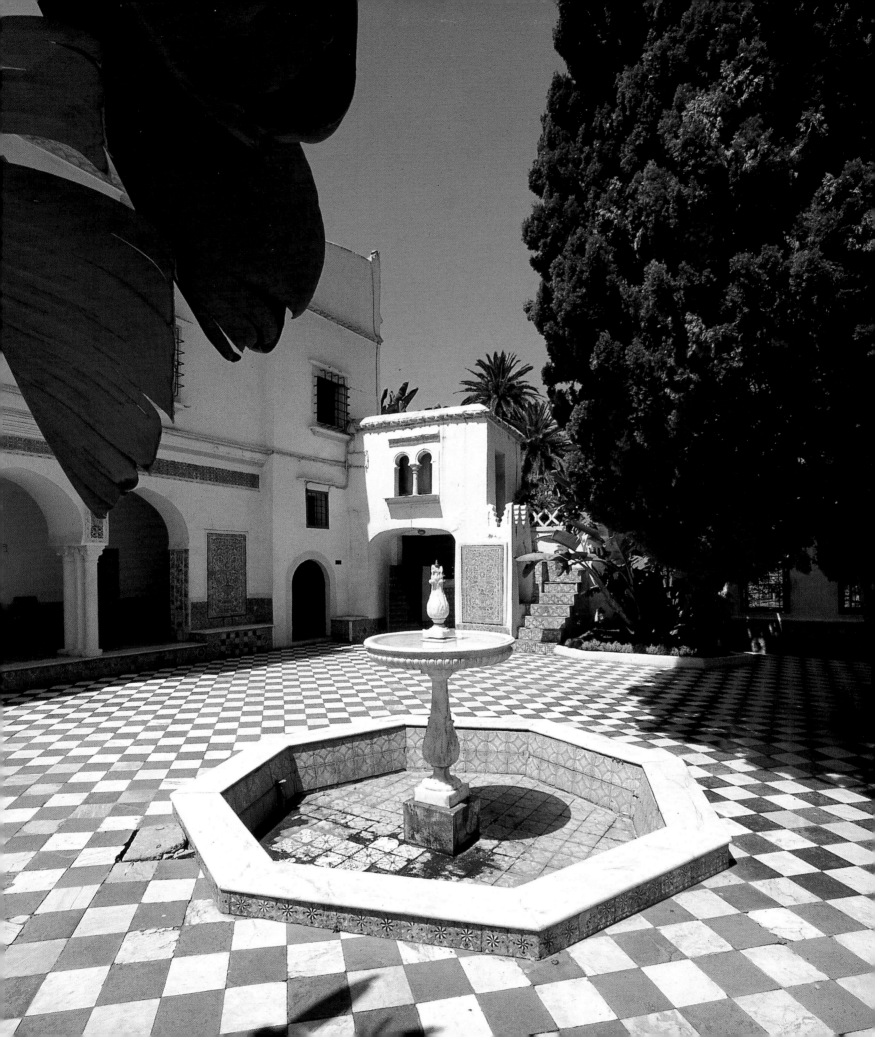

The Majorelle gardens and dwelling, realized by the painter and cabinetmaker Louis Majorelle at the beginning of the twentieth century. Today the complex belongs to Yves Saint-Laurent, who has restored it and opened it to the public.

The garden of Majorelle in Marrakech, one of the best preserved of the celebrated Moroccan gardens. Such spaces attempt to re-create the Islamic conception of paradise.

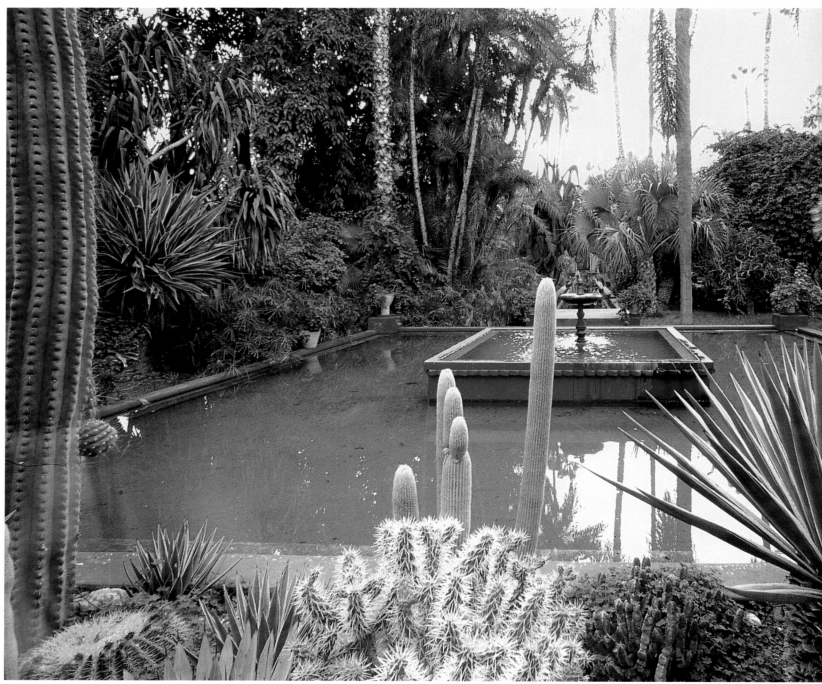

*The spacious
courtyard of Dar Si
Said in Marrakech.
Two paths intersect
with a central circular
pool, forming four
flowerbeds.*

*An building belonging
to the Mamounia
Hotel, formerly
a stately residence
of Marrakech.*

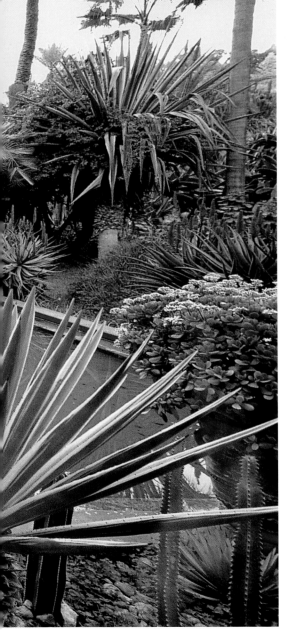

Life on a Veranda

The history of the Seychelles commences no more than two centuries ago, and in this relatively short time the African archipelago has enriched itself with noteworthy cultural history. One of the most impressive aspects of this heritage is its residential architecture and gardens: both grand residences of French and English planters and more modest local dwellings are immediately recognized as part of the native character of the Seychelles.

The houses, even the stately ones, usually consist of one raised floor. Underneath are storage areas and above is an attic, generally not habitable. The structures are wooden; the supporting pillars, of blocks of white coral or gray granite. The traditional roofing material, dried and bound coconut leaves or thin vines, has been replaced with corrugated tin, which in the Seychelles acquires new tones and shades and has become an integral part of the local panorama, blending well with the bright colors of the luxuriant tropical vegetation. The numerous references to European architecture have been changed and reinvented by their new context.

The climate, normally hot and humid, makes ventilation extremely important. Large porches surround the raised living floors, permitting residents to spend long periods outside, sheltered from the sun and rain. Since the exterior of the house is as important as the interior, buildings in gardens—connected to the dwelling by covered passages—are often used as kitchens and bathrooms. The passageways are carefully designed—always shady, flanked by flowers and aromatic and medicinal herbs—and represent the boundaries of the historic gardens.

The green spaces themselves are not defined by a particular style. They are domestic, for the most part, and express the relationship between the landscape and the lush vegetation. In the Seychelles, European traditions influenced the architecture more than the gardens.

The great clearing in front of Union Estate, the presidential residence on the small island of La Digue.

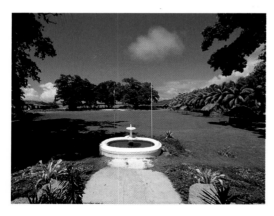

The vast and luxurious park of the State House in Mahé, the official residence of the head of state.

The gardens are landscaped, but certain elements are regulated with hints of geometry.

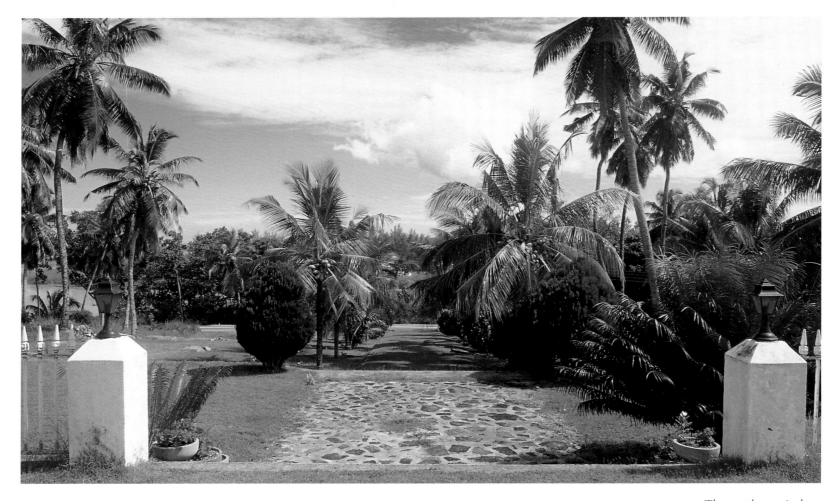

The ample tropical garden of a stately residence along the coastal road on the outskirts of Mahé. Many such dwellings were built at the end of the nineteenth century and the beginning of the twentieth century.

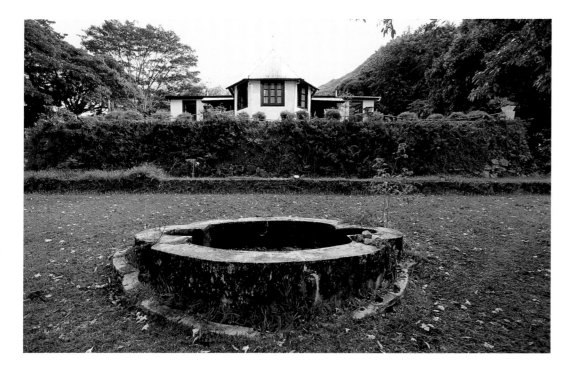

Basin and terrace in front of the Bailey House in Mahé, today a restaurant.

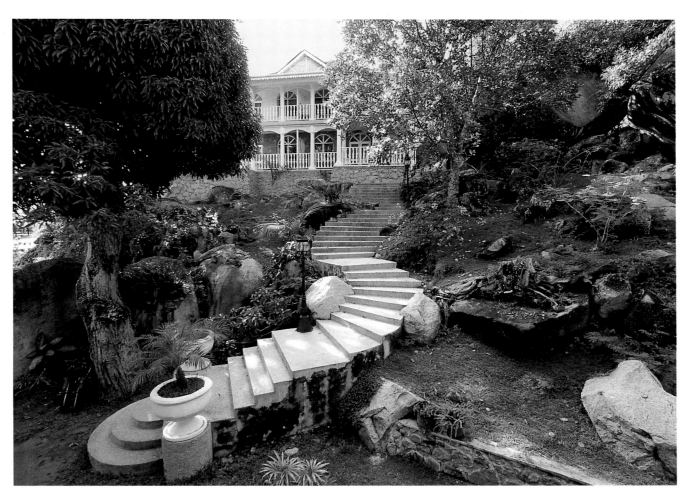

Narrow and winding stairway leading to the main dwelling of the village of La Reserve, on the island of Praslin. Houses and bungalows are inserted in a spacious garden.

The contemporary garden surrounding the residential and service buildings at La Reserve.

A resort on Silhouette, a small island that can be reached only be helicopter. A covered bridge leads to the resort.

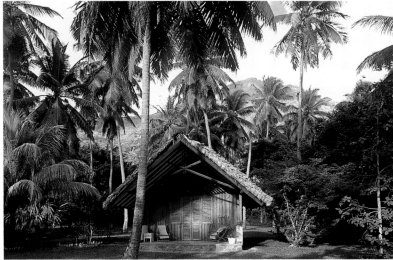

A small structure on Silhouette. Beyond the few houses of the locals are a stately residence of the 1800s and the resort village.

A funeral temple erected at the edge of the simple garden surrounding the stately residence of Silhouette.

Red Clay

From its height of 4,500 feet above sea level, Antananarivo (known as Tana) dominates Madagascar not just politically but strategically. The first to populate the island were the Indonesians and the Malaysians around the sixth century; Arabs arrived in the fifteenth century and the Portuguese in the sixteenth. The French explored the land, and pirates, attracted by the route to the Indies, which passed nearby, settled on Madagascar at the end of the seventeenth century. It was not until the eighteenth century that the first Madagascan kingdom and national identity were born.

Diverse races and cultures created the island's architectural style. The houses are tall and narrow and made of red brick; the mortar is often of the same red tone. Narrow windows with spacious balconies supported by pillars adorn the facades, which always face west. In 1885, France imposed its protectorate and European architectural styles were manifested in neoclassical houses, spacious verandas, and, from the 1930s on, buildings influenced by the modern movement. Vestiges of the past can still be felt in Antananarivo. Small alleys, fountains, columns, stucco, portals, and stairways—somewhat dilapidated, damaged by frequent rains, forgotten and threatened—can be found among huts and vegetable gardens. In Antsirabe, a famous thermal town to the south of the capital, however, the gardens of resort houses of the Madagascan nobility stand along straight, flowered boulevards.

A certain neglect characterizes the gardens of Madagascar. The many layers of the island's history are often evident in the green spaces. But nature—always bountiful and helping to delineate what is "picturesque" in the area—has intervened where humankind has left no traces. In fact, it is nature that has provided Madagascar's *genius loci*.

A walled garden in Antananarivo, the capital of Madagascar, which echoes formal European solutions.

A stately residence in Antananarivo, today a restaurant, surrounded by a luxuriant park.

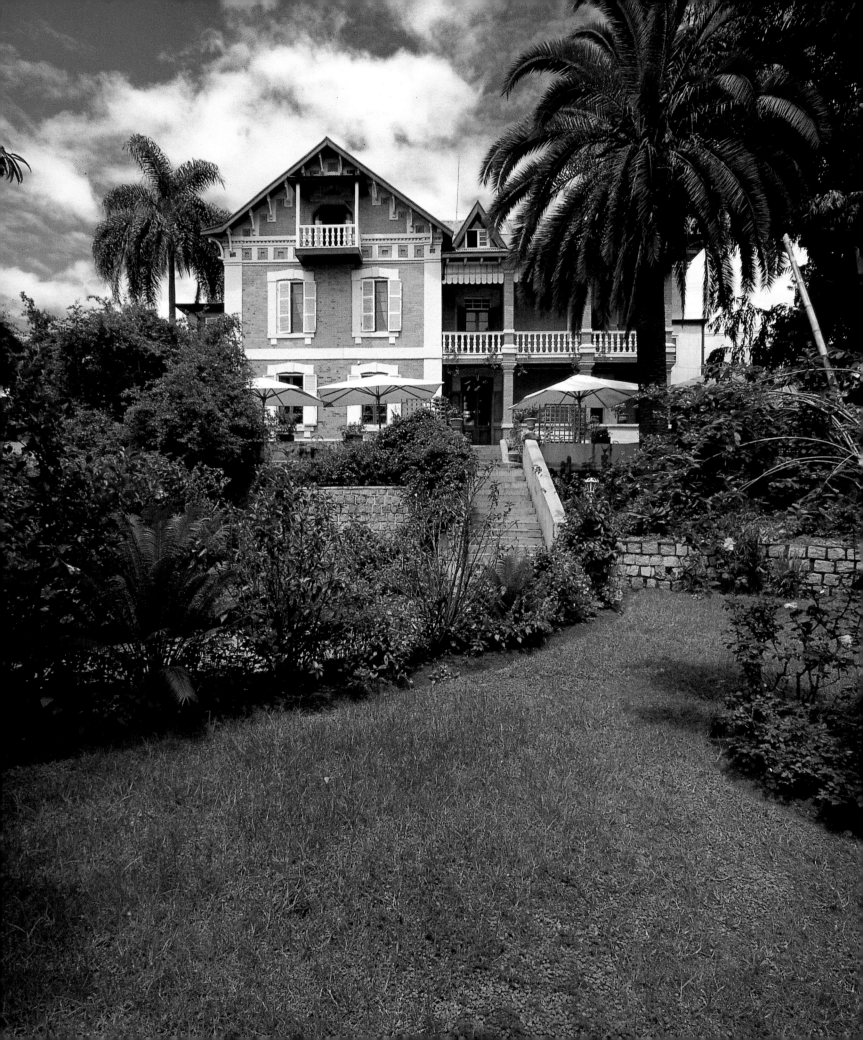

A resort residence in Tamatave, on the eastern coast. The garden is bordered by shrubs.

Luxuriant green space in Antsirabe, a small thermal town to the south of Antananarivo. Plant life is richer than on the coast, thanks to abundant rains.

*Abandoned stately
dwelling with the
remains of a formal
French garden.
Several of these
abandoned planta-
tions are on the road
between Antananarivo
and Tamatave.*

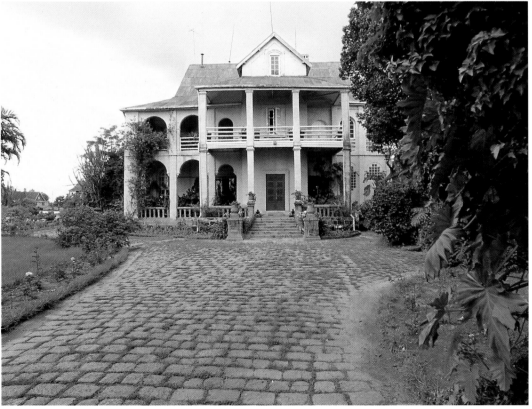

*The noble facade of a
villa on the outskirts
of Antananarivo. The
paved entrance drive
crosses a romantic
park.*

African Rigor

Réunion

One of the Mascarene Islands, Réunion can itself be considered a garden. The wealth of botanical species found there, the luxuriance that characterizes them, and the pleasantness of the countryside make it a place of rare splendor. Yet there are many designed gardens, including those created by colonists and those created by the natives. In both can be found influences from French and English garden styles as well as Islamic ones, which were imported through commercial exchanges with India in the 1700s and 1800s.

Formal gardens in Réunion begin with the *baro*, the monumental gateway on axis with the main house, and continue with the *allée triomphale*, a long drive delineated by majestic trees and flowering borders. To the sides are *parterres* of low hedges. Pergolas of roses and jasmine, terraces, and so-called surprises break the geometric order, as do groups of trees disposed in an apparently casual manner. An Islamic influence is found in the ponds and canals that collect rainwater and direct it for irrigation. Each composition has been designed for maximum visual impact.

The native gardens, on the other hand, are a combination of diverse styles and influences, a miniature reproduction of nature. More modest in size, they are popularly called *la cour devant*, "the court in front," and are characterized by an explosion of color in the flowerbeds, a dramatic contrast to the dark green landscape. Orchids and azaleas alternate with frangipanis, tamarinds, and banana plants, as do clusters of agapanto; bougainvillea provides the frame. In local tradition the plants welcome visitors and lead them to the entrance of the house. Moreover, plants and flowers accompany every important moment in the life of the people of Réunion. These gardens reflect a style of life and offer the image of an interior world; they are an encounter not only with the residents of the island but with nature, which has been so generous to Réunion.

Composition formed by palms and agaves alternating with other tropical plants.

A Monstera deliciosa, a flower widespread at this latitude.

An ancient tree in front of the Domain de Villèle.

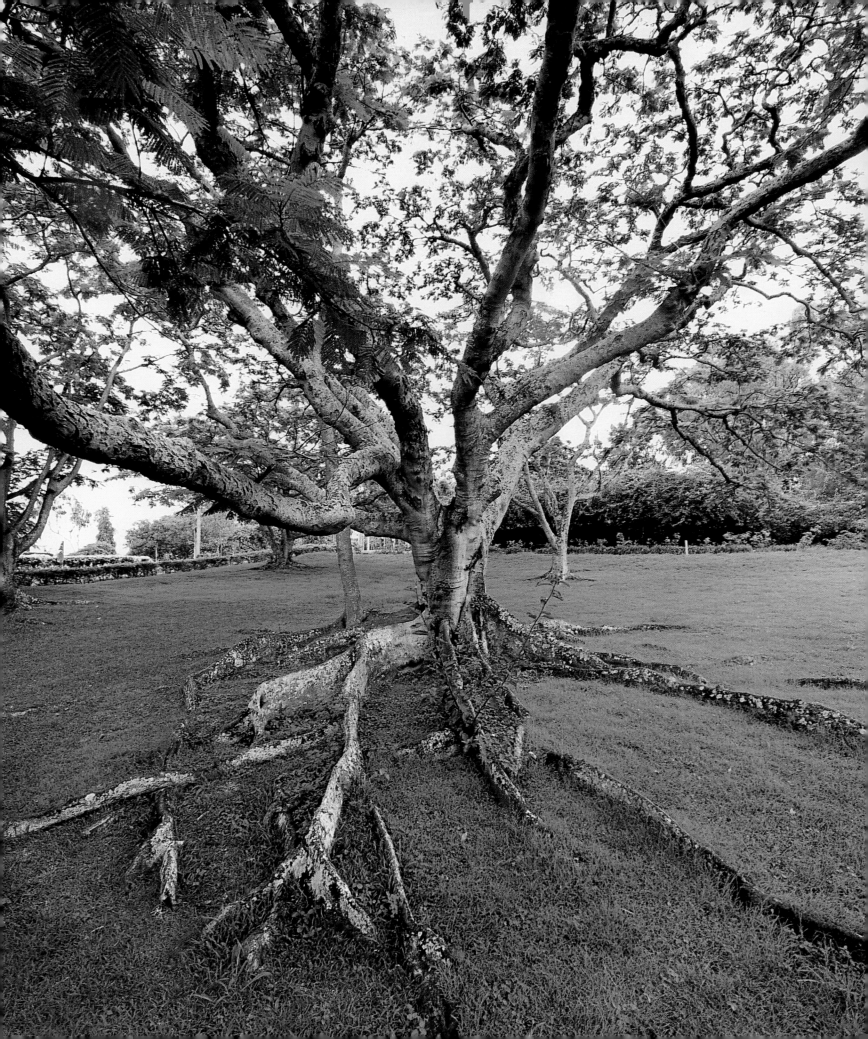

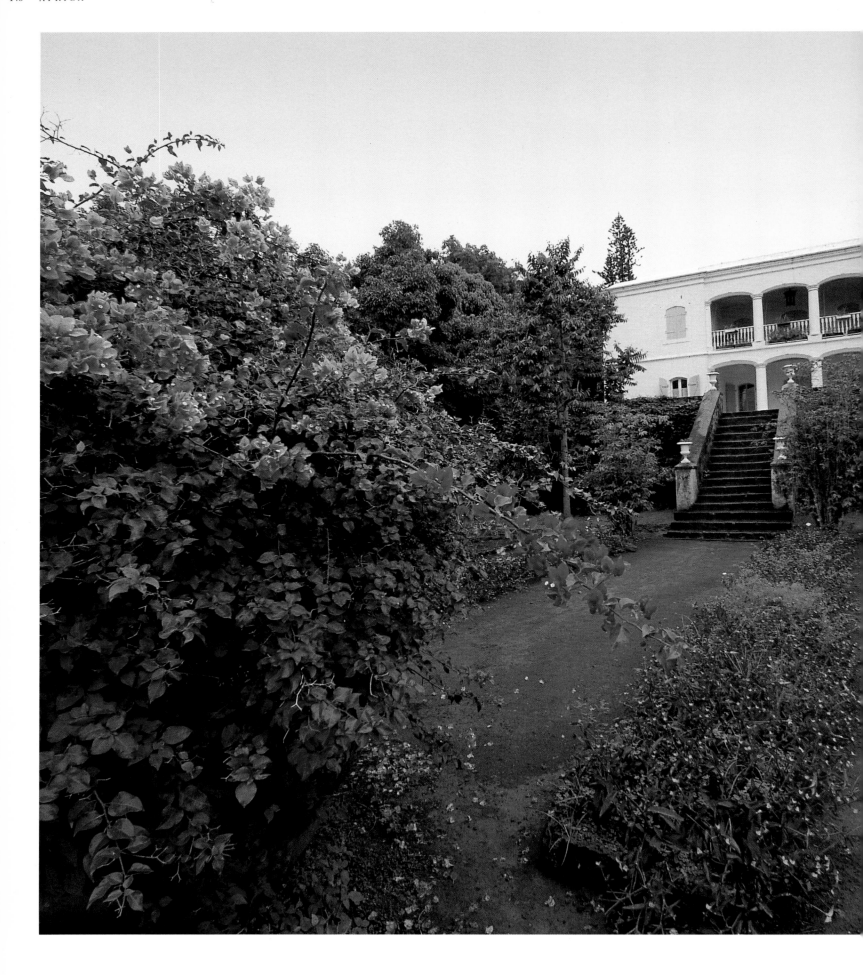

The main house of the
Domain de Villèle,
which faces a parterre
crossed by paths and
bordered with hedges
and stones.

The parterre of the
Domain de Villèle
seen from the stairs
leading down from
the house.

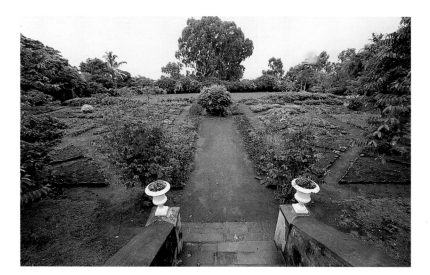

An ample clearing
between the designed
parterre at the
Domain de Villèle
and the natural
vegetation beyond.

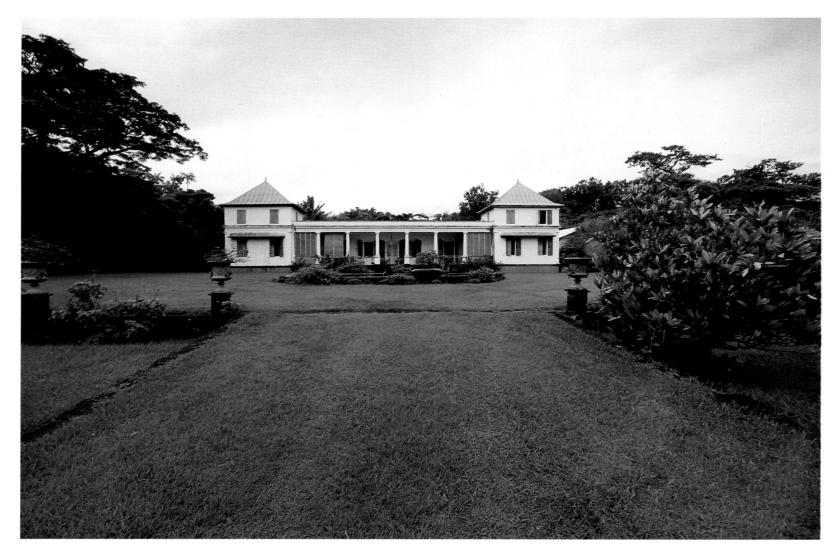

A stately residence on a slope facing the sea not far from the town of Saint-Denis. On axis with the entrance allée is a large formal garden; the woods begin just behind the house.

One of the great number of plants that flourish due to the abundant rain and warm year-round climate.

The Garden of Eden created in Saint-Gilles in 1990 by the agronomist Philippe Kaufmant, who gathered and cataloged numerous types of vegetation.

The garden of Mascarin in the heights of Saint-Leu, which is composed exclusively of indigenous plants.

A trail in the Jardin Exotica, which leads through a wealth of cactus plants on basaltic rocks to a garden with more than five thousand plant species.

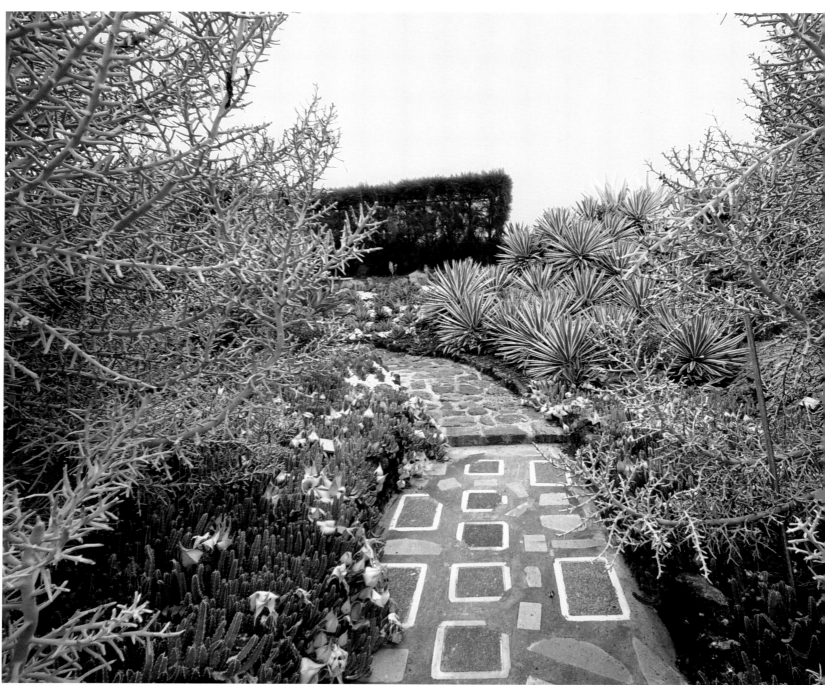

The Jardin de l'Etat, a spacious public park crossed by a long pool, in the center of Saint-Denis.

A particularly luxuriant and "natural" corner of the Jardin de l'Etat. In the center of the park is the Museum of Natural History.

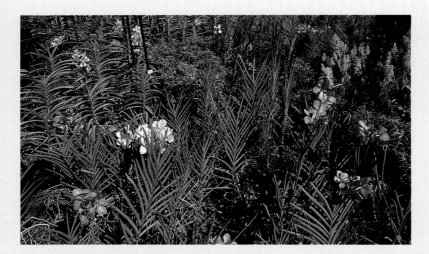

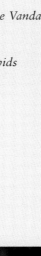

Left:
Orchids of the Vanda type

Right:
Epiphyte orchids

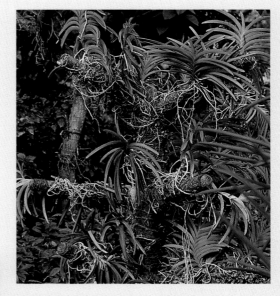

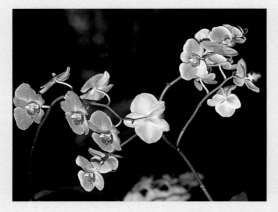

Three types of orchids

Couroupita guianensis

FLOWERS AND PLANTS OF REUNION

The mountainous island of Réunion emerged from the Indian Ocean three million years ago following suboceanic volcanic eruptions. Situated in the southern hemisphere between the Equator and the Tropic of Capricorn, it enjoys a tropical climate strongly influenced by the trade winds from the southeast, which bring abundant precipitation to the southeastern slopes and very little to the western ones. Thanks to these favorable climatic conditions and to the passions of its inhabitants, Réunion has become a veritable botanic garden.

Geographic formations on the inaccessible sides of volcanoes have created various distinct zones of vegetation. In lower areas where precipitation is more abundant, ancient forests rich in creepers, palms, epiphytes, and arboreous ferns yield space to crops of sugarcane and gardens of fruit trees and ornamental plants. In the forests are species such as *Mimusops maxima, Dombeya ficulnea, Agauria salicifolia,* and numerous ferns, including the beautiful epiphyte *Asplenium nidus,* whose branches can reach six feet in length. Among the exotic plants that have been acclima-tized are *Rubus alcaefolius, Psidium cattleyanum,* and *Ravenala madagascariensis;* the leaf base of *R. madagascariensis,* rich in fresh water, has given it the common name "the traveler's palm." Expansive woods of *Pandanus utilis* grow along the rocky coasts of the island; humid zones at higher altitudes favor giant arboreous ferns and the *Acanthophoenix crinita* palm host instead of the similar *Pandanus montanus.* Also found are a great number of aristocratic orchids, including epiphytes and the *Vanda* type: *Aeranthes, Angraecum, Bulbophyllum, Phajus, Calanthe, Crytopus, Habenaria,* and so forth. At higher altitudes, where conditions are not very favorable for culti-

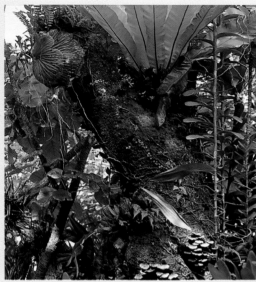

Asplenium nidus

Solandra guttata

Pandanus utilis

Ravenala madagascariensis

Hibiscus schizopetalus

Strongylodon macrobotrys

vation, the original vegetation is still relatively abundant. In these forests the ancient arboreous ferns of the *Cyathea* type and the endemic tamarind of the plateaus *Acacia heterophylla*, accompanied by the bamboo *Nastus borbonicus*, reach their maximum size. Yet at the same altitude, vast areas on the western slopes have been deforested since they are particularly favorable for the cultivation of the renowned ornamental geranium *Pelargonium*. Shrubby heath, dominated by the ericacea *Philippia montana*, occupies the higher volcanic slopes.

Native plants are, for an island, conspicuous by their presence, including *Acacia heterophylla*,

Nastus borbonicus, the campanulacea *Heterochaenia borbonica*, the leguminous *Sophora denudata*, and the *Hyophorbe indica* palm. The seeds of almost all the native plants of Réunion are of African and Madagascan origin and were transported by the sea current, wind, and birds; vegetables from other parts of the world were introduced to the island starting in the seventeenth and eighteenth centuries. Cultivated in gardens and along the boulevards, or acclimatized to the point of competition with indigenous plants, a great number of exotic and ornamental species populate the most accessible zones of Réunion. *Strongylodon macrobotrys* with its un-

usual flower, the vine *Solandra guttata* with its enormous perfumed corollas, *Couroupita guianensis* (also called "the cannon tree"), the elegant *Hibiscus schizopetalus*, and the intrusive *Hedichium* constitute only a small part of the wealth of vegetation of Réunion.

Afrikaner Melancholy

South Africa has provided generously for both colonists and natives. The Afrikaner (Dutch colonists) found, especially in the south, a climate similar to that of the Netherlands—perhaps even more favorable—and particularly fertile. The colonists dreamed of constructing an idyllic place with an unparalleled natural setting, and their descendants preserved and renewed the vision of the original settlers. The climate, vegetation, and ordered landscape are different from anything else in Africa, and the colony prospered like no other on the continent.

Gardens, formal, English, and eclectic, were necessary to realize the colonists' hopes. In fact, the elegant residences in the Cape Dutch style are inserted into the rigorous geometric forms of vineyards and fruit groves with the help of manicured gardens. Stellenbosch, "the city of the oaks," the South African wine capital, was founded in 1679 and grew rapidly thanks to its vineyards, which have made it rich and famous. Next to the colonial farms arise modern residences that incorporate Georgian and Victorian influences. Even in places where there are no true gardens, secular camphor trees and the omnipresent jacaranda trees, which periodically paint the city and country with their intense lilac, can be found. The gardens in Johannesburg or Durban, on the western coast of the country, are not dissimilar, although the Anglo-Saxon influences are more marked and the gardens are almost exclusively English.

An unusual zoomorphic sundial in Benthurst Garden in Johannesburg.

A gigantic camphor tree in front of the eighteenth-century farm of Vergelegen in Stellenbosch, near Cape Town.

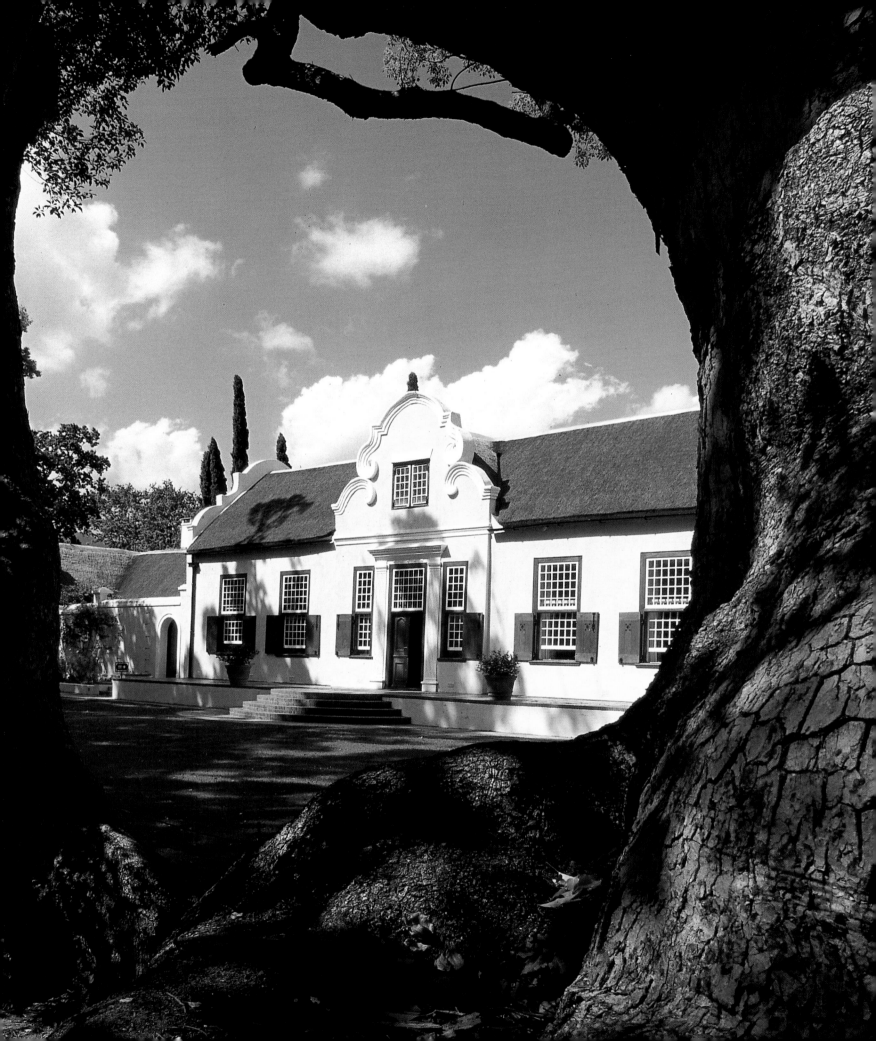

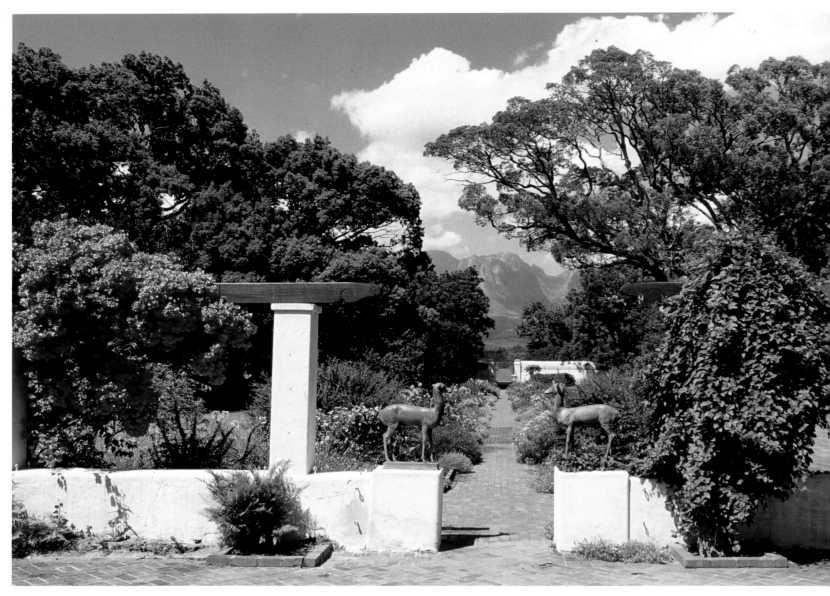

*A small formal garden
at the Vergelegen farm.*

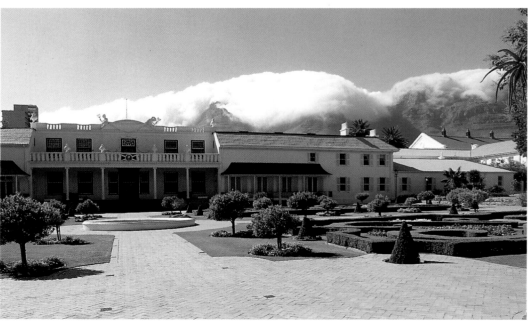

*A formal garden in
Cape Town.*

The garden of Grand
Roche in Paarl, in
the province of Cape
Town, composed of
a few plants and fields
that end where the
surrounding vineyards
begin.

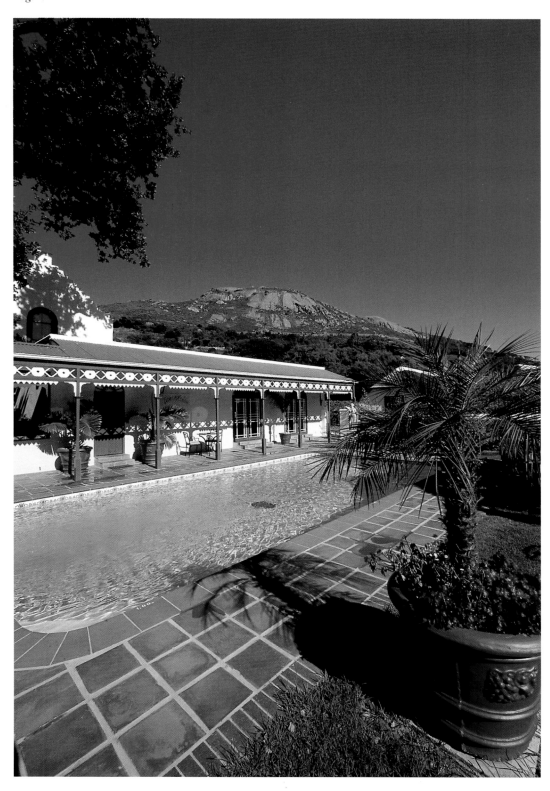

A drive in Benthurst Garden, where over the years the Oppenheimers have gathered a great number of plants from all over the world.

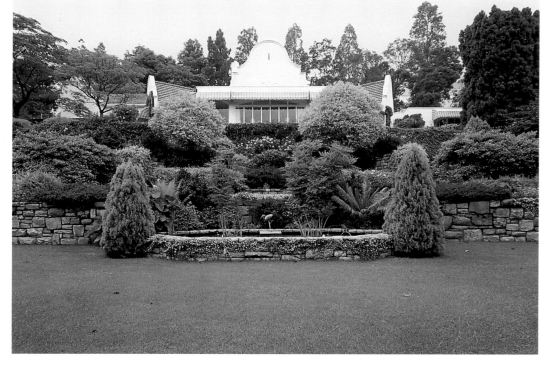

The stately dwelling of Benthurst Garden. Constructed at the beginning of the twentieth century in the era of the great gold mines, the building was purchased in 1920 by the Oppenheimers, who planted a garden there.

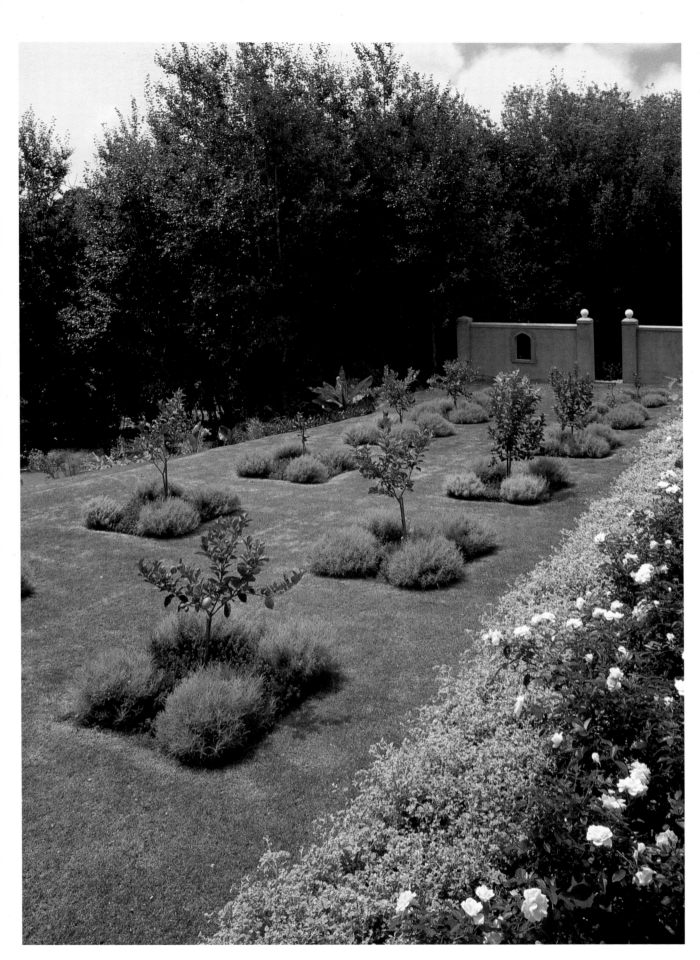

Amphitheater at Sun City erected in the middle of the desert and surrounded by luxuriant vegetation.

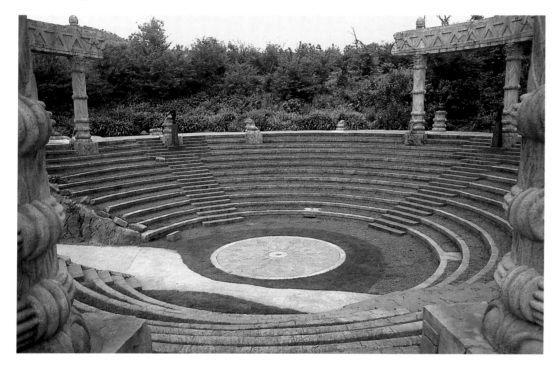

The garden in front of the Selbourne Hotel in the province of Durban, previously a stately residence.

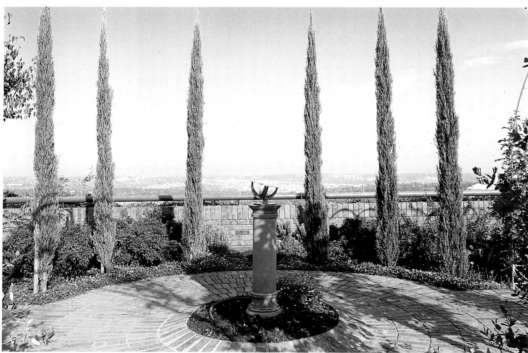

The roof garden of the Sunton Towers Hotel in Johannesburg.

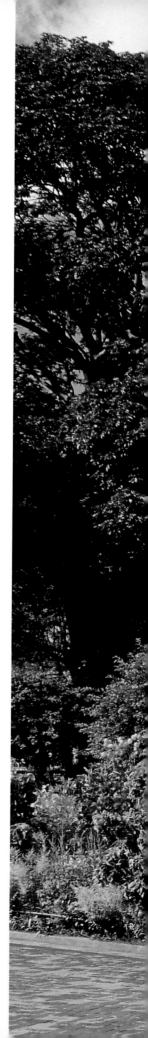

L and of many ancient civilizations, Asia is also the birthplace of the garden. It is here that the idea of green space destined for the pleasures of earthly life but created in the image of the afterlife —a paradise on earth—originated.

Yet while the garden was born in the Near East and its first noteworthy manifestations were those of Babylon, it also developed in many other areas of the continent. For instance, the garden evolved autonomously and in very diverse forms in Kashmir and in China and Japan, where the concept of garden is allied even more with philosophy than with religion.

Thousands of miles, myriad experiences, and diverse influences separate the Middle Eastern oasis, the first natural garden, from the eclectic contemporary green spaces of Hong Kong and Macau, where the Orient and Occident meet. Yet such worlds, so far apart, are ever united because they belong to the same land.

Asia

The Gardens of Aphrodite

The "island of Aphrodite," the Greek goddess of love, is appreciated for its gentle landscape, good wines, kind inhabitants, and varied vegetation. In spite of the hot dry climate almost all year, numerous woods of Calabrian pines (*Pinus brutia*), black pines (*Pinus nigra*), juniper, and strawberry trees grow on the island; alternating with them are oaks, carob, and some Cyprus cedars (*Cedrus bravifoglia*). Parks, such as those on the Akamas Peninsula, near Paphos, and at Athalassa, near Nicosia, have been created to preserve endangered species.

The strategic location of Cyprus made it a land of conquest for nearby nations, first the Persians, then the Greeks, Romans, and Turks, and afterward the English. Varied cultures, tastes, and artistic expressions have enriched the traditions of the Cypriots. The concept of gardens on the island crosses the Arab variety with that of imperial Rome: a courtyard garden with a surrounding peristyle. The mosaics of the Roman houses in Paphos testify to the antiquity of these green spaces.

In a place where the first orchids begin to bloom in January, it is evident that the garden is important. Surviving historic gardens, like contemporary ones, simple and elegant, demonstrate the Cypriots' desire for greenery and privacy.

*Previous pages:
Zoomorphic fountains
in the garden of
Tirtagangga in Bali.*

*Below:
Stone doorway near
Larnaca leading to a
private green space.*

*The courtyard of the
Château de Covocle
near Paphos, which
has been transformed
into a museum.*

The fortress of Kolossi in Limassol, which is also used as a residence and is surrounded by a garden with little stone walls.

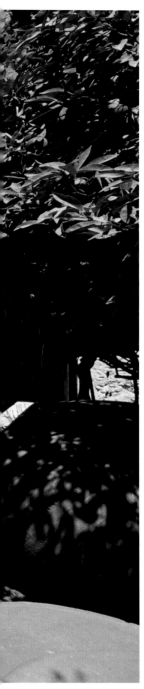

The private garden at the Château de Covocle, with fruit trees and herbs. This area was originally the private space of the dwelling.

The entrance courtyard of the Château de Covocle, delimited by the main house and the service buildings.

At the Source of Myth

Syrian gardens offer a particular pleasure: atmosphere, lights, colors, and fragrances. Typically Arab, the green spaces of this Mediterranean land arise just at the edge of great expanses of desert. Yet it is also a country where snow-covered mountains and fertile valleys alternate with the arid deserts; where Egyptians, Babylonians, Greeks, Romans, Assyrians, Sumerians, and Phoenicians met; where the birth of a rich and varied culture could not have been avoided. Traditions, techniques, and diverse experiences fused under Islam.

In a country where there are no completely uninhabited areas, where Bedouins are found where it seems impossible to live, the concept of the garden is above all that of a protected place—protected from the vastness of the landscape, from the wind of the desert, and from the rapacity of humankind. Thus many green spaces are closed gardens, kept inside courts. Yet they are richly decorated, graced with running water in fountains, canals, and basins, and perfumed by citrus trees and other fragrant plants. The idyllic tableaus are not so different, in fact, from the images in sixteenth- and seventeenth-century miniatures.

Polychrome marble on the courtyard facade of the Azem Palace in Damascus.

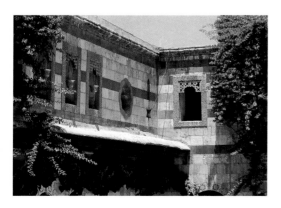

A "room" open to the shady courtyard of the Azem Palace.

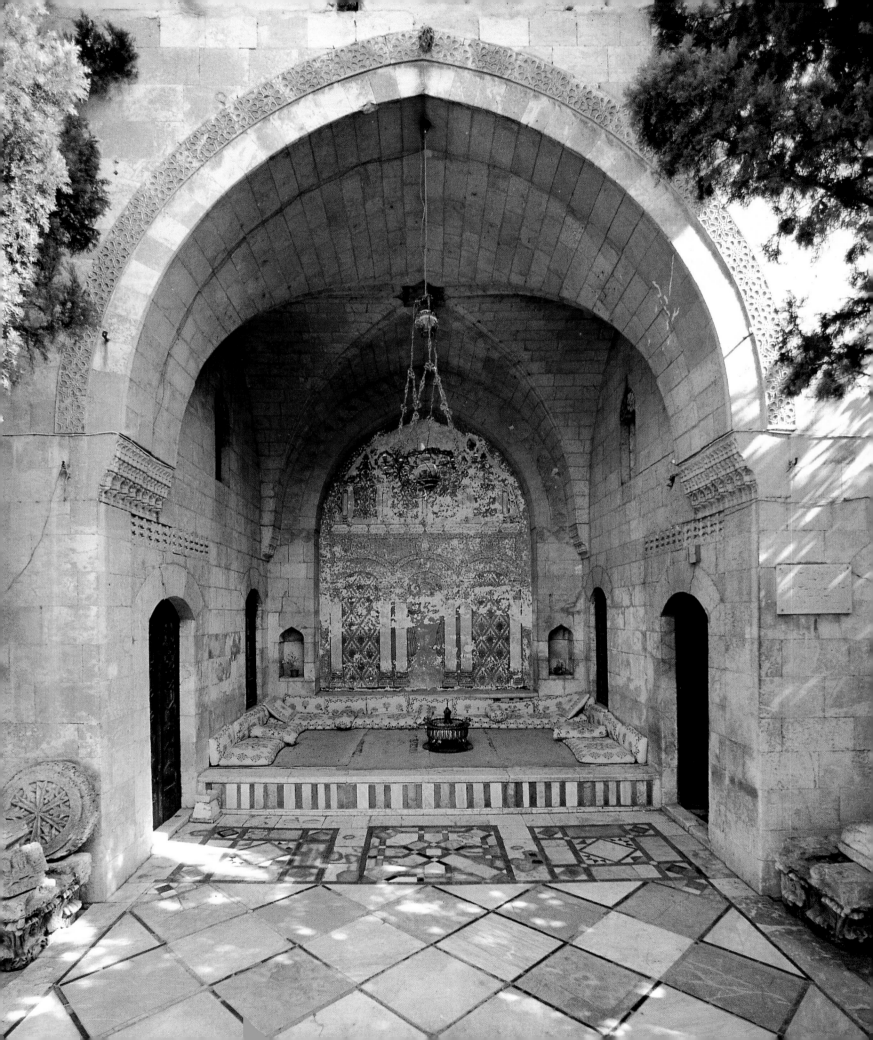

Rigid geometric
designs on the floor
of a courtyard of the
Azem Palace. Areas
of vegetation alternate
with the built areas.

Opposite top:
The courtyard-garden
of the Anbar Palace
in Damascus.

Opposite bottom:
The courtyard-garden
of the Ajakbash
Palace in Aleppo.
The rich decoration
on the walls facing
many such courtyards
is very different from
the spartan street
facades.

A pool and fountain
in a courtyard of
the Azem Palace.
Such water features,
fundamental in
Syrian and Arabic
courtyards, both cool
the inhabitants and
serve as decorative
elements.

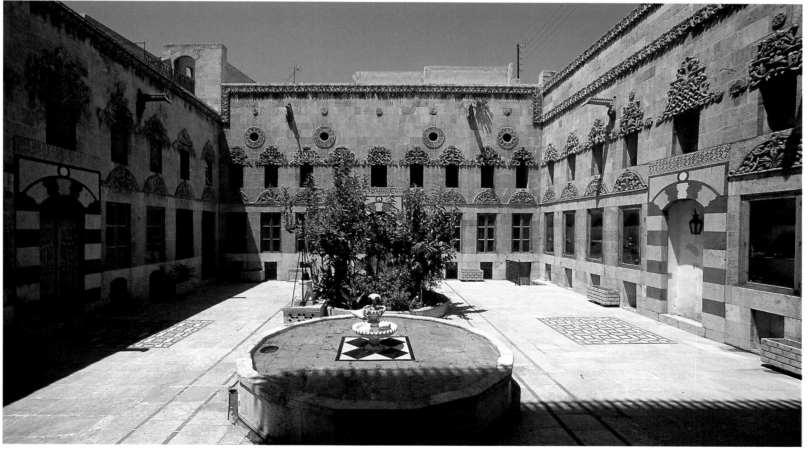

Gardens and Stones of Sheba

Yemen

In the realm of the Queen of Sheba, in Arabia Felix ("Fertile Arabia") along the routes of incense and of Mocha coffee, survive the Middle Ages. The *gabilis*, tribal warriors, continue to carry arms; adult males chew *qat*, little leaves that induce sleep; many of the streets of the historic center are still unpaved. And behind the high barriers of the city buildings, behind the tower-houses that face narrow and dark streets, is an enchanting world—unimaginable from the street— of vegetable gardens and luxurious flower gardens as large as public squares.

Vegetables, ordered in rectangular beds, abound; together with fruit trees, they mark and give rhythm and symmetry to these spaces delineated by the surrounding houses. The gardens are at the disposal of the residents of the houses as a kind of public vegetable and flower garden, and sometimes open to the inhabitants of the block.

Thus even in the city, where the only green seems to be in polychrome windows of elegant houses, the right doorway leads to a new world. Each green oasis is comforting—for the body and for the mind—to the inhabitants of this arid and rocky land.

A pool in the courtyard of a palace in Sanaa, recently restored by Marco Livadiotti.

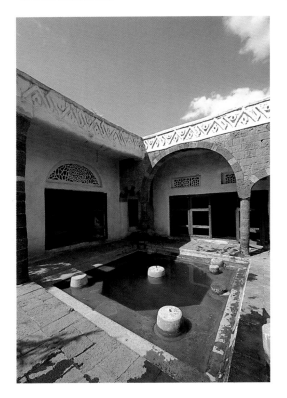

A great palm in a garden in the center of Sanaa. Such gardens extend deeply into the interior blocks, a great contrast to the streets outside.

The headquarters of
Universal Travel and
Tourism in Sanaa,
housed in a restored
building and garden.

The door from a
private street to the
small, walled garden
of Livadiotti Palace,
a recently restored
eighteenth-century
dwelling.

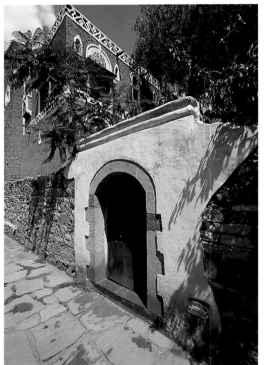

The small garden
at the Livadiotti
Palace. In Yemen
such gardens offer
private space for
daily family life.

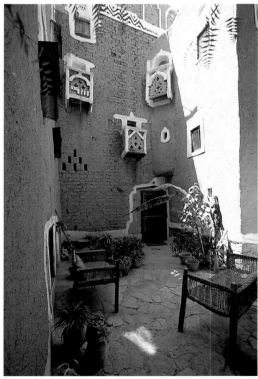

Walled gardens of the Suq al-Dhar oasis, nestled into the sunny and arid Yemenite mountains a few miles from Sanaa and not far from the Wadi Dhar palace.

Overleaf:
The great courtyard of the summer residence of Imam Yahya in Wadi Dhar, built in the 1930s. Though there are no permanent plantings, the generating idea is the same as that for gardens.

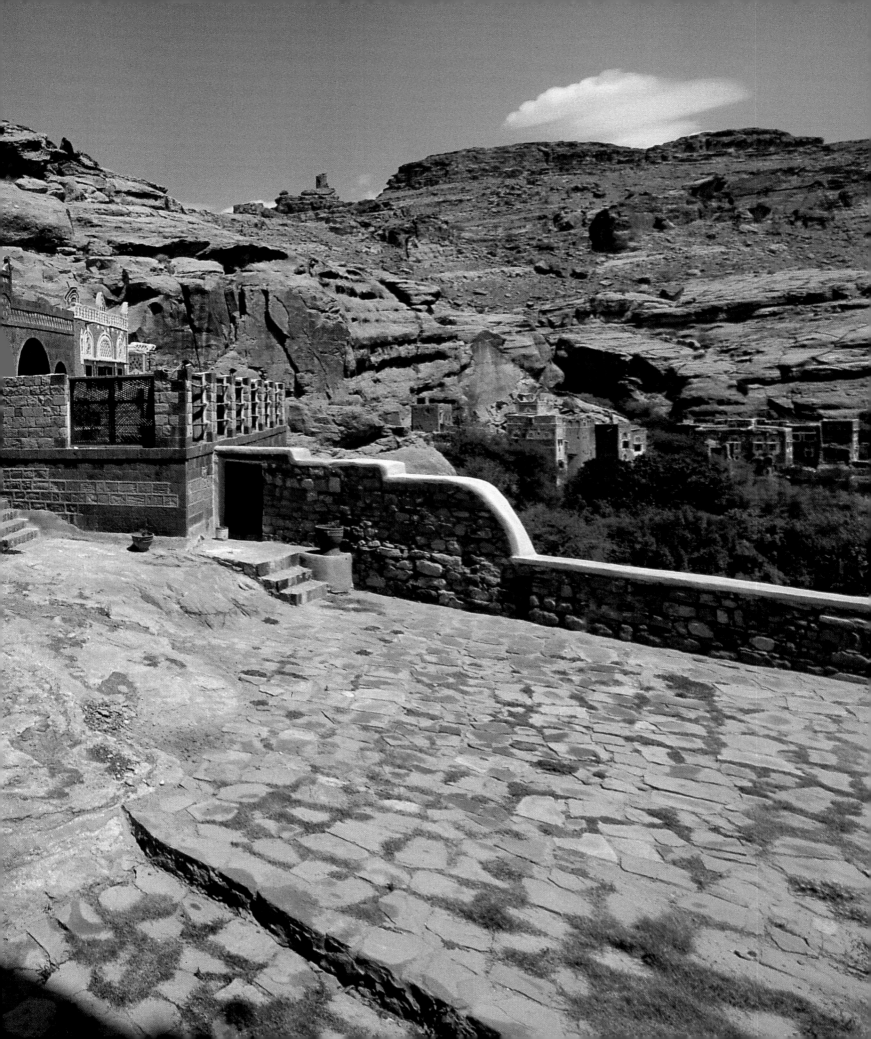

The Fragrance of Incense

Oman

Behind imposing walls, stately Omani dwellings of the 1600s and 1700s are characterized by palm gardens, with their wells, towers, and belvederes. From the beginning these fortified desert residences—built in a land of both violent conflict and important artistic developments—arose to protect vital centers such as villages and markets as well as to symbolize power and prosperity. At the time of the Romans, the Omanis were the major producers of incense and myrrh. Later they cultivated date palms, bananas, and citrus trees and continued to raise goats and horses, as they had in previous times.

The most felicitous period of the sultanate began in the 1600s when it extended to Africa, India, and Pakistan. The land was a great center of commerce: the Portuguese stopped there en route to the East Indies and the English insisted on signing protection treaties. It was due to its prosperity and to contacts with other countries of the Islamic world and Europe that the culture of the garden—manifested as an enclosed space next to a stately residence, with palms and fruit trees, a well or a cistern—spread in Oman. Paths atop the fortification walls could be used for defense or, in times of peace, as a belvedere walk. The gardens are hybrid spaces, in equilibrium between the past and the future, resulting from both the diverse cultural currents and the chronic lack of water.

A fortified residence in Oman, typical of those in the Persian Gulf. The associated gardens are tree-lined courtyards or orderly compositions of shrubs against the walls, as at the fort of Jabrin.

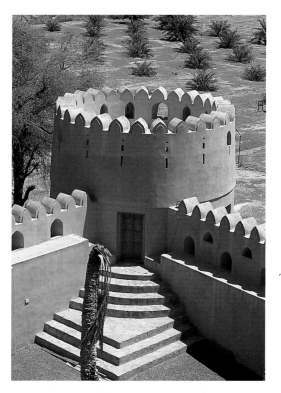

The luxuriant oasis of palms around the fort of Nakhl, which encircles the rocky escarpment where the dwelling stands.

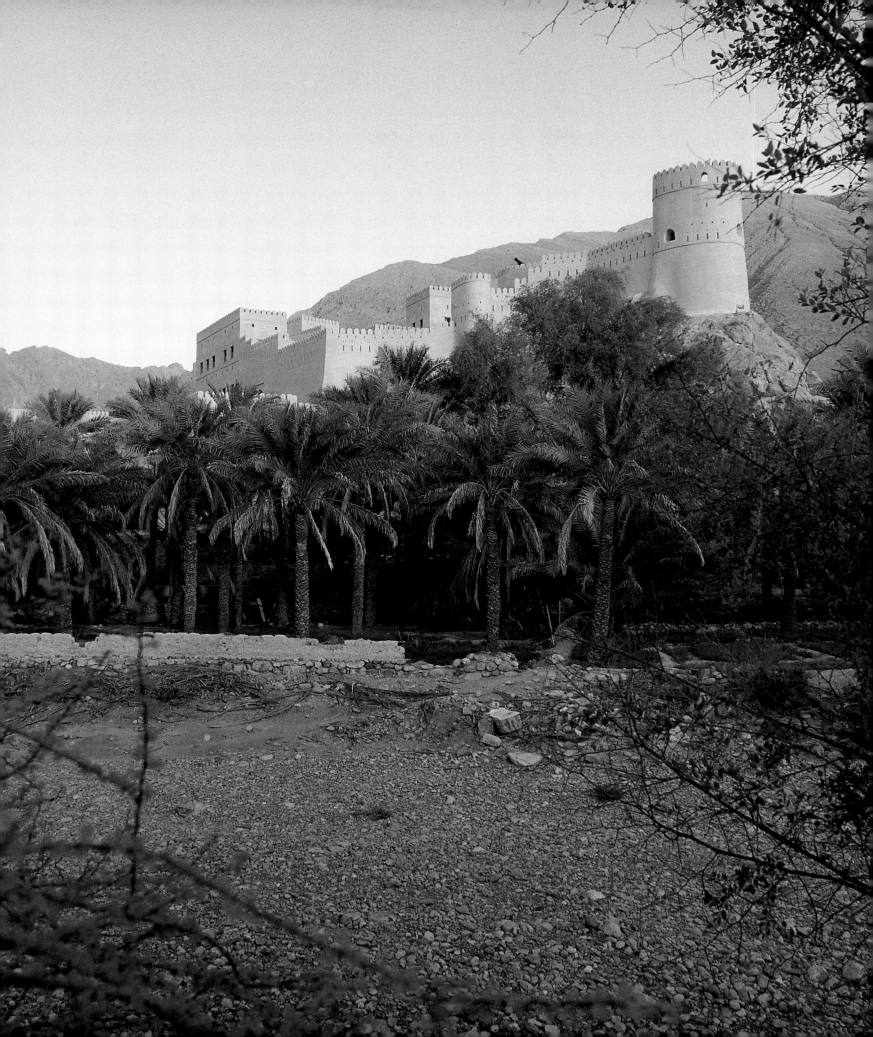

Protected, discrete garden. Such areas are kept as green as is possible with the limited water of the Near East.

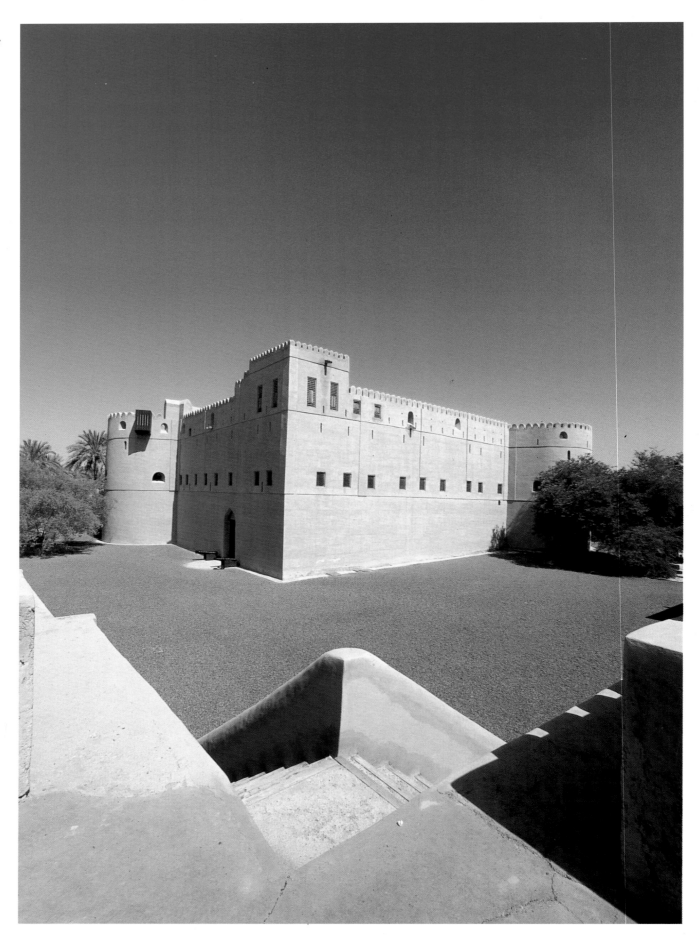

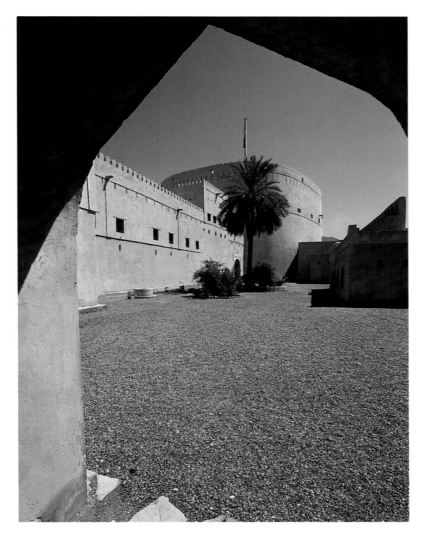

A palm tree next to the main residence of the fort of Nizwa.

A courtyard with a beaten earth floor and three trees, which composes the "garden" of the Bait Na'man on the northern coast of Oman.

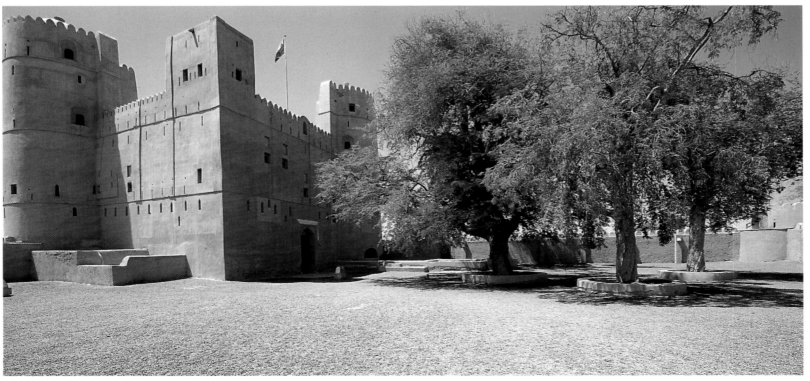

The Teachings of Cyrus

Persian gardens have played an important part in the history of Islamic green spaces. Some of the most beautiful gardens of Esfahan and Shiraz have survived wars and transformations, but it is only the miniature, a widespread art in Persia, that records the gardens that have disappeared. These images also capture the flora, especially the flowers: tulips, anemones, buttercups, jonquils, lilies, violets, carnations, and roses.

Private gardens usually took the name of the owner; royal ones were given poetic names inspired by paradise. One of the typical gardens of the Persian court was the *bagh-i takht*, the "garden of the throne," which grew on terraces at different levels. Another was the *mi'maz*, where landscape architects composed an organized and geometric vegetation with entrance structures, water channels, and pavilions, sometimes in circular, polygonal, quadrangular, and composite forms.

The various names of Persian gardens both mirrored the diverse times and places and denoted some differences. The term *pairidaeza* ("enclosure") refers to the ancient gardens of Cyrus the Great who filled the courtyards with "all the good and beautiful things that life afforded." Senofonte, in his *Encomio*, reported these facts and also described the gardens as walled, with covered pavilions, water channels, and great numbers of aromatic and medicinal herbs.

The *bagh* in contemporary terminology is "fruited garden"; originally it meant only "lot of land." *Bagh* can refer to buildings, gardens, and whatever else is associated. The *bustan*, "place of fragrances," was coined to indicate a garden inside a court with pools and canals. The Persian garden and its various forms remained dominant until the end of the nineteenth century, when the European romantic fashion started to make an impact.

The entrance to the great park of Shemiran, which surrounds the summer residence of the last shah on the northern outskirts of Tehran.

The residence at Shemiran, the last dwelling of Shah Reza Pahlavi and today the Museum of the National Palace.

The courtyard of
Boroujerdiha Palace
in Kashan, which is
crossed by a long pool
flanked by trees.

The garden of Fin
in Kashan, known in
the past as Bagh-è
Amir Kabir or Bagh-è
Shah and one of the
best preserved in the
country.

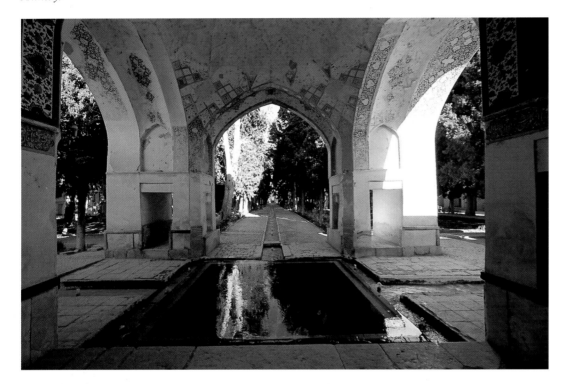

Pools, canals, and
plays of water at
the garden of Fin,
designed by Shah
Abbas I.

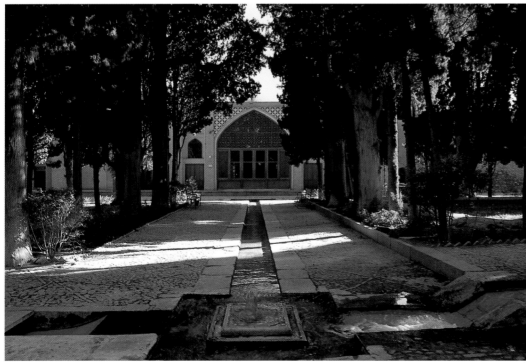

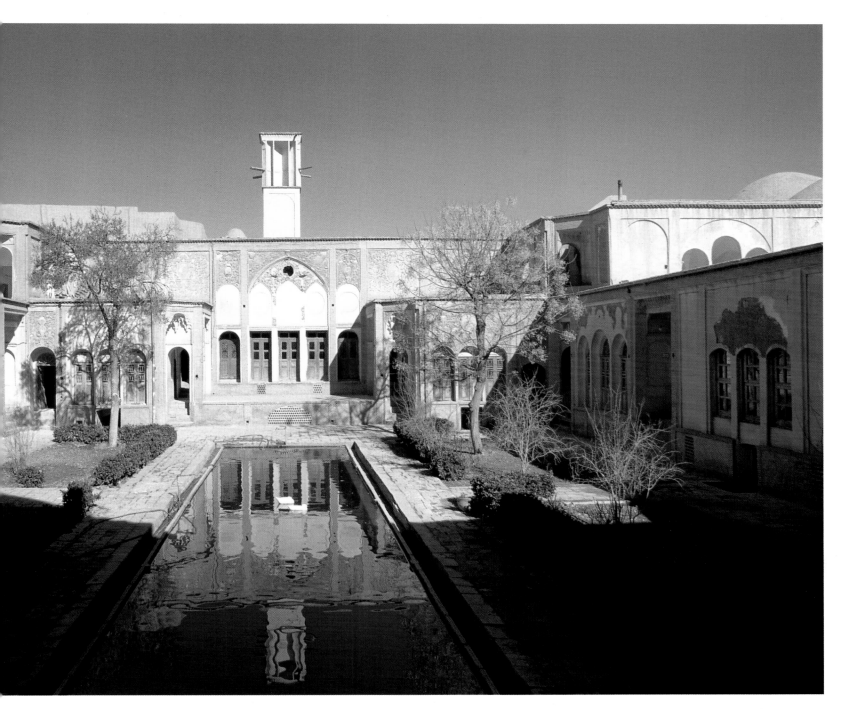

A great niche used for rest and meditation in a garden in Shiraz, in the south of the country.

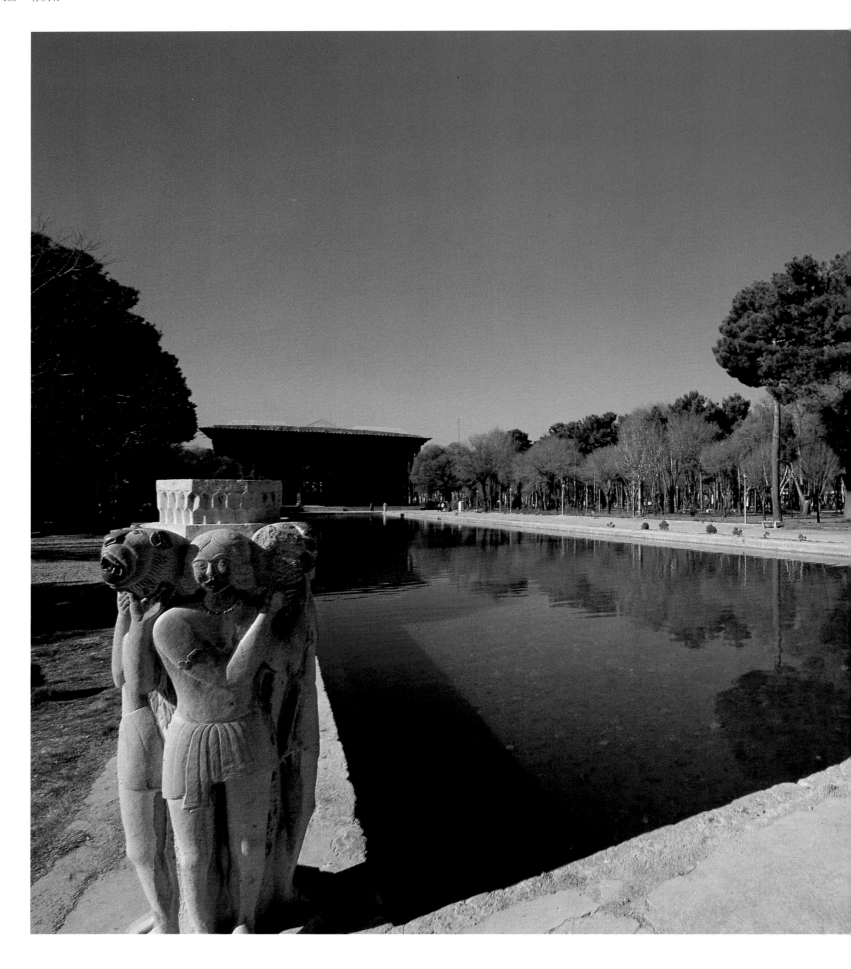

An immense pool
in front of the Chehel
Sotun, a grand
pavilion in Esfahan
commissioned for
receptions by Shah
Abbas I.

A high wall with
niches encircling
a shady garden in
Shiraz.

Emerald Atolls

The Maldives are a grand and immense aquatic garden. The various coral atolls amass innumerable small islands that were, until recently, immune to Arab, Portuguese, Dutch, and English influences. The islands kept their culture and traditions intact until the 1960s, when tourism began to have an impact.

Thus the Maldives have neither influenced nor been influenced by the international development of the ancient and modern garden. It is instead nature that has defined the gardens of these islands. The local vegetation is singularly luxuriant and varied, manicured and protected. Only a minimum of design is found in the island-villages; it is the environmental setting that is dominant. And swimming pools, basins, fountains, and water features are not part of gardens in the Maldives: the surrounding ocean is a giant pool whose borders, like sea beds, are the site of innumerable surprises.

Below:
The beach of
Makunudu Island.

Bottom:
The simple vegetation
typical of the island,
which often changes
drastically when it
flowers.

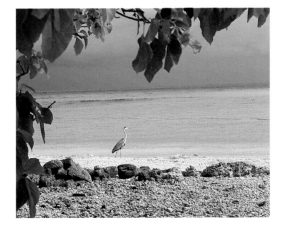

Opposite:
The interior of
Rihveli Island.

Overleaf:
The great
beach-garden
of Dhigufinholu,
home to both
native and
imported
vegetation.

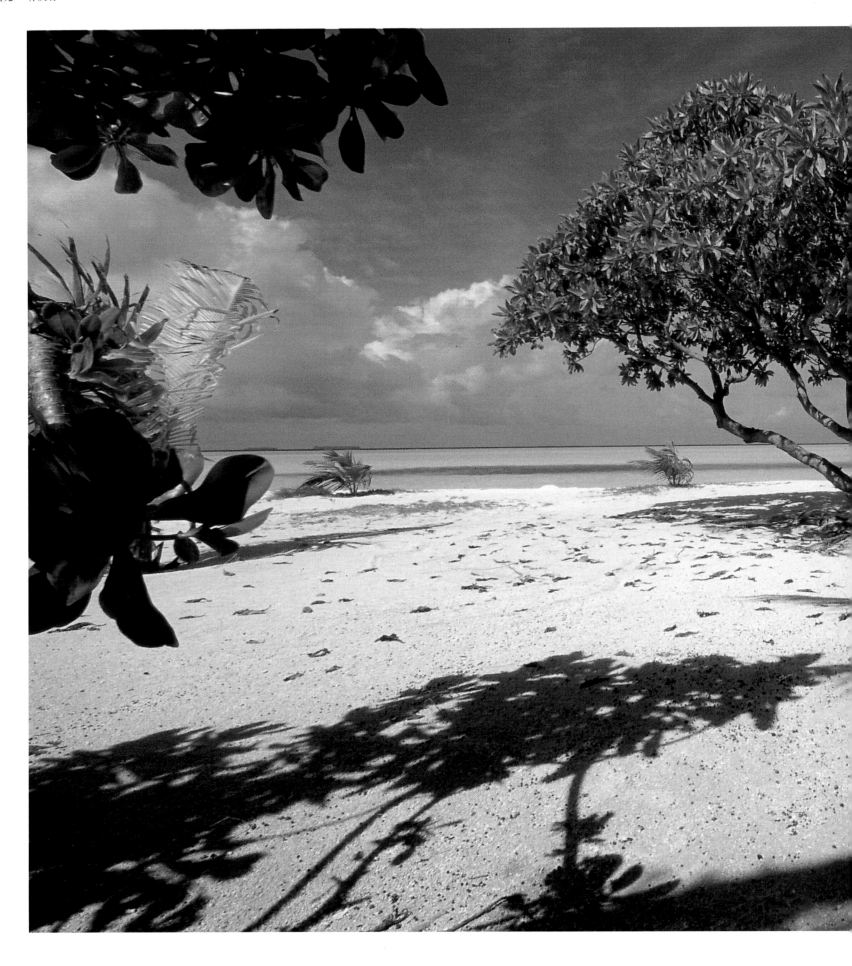

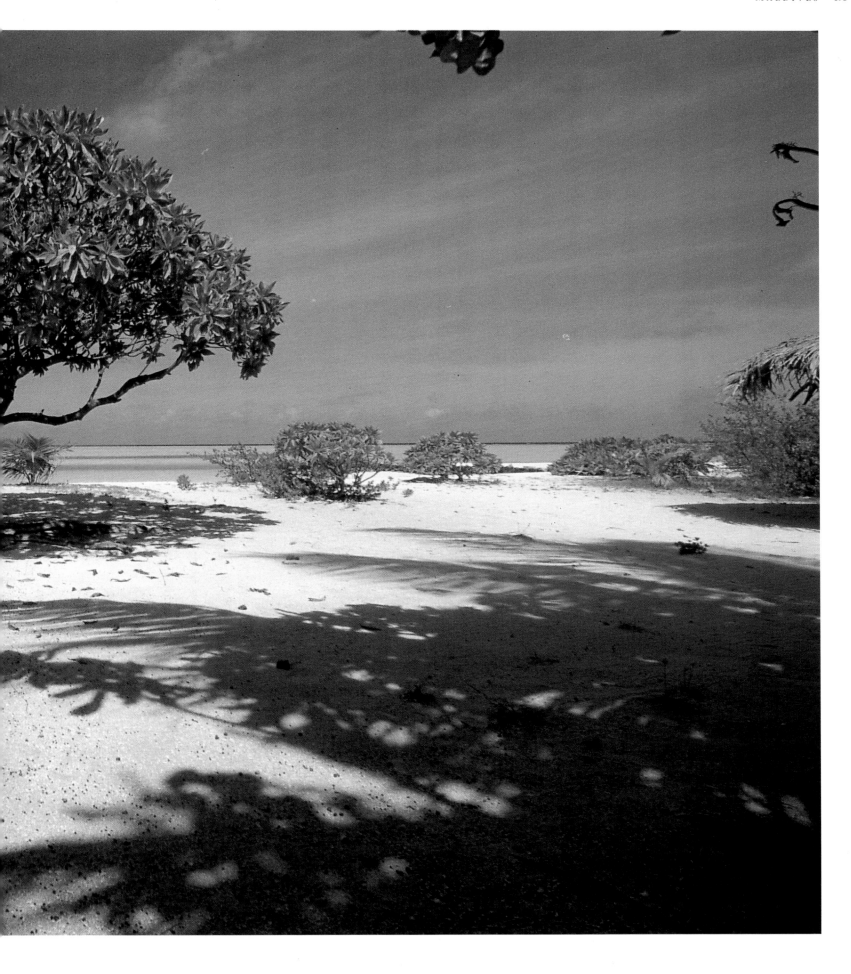

Moghul Jewels

Sumptuous residences testify to the wealth and importance of Indian art. Delicate stone tracery alternates with imposing pillars in patios made from mirrors, majolica, and Italian marbles. Music, spices, and incense complete the environment that is today mostly inhabited by maharajahs.

The diverse ethnic groups of India have all contributed to the varied artistic expressions, materials, colors, and furniture. The art of the Islamic garden was brought to this country in the 1500s with the invasion by Babur, a descendant of Timur who was steeped in the artistic experiences of Samarkand.

In the second half of the sixteenth century, the power passed to the Moghul dynasty, which left its own mark on the art history of India. The masterpiece of this period is the Taj Mahal, the mausoleum erected in the middle of the 1600s by Shah Jahan for his wife Mumtaz Mahal. The gardens surrounding it are the most important of the surviving Moghul gardens. The complex system of pools and canals is supplied by an apparatus of pumps that draws water from the river nearby. The rigid symmetry dominating the entire composition starts at the entrance and continues throughout the grounds and up to the imposing edifice.

This type of garden—characterized by long axes of longitudinal symmetry and a sequence of terraces adapted to the terrain—spread in Kashmir from the sixteenth century on. The abundance of water and the mild climate favored the work of the Moghul landscape architects, who created important compositions. Dominating the design was the Islamic concept of the garden with four rivers—the rivers of paradise—surrounded by all the amenities desirable on earth.

Below:
The chhatrie, *the cenotaphs of Orchha, with green space around them.*

Bottom:
The grand parterre *behind the Umaid Bhawan Palace in Jodhpur.*

The tree-lined courtyard of the Lake Palace of Udaipur, created as a summer residence of the local rajah and constructed above a rocky escarpment in a lake.

A stone elephant
that seems to drink
from the great pool
of the Sahelion-ki-
Bari in Udaipur,
where local tradition
and European
influences fuse.

A stone "garden"
encircled by a
luxuriant park
in Shivpuri.

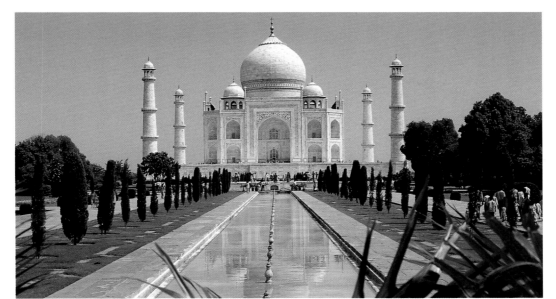

A long pool with
a plethora of small
fountains on axis
with the entrance
to the Taj Mahal
in Agra.

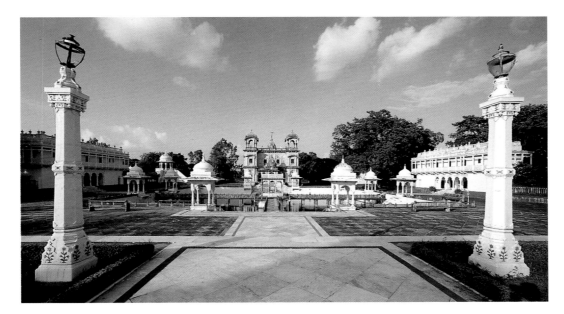

The grand paved
court of the chhatri
in Shivpuri. In the
center is a pool with
several gazebos.

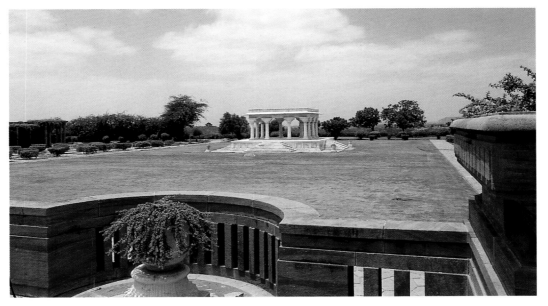

The garden of the
Umaid Bhawan
Palace of Jodhpur.

Amid the Tea Gardens

The vegetation of the island of Ceylon is both rich and clearly tropical. It forms an interesting juxtaposition with the European architecture that is typical of so many colonies but that has remained intact here longer than elsewhere. The countryside leading toward Nuwara Eliya is very European, even English. In fact, in the 1800s this city was the favorite of Anglo-Saxon colonists, who, due to a particularly pleasant, almost cool, climate and morning mists, probably felt right at home. The hot city of Colombo offers another environment, as does the southwestern coast between Bentota and Galle. Thus numerous different microclimates and diverse types of vegetation characterize the island. Sri Lankan gardens combine this wealth of raw materials with landscape concepts brought from Europe. The result is simple gardens, with mown fields, mounds, and ponds.

The tea gardens on the central mountains present a different appearance. Entire hills, crossed by paths and stairways dug out of the rock and used for harvesting, are covered with these green plantations. As in few other places, the cultivated areas here characterize the landscape absolutely, bringing the countryside entirely into being and at the same time publicizing the country's most important national product.

The tea plantations of the center of Sri Lanka, which seem to cover the hills with a thick mantle of green cut by winding paths.

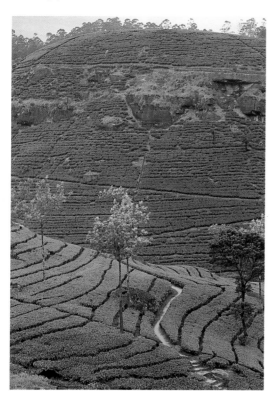

The gardens of the Culture Club resort.

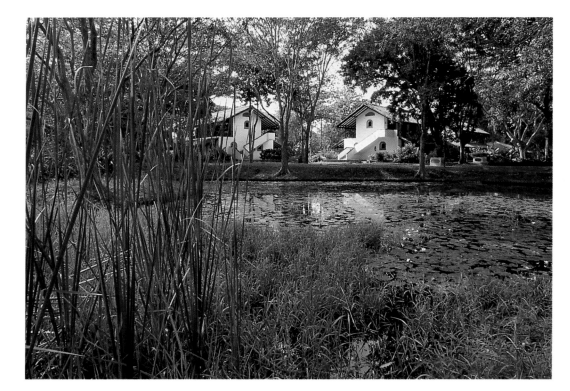

The Lodge resort, which is in the center of the island in a park with a placid lake.

The portico of Wijetunga House, headquarters of Tourismo Oasis Lanka in Colombo. The dwelling is framed by a shady garden; in the center is a circular lawn with an ancient mango tree.

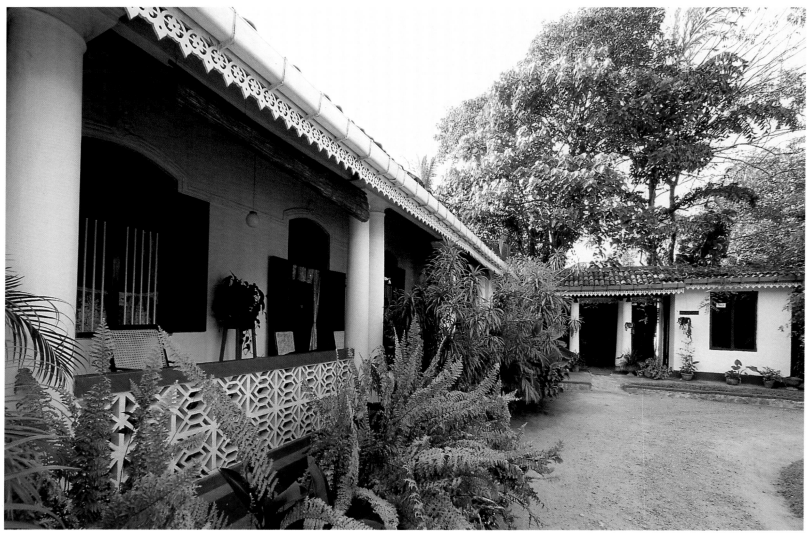

Right:
A formal garden and a colonial house in Nuwara Eliya.

Far right:
A neoclassic residence and a simple green space on the Colombo-Bentota road.

A pool with stone terraces in the center of a public park not far from Anuradhapura.

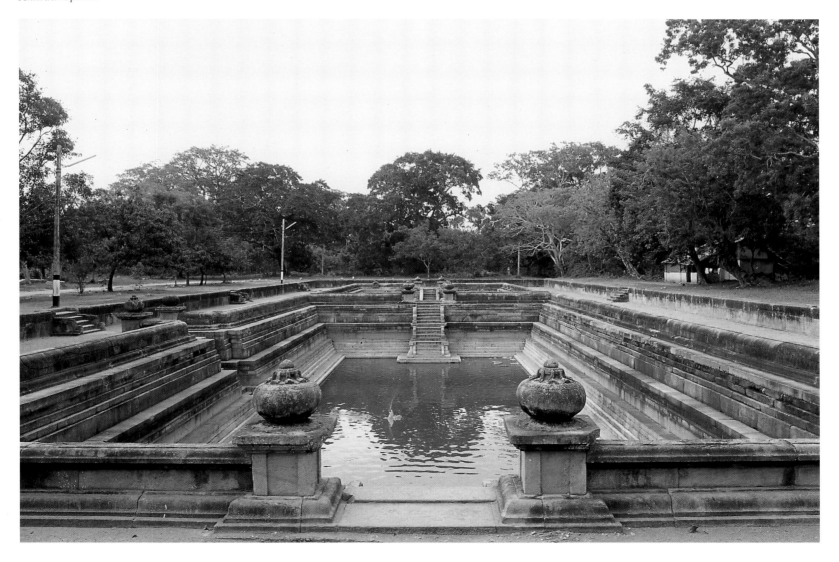

Tabebuia serratifolia

Phaius wallichii

Thespesia populnea

Right:
Asclepias curassavica

Far right:
Alpinia purpurata

Coelogyne zeylanicum

Erythrina indica

FLOWERS AND PLANTS
OF SRI LANKA

Situated between five and ten degrees north latitude, Sri Lanka enjoys an equatorial climate with high temperatures and humidity all year long. Precipitation is abundant from May to October, due to monsoons, and scarce during the winter months. The mountainous zone in the interior of the island leads to substantial climatic differences that strongly affect the vegetation.

The southern and western parts of Sri Lanka consist of equatorial rain forest, a complex environment dominated by evergreen broad-leaf plants. Five strata of vegetation can be distinguished: three arboreous, one shrubby, and one of undergrowth, composed for the most part of vegetal debris and cryptogams. Density of trees and great variability characterize this zone; it is the ideal habitat for such creepers and climbing shrubs as the bignoniacea *Bignonia magnifica* and the apocynacea *Allamanda cathartica*. *Epidendron radicans* is one of the numerous epiphyte orchids that live attached to the limbs of the trees; thanks to their aerial roots, they absorb great quantities of water from the surrounding humid atmosphere.

Among the more interesting species of the Ceylonese forests are the cinnamon tree *Cinnamomum zeylandicum*, the pepper plant *Piper nigrum*, and the serpentlike *Rauwolfia serpintina*, which can be used against snake bites and hypertension. *Peltophorum inerme*, *Standmannia oppositifolia*, *Lagerstroemia speciosa*, and *Tabebuia serratifolia* all have beautiful flowers. Indigenous species, such as the orchids *Ipsea speciosa* and *Phaius wallichii* as well as *Fagraea* and *Coelogyne*, whose specific name—*zeylanicum*—leaves no doubt as to its origin, are also numerous. Various species that are not native to Sri Lanka but that have been acclimatized in cer-

Tacca chantrieri

Ipsea speciosa

Bignonia magnifica

Allamanda cathartica

Spathodea campanulata

Lagerstroemia speciosa

Amherstia nobilis

tain zones are particularly noted for their striking flowers, including the "bat flower" *Tacca chantrieri*, the zingiberacea *Alpinia purpurata*, the bignoniacea *Spathodea campanulata*, the elegant *Amherstia nobilis*, and the asclepiadacea *Asclepias curassavica* with its unique red and yellow blossoms.

Along the coast, flat swampy areas offer a habitat suitable for palms, mangroves, and numerous species of unusual and colorful flowers like *Thespesia populnea* and *Erythrina indica*. Mixed forestal formations of evergreen and deciduous broad-leaf plants occupy the northern region of the island, which is characterized by a subequatorial climate. During the dry season, many of these plants lose their leaves, conferring a characteristic physiognomy to the entire formation, which appears less stratified and imposing than the equatorial rain forest.

Great portions of the extensive forests that used to cover the terrain of Sri Lanka have been destroyed to make pastures and fields for cultivation. Such practices have impoverished the terrain, and a great part of the so-called primary forests have been substituted by secondary formations that are characterized by limited variety and somewhat smaller species. Rice, tea, and wood constitute the major products of the island; most particularly, from Sri Lanka come trees that produce precious woods like *Tectona grandis*—which yields teak—the satin tree *Chloroxylon swietenia*, and the ebony *Diospyros ebenum*.

In the Footsteps of Marco Polo

The tradition of the Chinese garden goes back to the third century BCE, and the first designed green spaces arose during the Qin and Han dynasties. However, it was only at the beginning of the first century CE that the garden assumed characteristics similar to contemporary Chinese gardens. Today the Chinese garden is asymmetrical, imitating nature and almost praising the curved line. Woods, kiosks, and rocks structure the garden in various, well-delineated "events." Small areas divide the green space visually; each piece alludes to the next, almost inviting the visitor along an obligatory route. Although Chinese gardens appear casual and spontaneous, they are in reality meticulously constructed. The lack of symmetry is called *sharawaggi*, "picturesque asymmetry"; both the concept and the term are meaningful. In the center of each garden arises a stone, called the guardian; the stone is the conceptual center of the garden as well as a central island where, according to tradition, anyone who reaches immortality will also find happiness. Such hermetic concepts characterize the gardens of the Far East.

There are three categories of Chinese gardens: imperial gardens, private gardens, and parks. The concept of Chinese green space was developed in imperial gardens, which belonged to a restricted elite class with almost inexhaustible financial means. Private gardens follow fashion and often indicate status and social ascent. Parks, on the other hand, generally surround temples, monasteries, and pavilions like an elegant frame. Two natural forms are frequently represented in Chinese gardens: water and mountains. Mountains, often visible against the horizon, serve as bridges between humankind and the celestial spheres; from them arise pavilions and belvederes.

In the Far East, vegetation is scarce and humanity exists there harmoniously; individuals feel part of the land without a need to dominate. Therefore the art of gardens is more than an ensemble of botanical notions corroborating compositional inspiration. Means are purposefully few and minimalism dominates. The art of gardens involves philosophy and religion, and it represents, amid plants and pavilions, the arc of life.

Alternating patios and courtyards in a Chinese garden, representing public and private spaces.

The Liú garden in Suzhou, which carefully juxtaposes foreground and background.

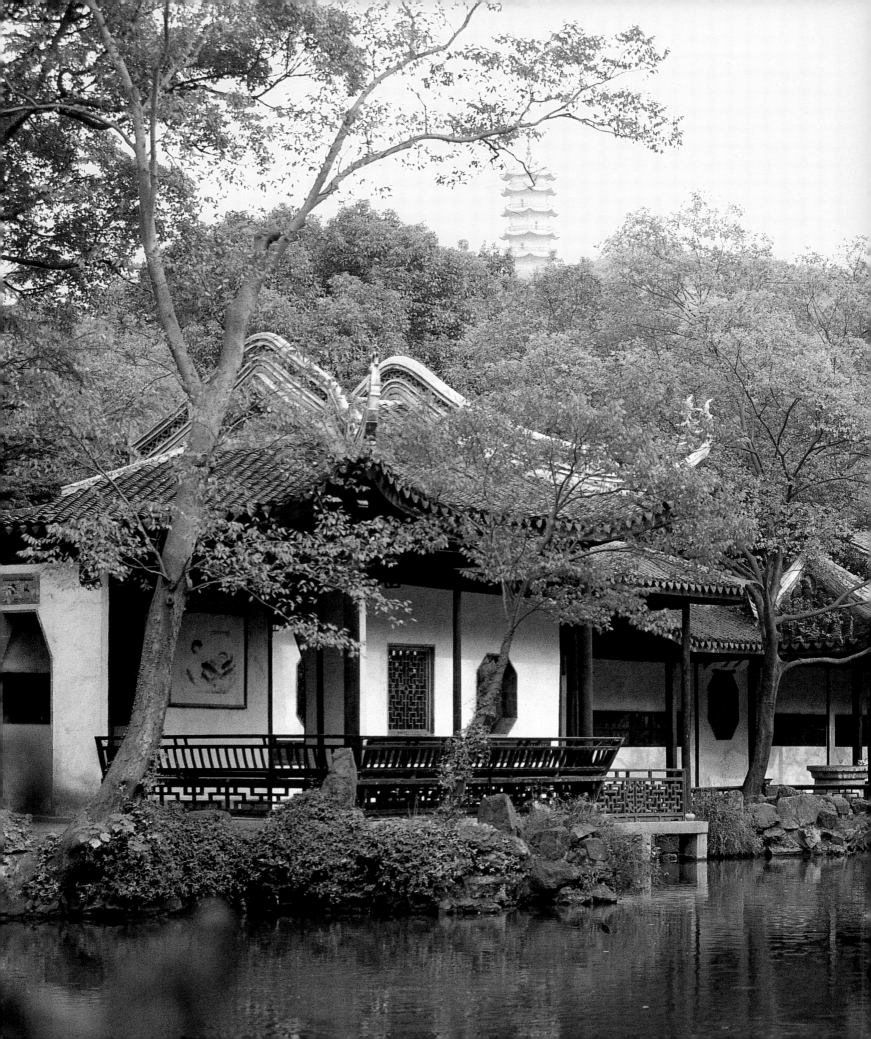

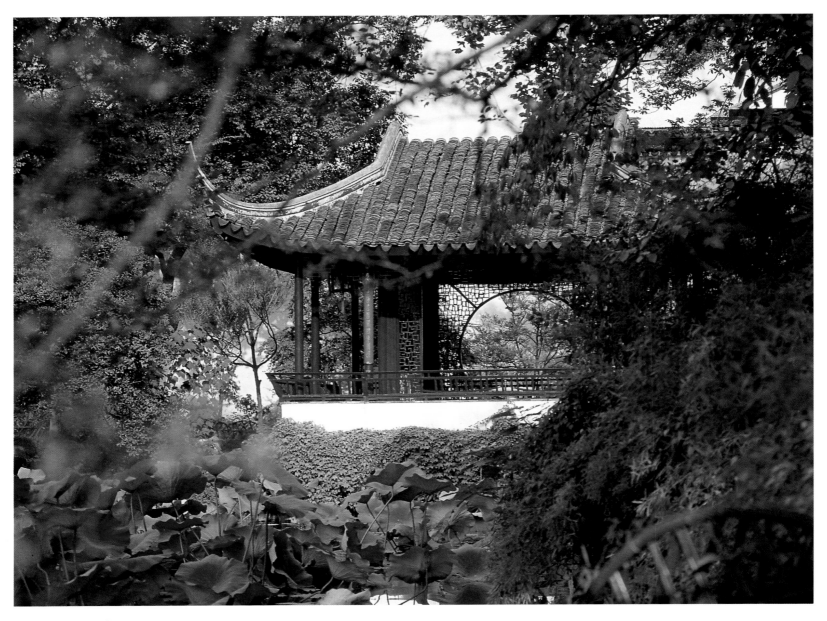

Garden in Wuxi, next to a stately residence, with pavilions, lakes with waterlilies, and paths through the dense vegetation.

Circular door framing a group of rocks in Wuxi, a scene typical of Chinese gardens.

A bridge and a pavilion in a public park in Suzhou.

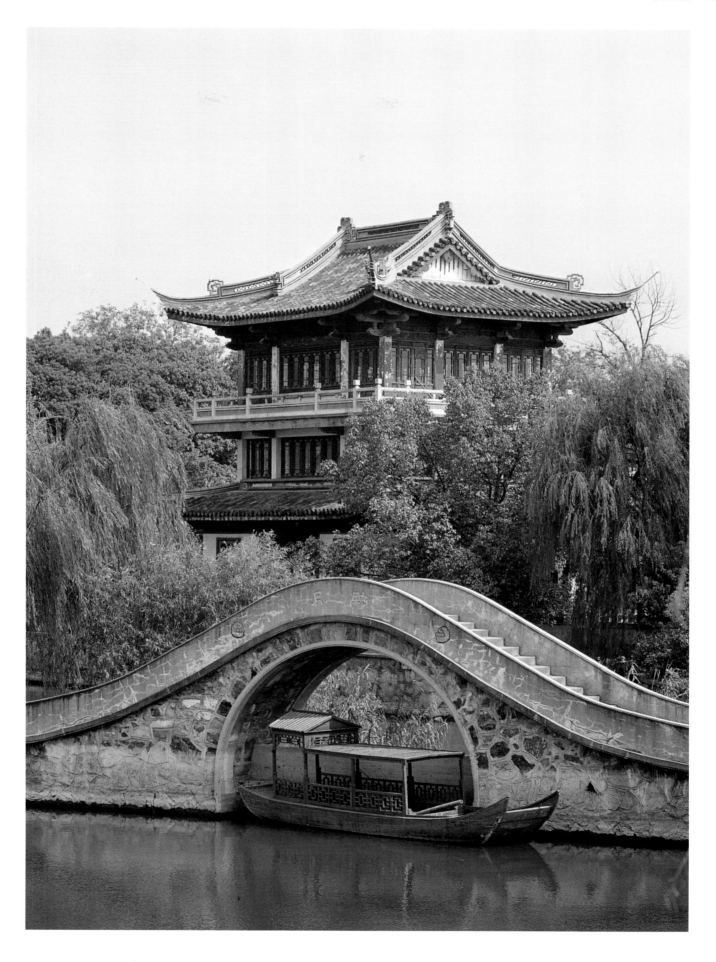

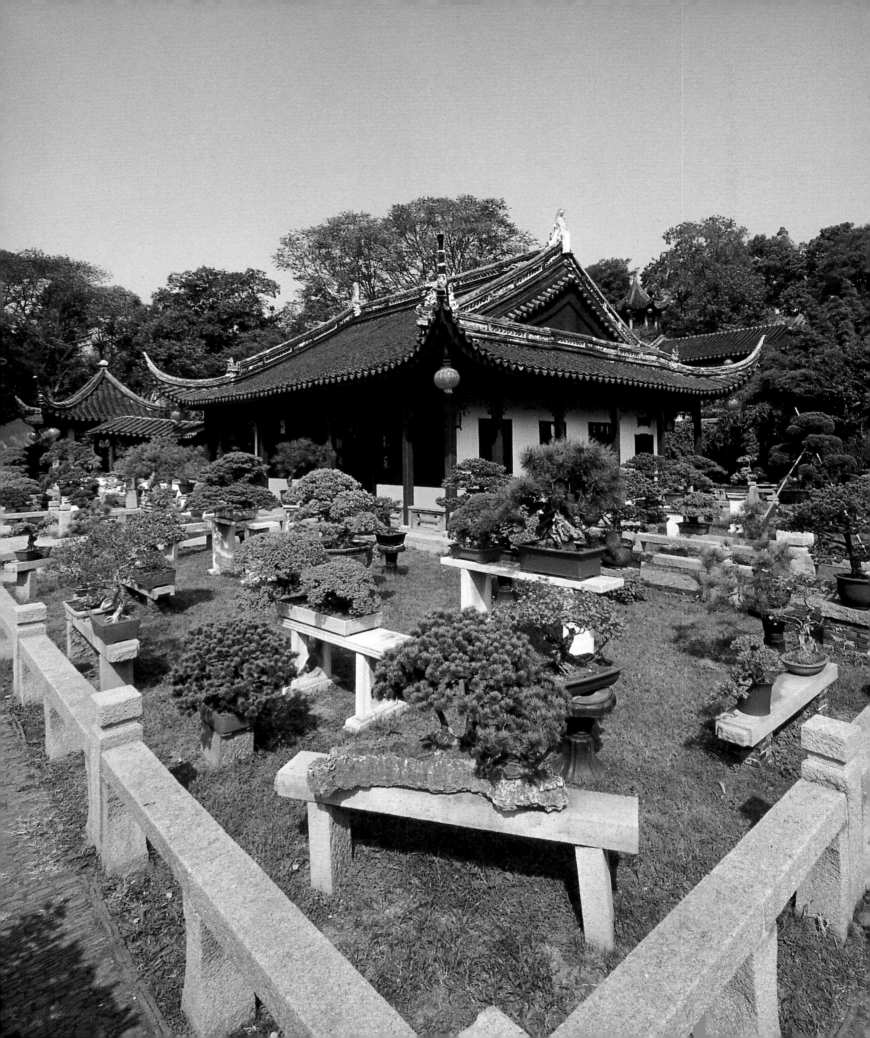

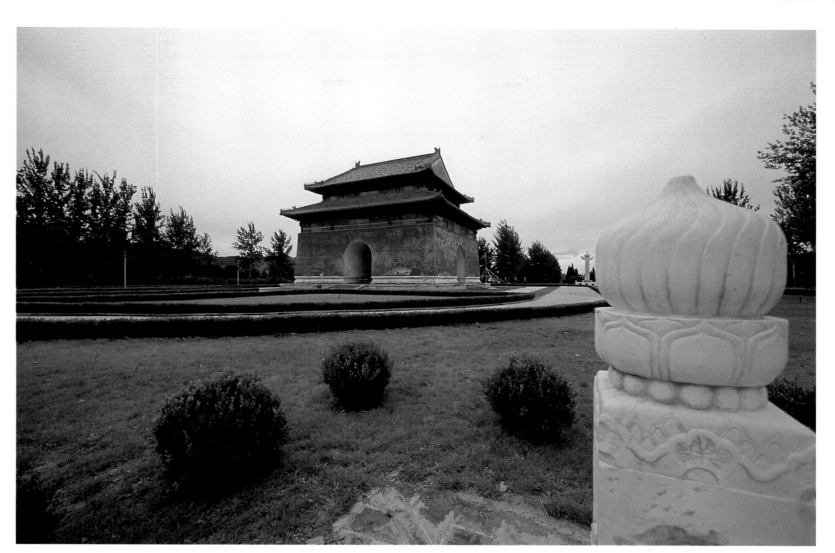

Pavilion marking the arrival of the Holy Way on the outskirts of Beijing.

A temple in Beijing, which encloses its garden with a low fence. The entrances to temples are emphasized.

Opposite: Pavilion in the Garden of the Humble Administrator in Suzhou surrounded by hundreds of bonsai.

Mythological Nature

Hong Kong

The English originally leased Hong Kong to set up a commercial base in a strategic position; they understood almost immediately, however, that the zone would never become a second India. As a result, the local populations cooperated, but there was never a real integration. In fact, Chinese culture prevented the island of Hong Kong, the peninsula of Kowloon, and the so-called new territories from becoming a real colony.

Today Victoria Peak dominates the Westernized center—the modern city of business—yet the Eastern influence is stronger; the temples, ideograms, and junks unequivocally betray their geographic position. While the elegant glass silhouette of Chinese-American architect I. M. Pei's skyscraper for the Bank of China stands over the city, it is surrounded by clan villages and ancient Chinese gardens. Arising next to the antique green spaces are modern parks designed by contemporary landscape architects; these inviting areas successfully link past and future.

Between the ancient and the modern gardens are a great number of eclectic ones, which have wedded tradition and innovation and thus contributed to the spread of new styles. Among these are the Aw Boon Haw, the garden of "tiger balm" and one of the most curious in the Far East. Populated by monsters, animals, grotesque masks, and mythological figures amid grottoes, brooks, and pavilions, it is a sort of Eastern Bomarzo, as fascinating as it is mythic.

A terrace-belvedere in the Aw Boon Haw Garden, the garden of "tiger balm."

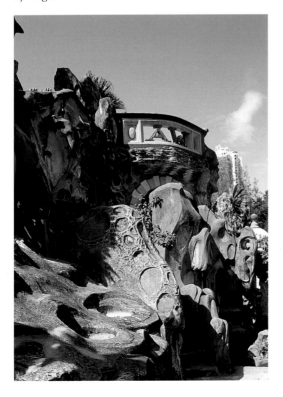

Hong Kong Park, a modern garden in the heart of the city.

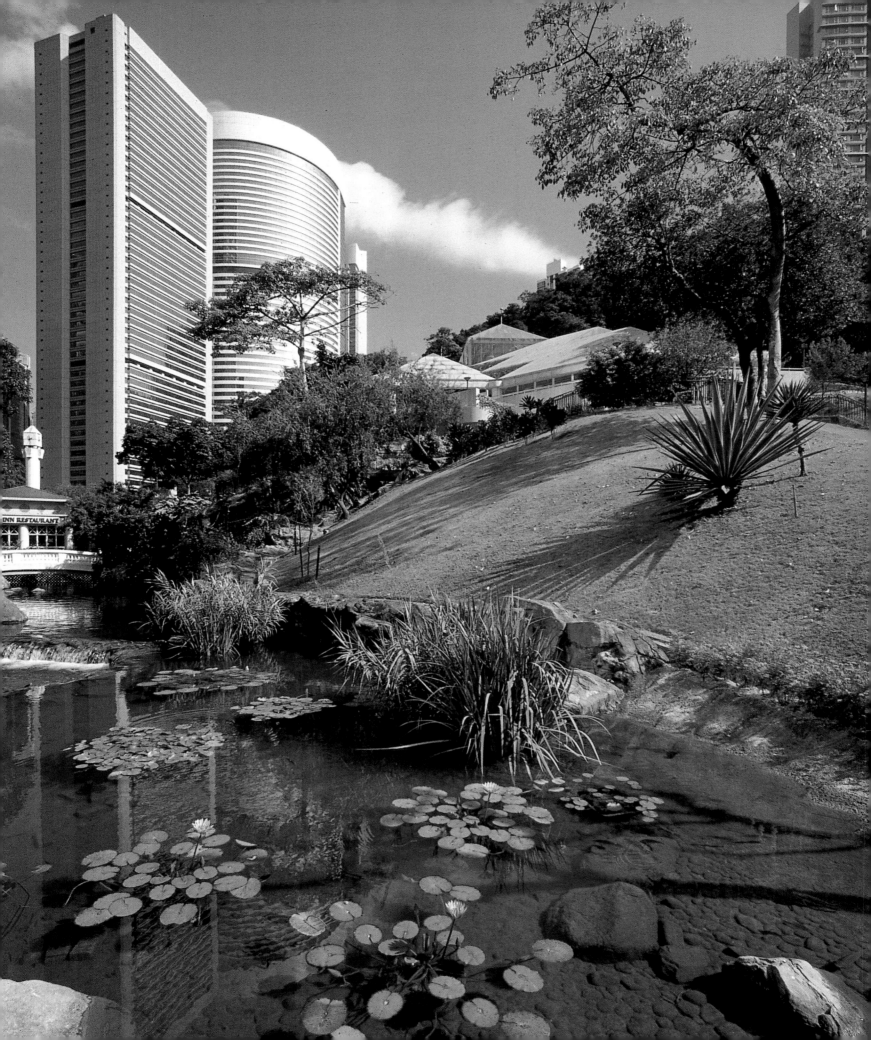

Sung Dynasty Village,
a recently restored
community where
the members of a
single clan lived. The
individual residences
are spread throughout
a garden.

An entrance to one of
the dwellings in the
Sung Dynasty Village.

Kowloon Walled City Park, which is rather articulated and opens onto a series of tree-lined courtyards.

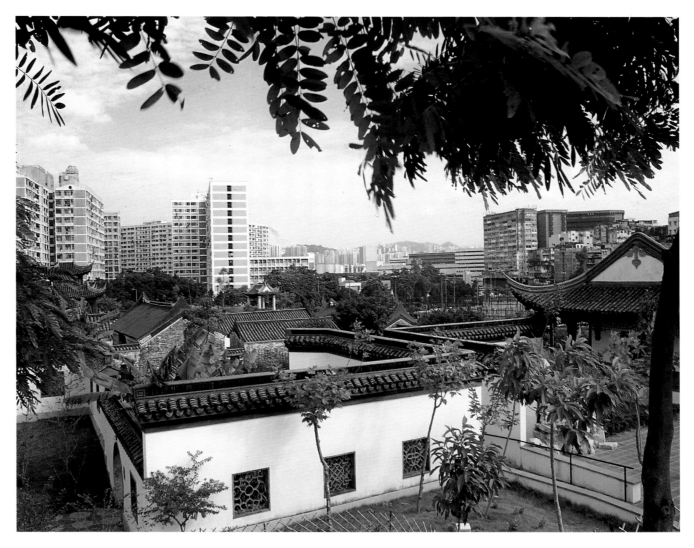

A divider between sectors of Kowloon Walled City Park.

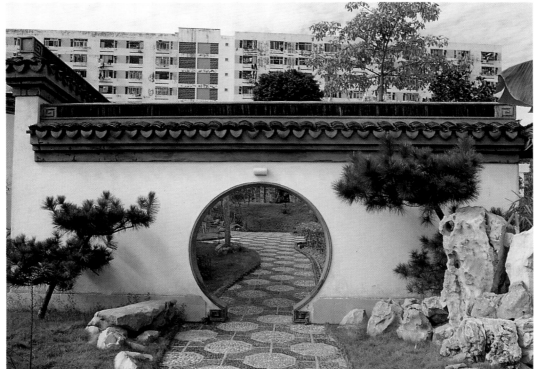

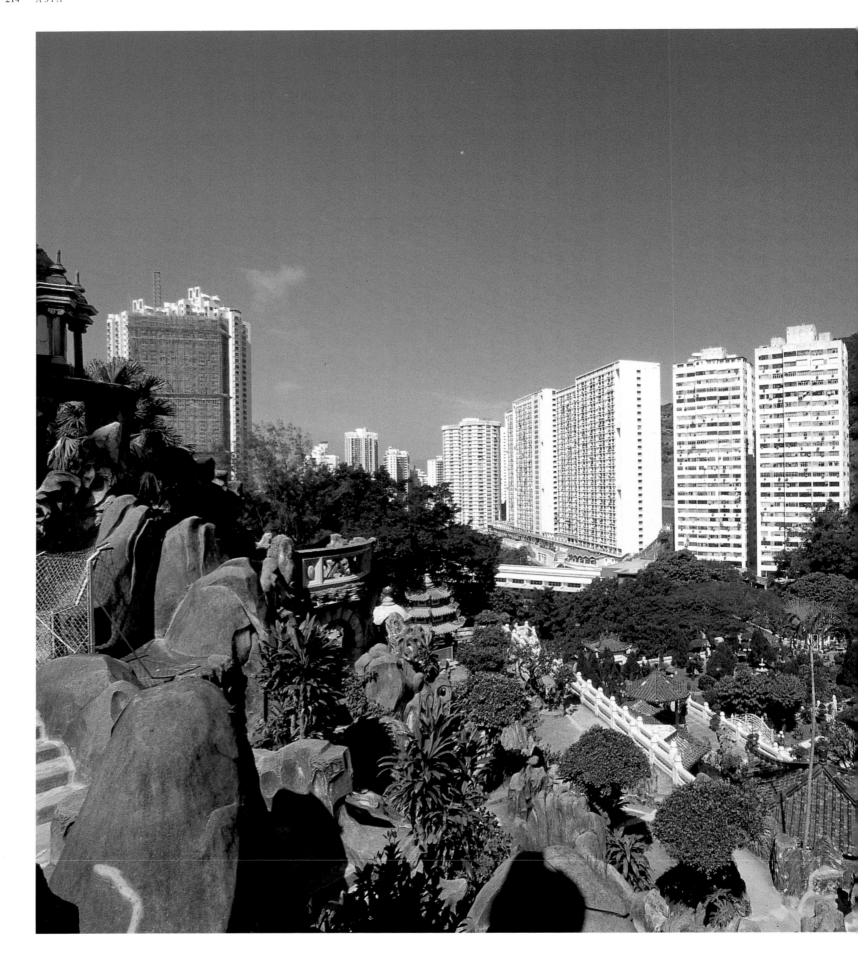

Aw Boon Haw Garden, once sheltered by a few hills and today surrounded by a city of skyscrapers.

Temples, balustrades, gazebos, and diverse plants in Aw Boon Haw Garden.

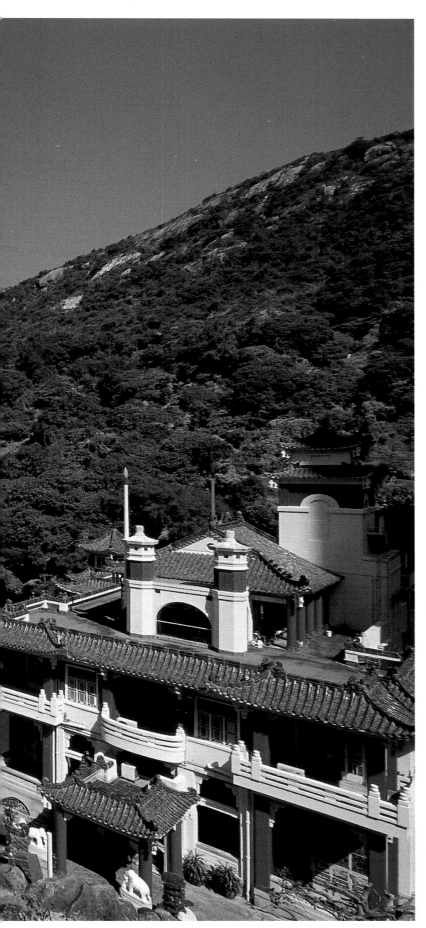

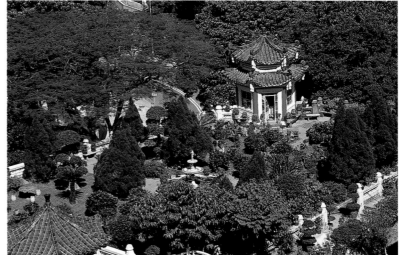

A contemporary sculpture in Kowloon Park.

To the East of Lisbon

Macau, along with Hong Kong the oldest Western colony in Asia, is also the richest. The small land consists of a peninsula—joined to China by the Portas do Cerco—and two islands, Taipa and Coloane, connected by a bridge; the population is a half million. Though small, Macau was so important as a base for Portuguese merchants and missionaries that both the Dutch and the English attempted to seize it; the English had to settle nearby Hong Kong to contest its commercial monopoly.

This prosperity led to the creation of beautiful Chinese and European residences framed by ample green spaces. The prevalent style of the gardens remains the indigenous one, although contacts with Europe brought a constant exchange of traditions and artisans. In the architecture and decoration, however, Portuguese taste can be distinguished almost exclusively.

A public park on Taipa, the residential island of the Portuguese colony.

A corner of Lou Lim Ieoc garden defined by a decorated wall.

Left and below: Passageways of various forms separating different areas in a Chinese-inspired garden.

The landscaped area of the Lou Lim Ieoc garden, where pleasant trails unwind in the dense vegetation.

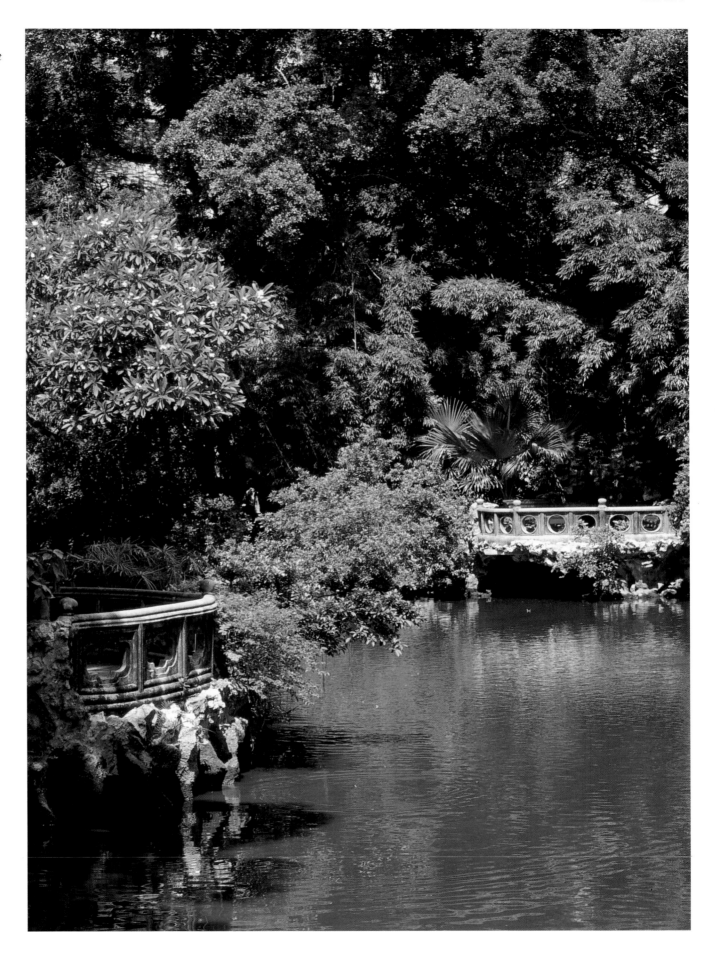

Morning Calm

Korea

*Korean garden
pavilions with
elaborate roofs.
Often the beams that
support them are
inlaid and embellished
with polychrome
decorations.*

Portals, pavilions, and gardens envelop the residences of aristocratic Koreans in an atmosphere of ritual and magic. Daily life, official tasks, and religious rites fuse in these places, far from the noise of the city and near the spiritual dimensions of Oriental culture. In the "land of the morning calm," the constant goal is interior peace; thus Koreans create pleasant green worlds where fantastic stories halfway between Taoism, Shamanism, and Confucianism flourish.

Stately dwellings, palaces, and temples are enclosed by high walls adorned with elegant Greek frets and other geometrical motifs. While a strong Chinese character is evident in the architecture, it was the English park with its alleys, pavilions, bridges, and gazebos that influenced the Korean garden. Only the handmade articles that populate such green spaces are of Chinese inspiration. And islands are a veritable leitmotif of Korean gardens. On the islands are small temples, or gazebos, or towers—or anything else that might justify a boat ride.

The gardens of Korea are much larger than their Chinese counterparts. They are often surrounded by woods, so much so that it is at times difficult to distinguish them, especially when fall leaves assume spectacular colors. It is remarkable that the Korean landscape, so far from Great Britain, is in respect to nature not so different.

*Decorative walls
surrounding a garden,
a tradition derived
from the Chinese
walled garden.*

A pavilion emerging
from the lake of
Anal-ji in Kyongju.

The monastery of
Suwon, an ensemble
of buildings in a
grand park.

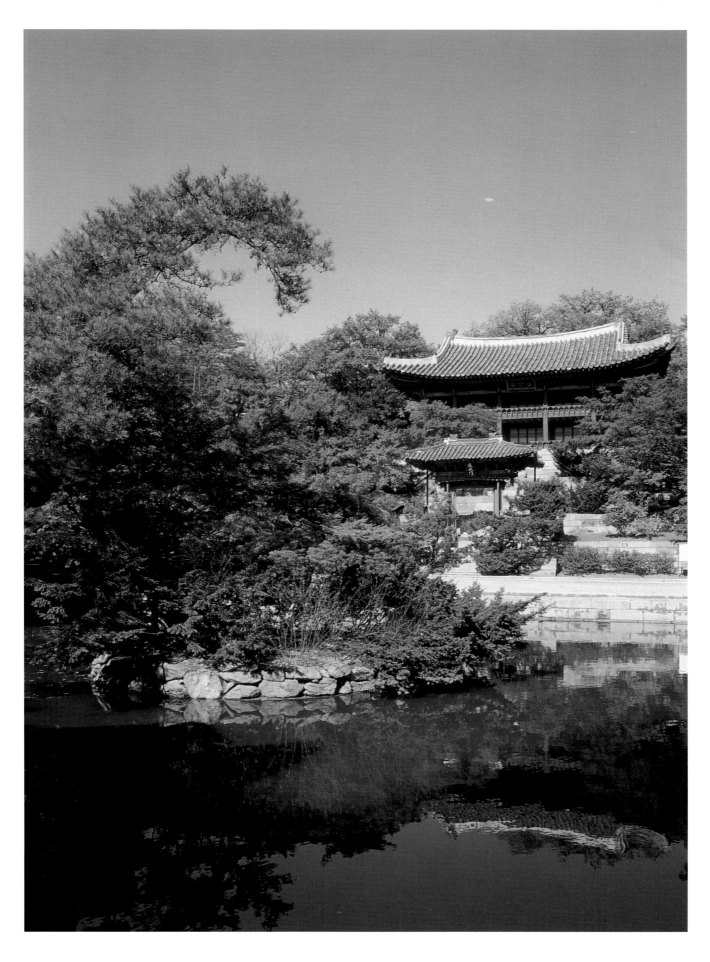

A small lake in the garden of Piwon in Seoul.

Zen Amenities

Below:
A sculpted stone along the edge of a lake. The composition was carefully planned.

Bottom:
A contemplation garden made of skillfully combed gravel.

Seasons, with their alternation of light and colors, have long characterized the sublime gardens of Japan. Generally three types can be distinguished: the garden with ponds, the contemplation garden, and the tea garden.

The first, also called *chitai,* is a garden of pleasure and consists of a pond encircled by paths. The space for contemplation is a dry garden (*karesansui*), that is, composed of pebbles, rocks, and white raked gravel. The *roji,* or tea garden, surrounds a pavilion for the ceremony dedicated to the preparation of tea. It is a landscaped area with ponds, brooks, stone paths, miniature woods, stone basins, lanterns, and other pavilions with sliding wood-and-rice-paper doors. Typical plants include willows, yews, pines, cherry trees, and bamboo; other elements are dwarf trees, aromatic herbs, sand, and water. It is not always possible to walk through Japanese gardens. In some areas, designed almost as a stage set, the illusion vanishes if a human figure enters. Thus many of the spaces are for observation only: from the garden pavilions, from the sliding doors, from the paths.

The *Sakuteiki,* the first book on Japanese gardens, dictates that the landscape architect must respect the conformation of the terrain, reinforce nature, recall earlier gardens by master designers, and re-create both the interior harmony of the new green space and that of the surrounding environment. Landscape architects continue to respect these rules, difficult though it may be. While the components of the Japanese garden are few, age-old traditions lead to green spaces of impressive composition and evocative power.

A pleasure garden composed around various paths.

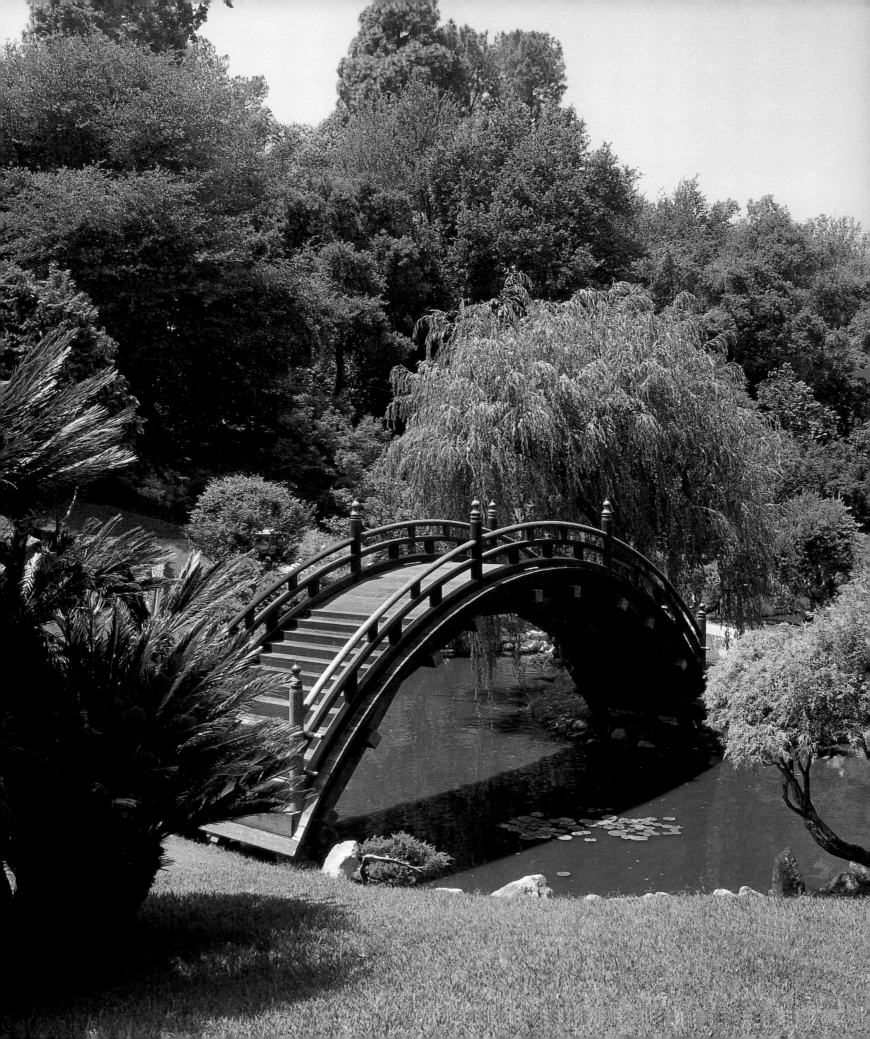

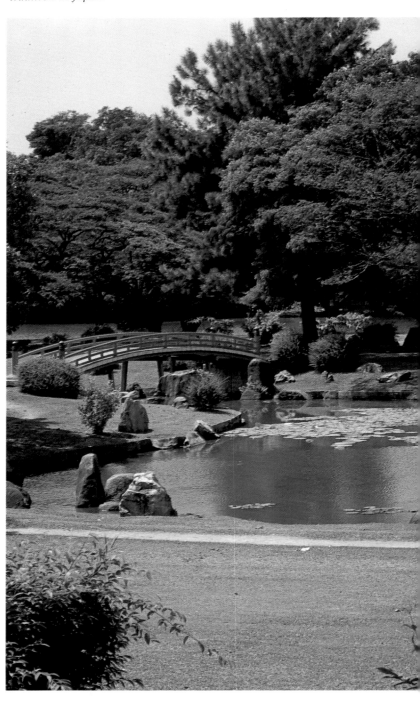

Bridges and islands in a Japanese garden. Both are recurring elements in the garden tradition in Japan.

Simple gardens walls, which often hide the beauty inside.

A summer residence in a park. On the side is a small contemplation garden, visible from inside the house.

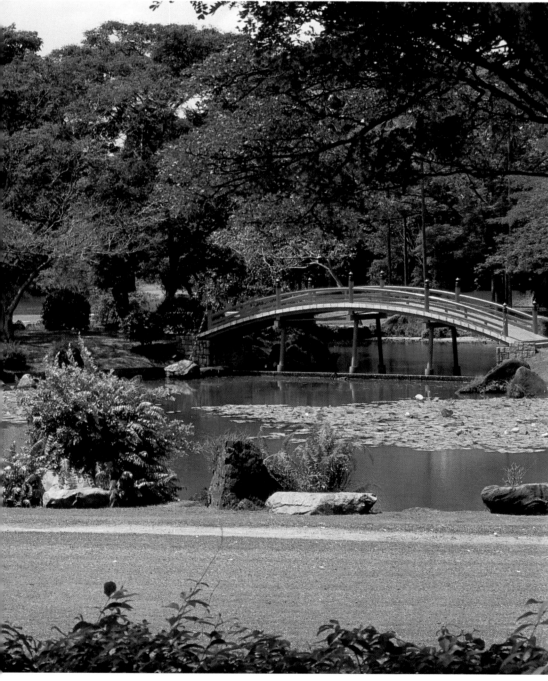

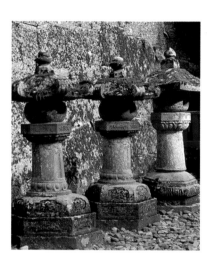

*Top:
Lanterns.*

*Above:
Balustrade on a bridge. Such details are essential in Japanese gardens.*

Island of China

The phrase *Bao Dao*—"island of treasure"—has long been used by the natives to refer to the island of Taiwan. It is fertile, characterized by mountains and also by ample valleys where camphor trees, cedars, bamboo, oaks, and pine and fir woods grow.

In former times, mandarins and others fleeing the intrigues and gossip of the populous court of the Forbidden City came to Taiwan. In the fifteenth and sixteenth centuries, the island was a port for pirates and unscrupulous merchants. Taiwan's prominent geographical position attracted the attention of the nearby Japanese, as well as that of the Dutch and Spanish, who in the sixteenth and seventeenth centuries constructed a number of forts. The Manchu threatened Taiwan in the mid-seventeenth century; the island was dominated by the Japanese from the end of the eighteenth century until 1945. And of course the English made Taiwan their destination.

Though Taiwan is a seaport, subject to foreign influence and control, it has always remained a bastion of Chinese values, traditions, and culture, especially when the island was the refuge of Chiang Kai-shek's nationalists. Yet the impact of the various European cultures that have visited Taiwan is evident in its gardens. Pools, obelisks, terraces, and *ars topiaria* mingle with the elements typical of the Chinese garden in an unusual and fascinating mélange.

Chiang Kai-shek Memorial Hall in the center of Taipei, surrounded by a garden and a lake.

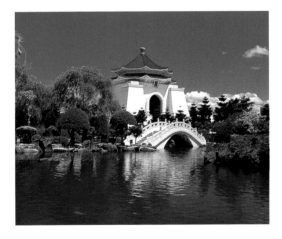

Water courses, bridges, and fountains immersed in the luxuriant vegetation that characterizes the island.

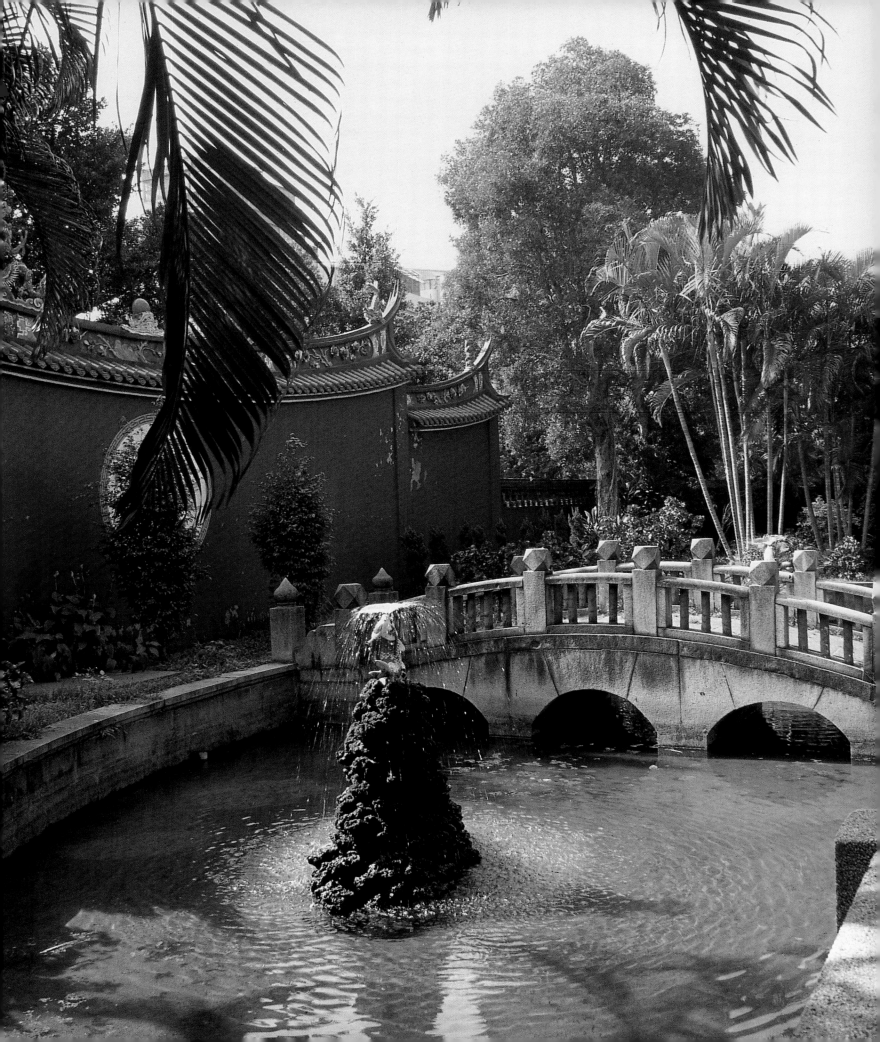

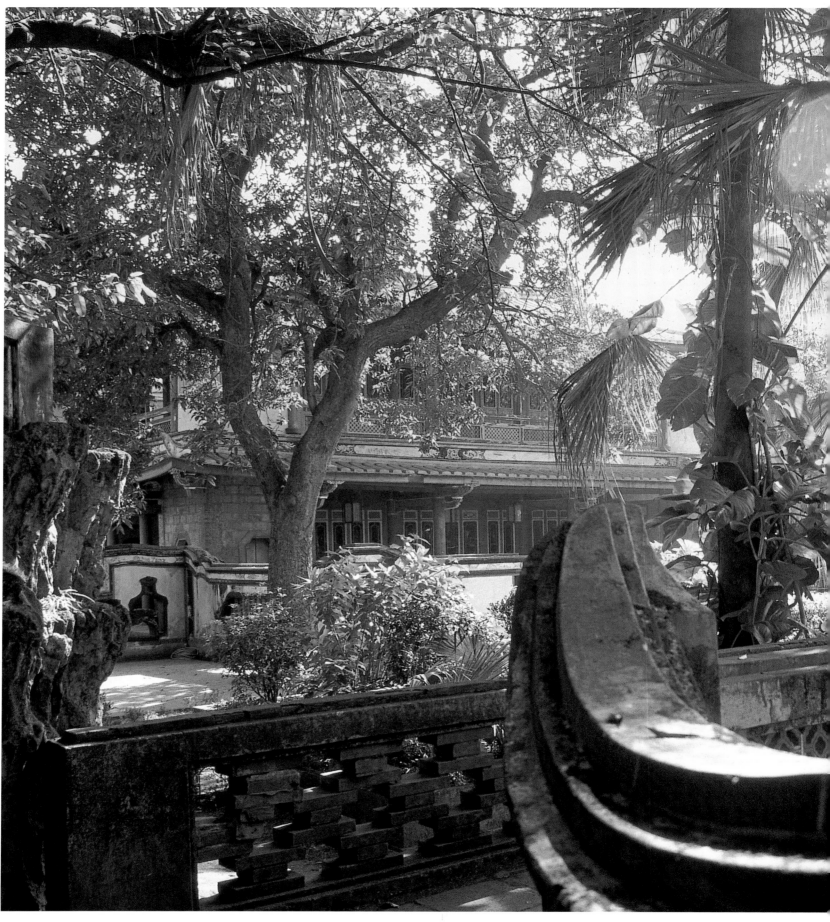

The Lin family garden in Taipei, which is distinguished by pavilions, gazebos, bridges, and little walls alternating with tall trees.

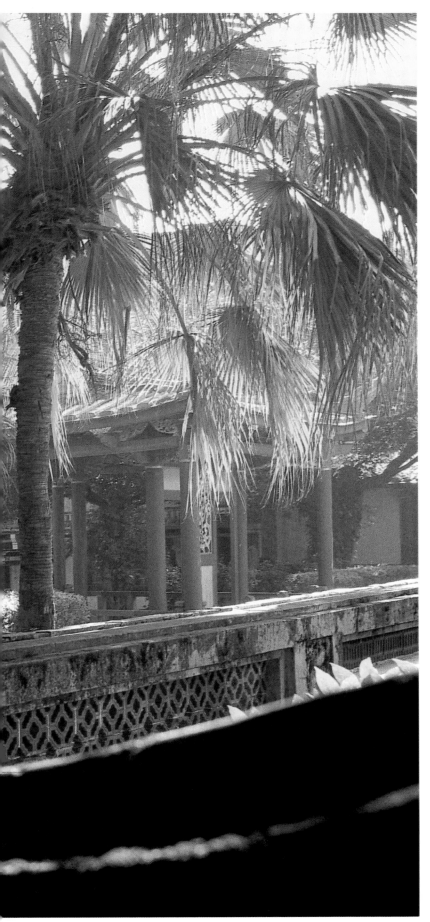

A "transparent" butterfly decoration on a divider between two areas of the garden of the Lin family.

Simple materials
creating effective
chromatic contrasts in
the Lin family garden.

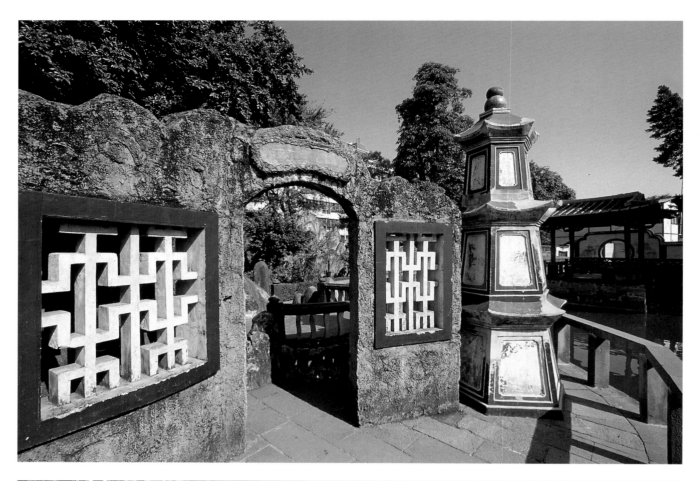

Pool covered with
dense vegetation in
the Lin family garden.
European influences
on the garden are
evident in such
elements.

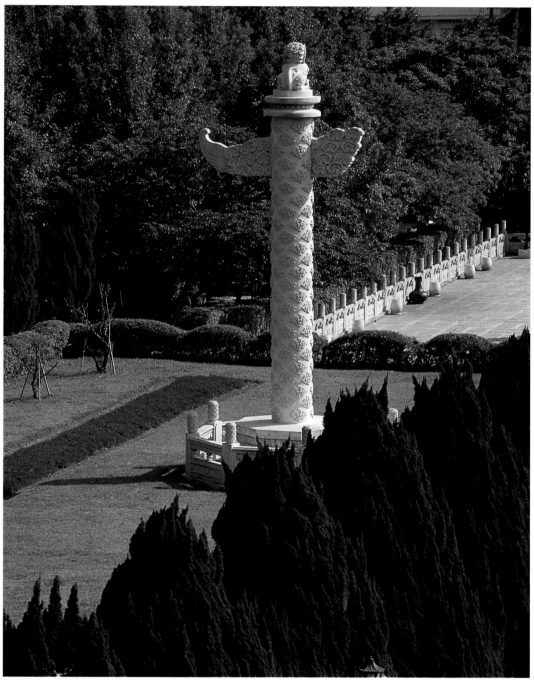

A totem in the center of the spacious park in which is located the National Museum.

The fort of Santo Domingo, built by the Portuguese in the 1700s. Located in a strategic position on top of a hill surrounded by a dense park, the fort is one of the few colonial testimonials.

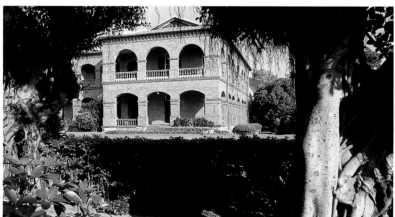

Under the Sign of Ayutthaya

An area outside Bangkok with reproductions of important pieces of Southeast Asian art. A miniature copy of the temple of Angkor Wat in Cambodia is reproduced on a stairway.

The ancient land of Siam is a populous multiethnic kingdom composed of Chinese, Malaysians, Indians, Khmer, and the indigenous inhabitants; such a heritage has greatly enriched the local art and culture.

The importance of Thailand is due to its fortunate location. European fleets heading to China and Japan awaited favorable winds in its harbors, and local commerce prospered: indigenous merchants offered silver ingots, silk, and porcelain in exchange for leather, teak, tin, and sugar. The English and the French, during their periods of colonial expansion, visited the ancient capital Ayutthaya, which, together with Melaka in Malaysia, was one of the symbolic centers of Southeast Asia. The constant movements of people from various European countries and from India and the Orient made of the country a crossroads of diverse cultures and styles with a cosmopolitan atmosphere.

Spacious volutes, arched roofs and fanciful peaks, pile structures and precious wood inlay characterize Thai residences. Stately houses of the past and the present gather small masterpieces of art, rather like a precious jewelry box. But it is the green spaces around the dwellings that are perhaps the most charming. Basins, fountains, ponds covered with aquatic plants as well as palms and other tall trees create compositions of an indefinite style that are carefully integrated with the lush natural vegetation of the country. It is difficult to distinguish the influence of one style as opposed to any other. Because Thailand has remained independent, its landscape designers and theorists have been able to develop an artistic—and fruitful—freedom of expression.

A lake of waterlilies surrounding several temples in a park in Bangkok.

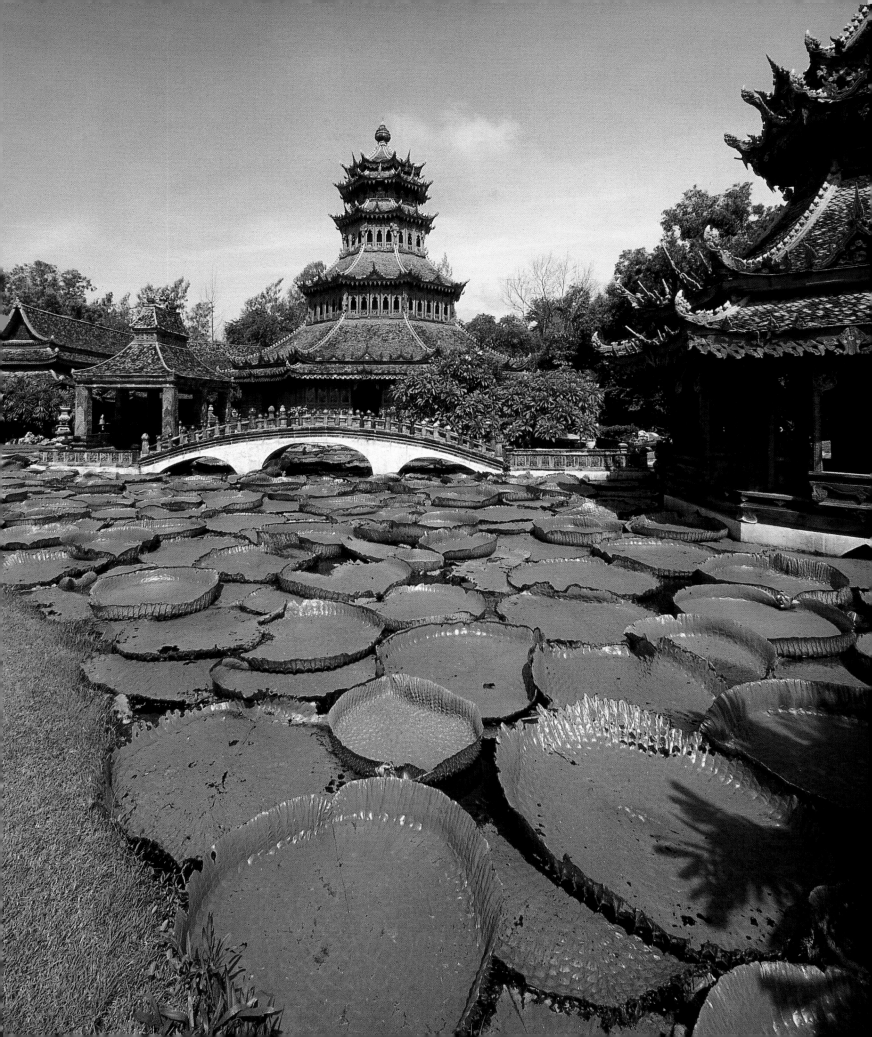

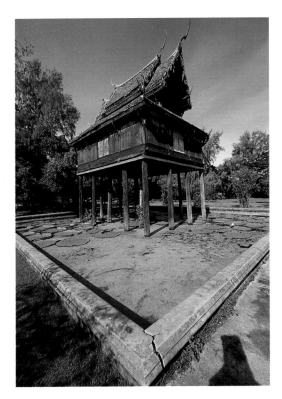

Traditional Thai
dwelling, in which
a single room on stilts
is crowned by the
classic double roof.

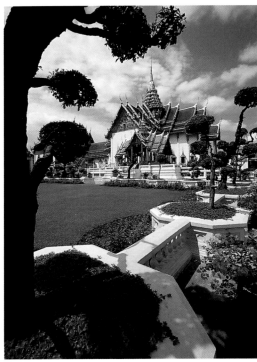

Complex geometric
hedges and walls
enclosing the royal
palaces of Bangkok.

Palms and other tropical plants around a lake in a Phuket resort.

Park dedicated to Rama II on the sea in the south of the country. Rama II built the park around a vast resort composed of pavilions united by parapet walks.

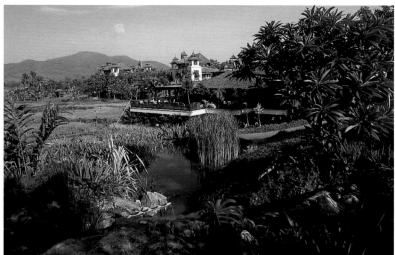

The garden of the Regent Resort in Chiang Mai among surrounding rice paddies.

Overleaf: The Regent Resort in Chiang Mai, which is composed of small villas in the midst of green space.

The Colors of Melaka

A feeling of welcome is expressed everywhere in this rich land, from Penang to Melaka to Johor Baharu, just a short distance from Singapore. The port of Melaka, one of the first commercial ports in Southeast Asia, was used even before a city existed, when Indian merchants—in the first centuries C.E.—landed there to purchase gold, spices, and aromatic woods. The site was strategically located at the meeting point between the northeast and southwest monsoons and so could serve numerous navigational routes.

The first to control the territory around Melaka were the Indians, who stopped there en route to China; later came Chinese occupiers (the Chinese community remains one of the most populous) and then, in the sixteenth century, when the city had just been founded, the Portuguese. The architecture was typically indigenous, and the arrival of the Dutch in the seventeenth century did not change the city much. It was only with the English in the eighteenth century that an urban planning and construction campaign was undertaken. In the nineteenth century, the East India Company prospered; the combination of foreigners and locals was important not just politically and economically but culturally, provoking a metamorphosis in Malaysian architecture and gardens.

Rain is abundant in the country, the climate is hot all year, and the vegetation is, to say the least, luxuriant; thus the traditional concept of gardens is confused with nature: beautiful and lush with abundant fruit. For this reason a true indigenous tradition does not exist. Instead, the arrival of the English and the concept of the picturesque stimulated landscape architects to mediate between construction and environment with designed greenery.

Nevertheless, the quality of the "natural" plant life surrounding stately Malaysian dwellings—an equatorial jungle slightly domesticated but almost uncontrollable—is surprising. Local styles, materials, and customs have been intertwined with European influences, especially the British picturesque tradition, to give life to eclectic yet assured compositions.

A fountain in the center of a parterre *in Kuala Lumpur.*

A regal colonial dwelling on the island of Penang, in the north of Malaysia. A dense landscaped park surrounding it honors the birthplace of the owners.

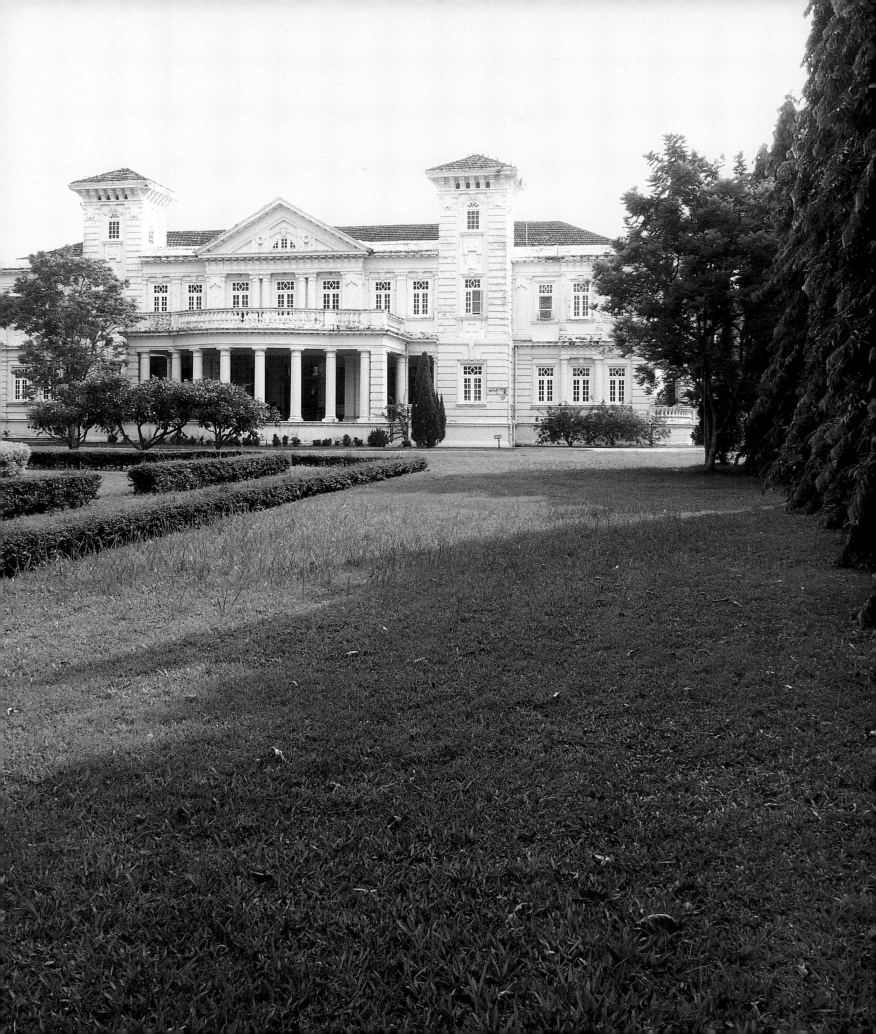

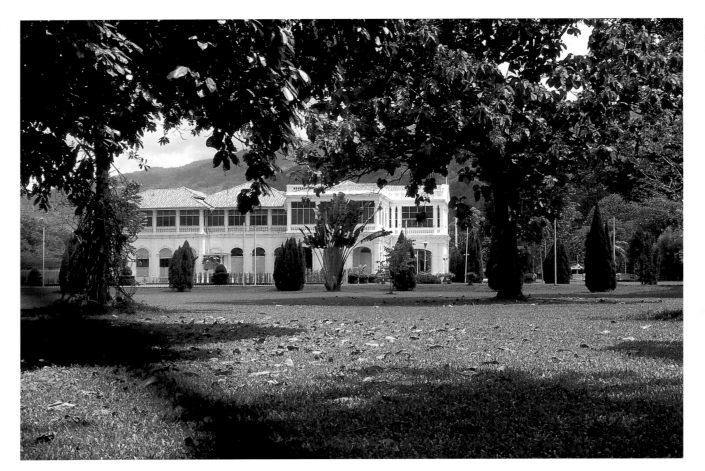

A colonial dwelling in Penang surrounded by a romantic park.

A spacious parterre, clearly of European inspiration, in a garden in Kuala Lumpur.

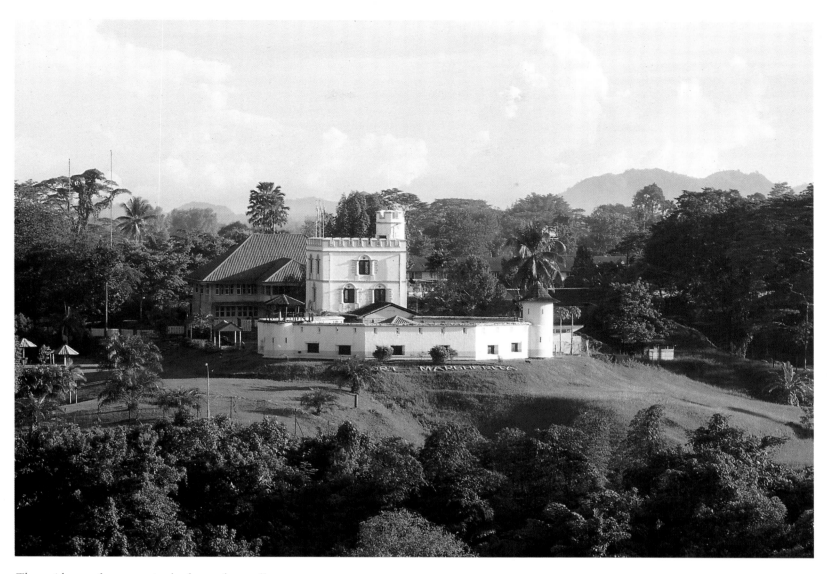

The residence of
the sultan of Johor
Baharu, built in the
nineteenth century

in the form of a small
fort. It is located in a
grassy clearing in the
tropical forest.

Below left:
The dense garden of a
Portuguese residence
in Melaka.

Below:
Two traditional wood
dwellings atop pilotis
in Seremban.

The Garden State

When Stamford Raffles, an officer with the East India Company, arrived on Singapore in 1819, nothing existed but the sultan's residence and a modest fishing village. But within a few years an urban plan was designed and Singapore became an important commercial base. The English and the Chinese, as well as other Europeans and Malaysians, settled in the new colony. The terrain lent itself to division in lots, and the residences of the new merchants arose on small hills of five to ten hectares each. Outside the center were coconut and sugarcane plantations; the owners' dwellings were constructed to get the best ventilation, usually in an elevated location in the center of the property.

Whether in or outside of the city, the houses always had surrounding gardens. European green spaces were usually landscaped, whereas those of the Chinese were more geometric and often enclosed. Tall trees, including ketapang (*Terminalia*), rhu (*Casuarina equisetifolia*), tembesu (*Fagraea fragrans*), and angsana (*Pterocarpus indicus*), were especially luxuriant, due to the hot and humid climate, as was Singapore's jungle, often delimited only by tall bamboo and bunches of bunga raya (*Hibiscus rosa-sineusis*). Within the garden were vast lawns with birdcages, gazebos, and tennis courts.

The public drives leading to the stately residences often came right up to the entrance and formed a vehicle turnaround. This element was an important part of the landscape scheme and was embellished with flowers, trees (kept low to avoid blocking the view of the house), and fountains. On occasion sheep and Arabian horses roamed freely. The colonial residences form pleasant interludes in contemporary Singapore; although the city is dominated by skyscrapers, the attention and passion for greenery has remained intact.

A small jungle reproduced in the interior court of the Shangri-La Hotel.

A paved path in a tropical garden. The hot and humid climate allows many plants to grow easily.

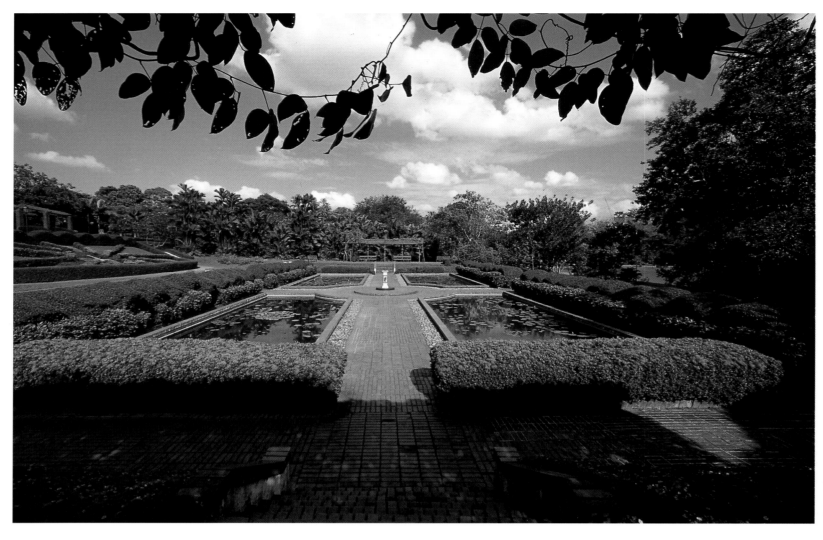

The parterre *in the Botanic Gardens. Two paths cross to form four pools for various aquatic plants.*

A gazebo in the center of a clearing in the Botanic Gardens.

A house built on Orchard Road after the city was founded.

The Botanic Gardens, which both collects the many and varied plants and uses them in garden compositions.

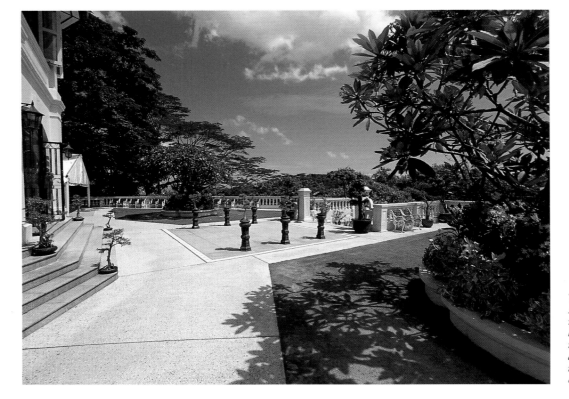

The garden in front of Alkaff House. The residence, built on a hill at the end of the nineteenth century for a wealthy Armenian merchant, today contains a restaurant.

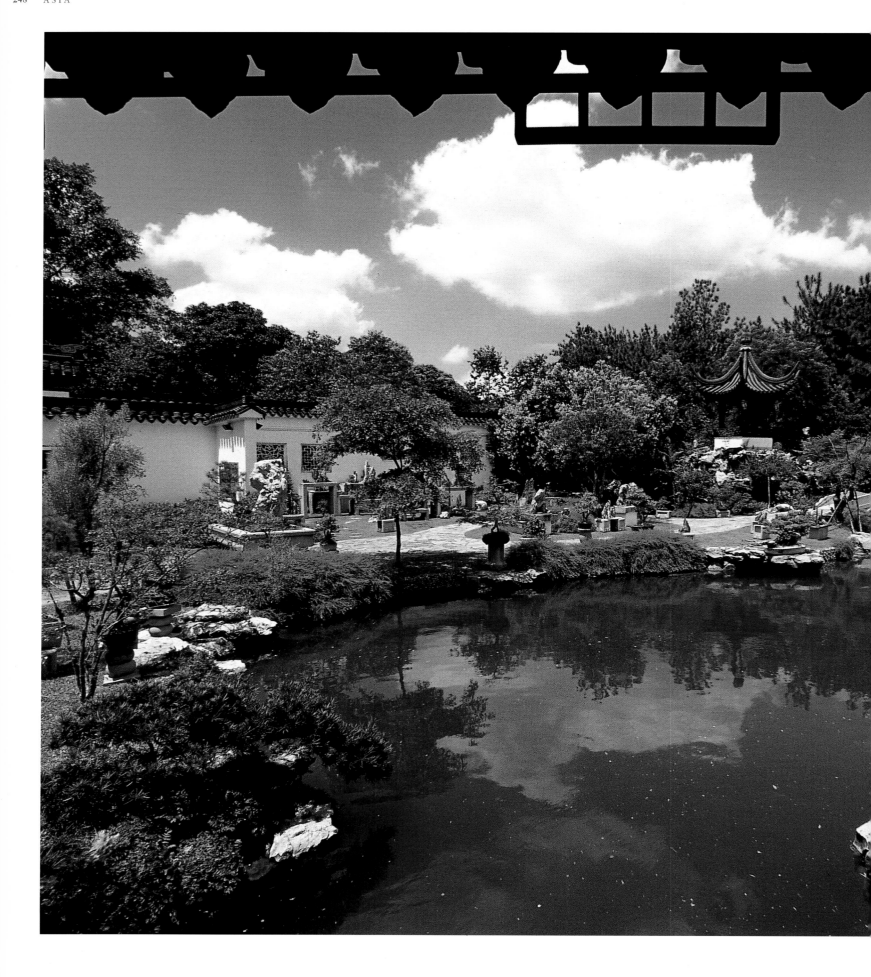

The grand Chinese Garden, which is in the middle of a spacious park that also has a tower-belvedere and a small Japanese garden.

The garden of the historic Raffles Hotel.

Amid the Sacred and the Profane

The early civilization of the Indonesian archipelago, one of the most vast in the East, was strongly influenced about the second century C.E. by models brought by Indian navigators. The famous temples of Borobudur and Prambanan, built in the eighth and ninth centuries, represent a fundamental moment in the fusion of Indian and indigenous art, which afterward would become ever more original and autonomous. The cities founded were open, with a lot of greenery: coconut palms, bananas, and vast vegetable gardens between the buildings, which were for the most part made of wood.

Indonesia changed very little, even during the period of Portuguese dominance in the 1500s, until the Dutch arrived at the end of the sixteenth century. The Dutch immediately understood the economic potential of these lands and as early as 1602 founded the East India Company, which would play an important role in the development of Indonesia. The building typologies dominant when the Dutch arrived—still widely used outside the urban areas—varied at least as much as the different islands. Clan groups live in small "villages" with an open hut (used as a common living area) at the center. The communities, walled and embellished with gardens, are surrounded by vegetation for both beauty and privacy.

The green spaces of Indonesia are found not only in family villages but also in royal ones and around temples. At the eastern end of Bali, at the foot of Mount Seraya, a few miles from the sea, arises the city of Karangasem, once the capital of one of the major Balinese kingdoms. After the Dutch conquest, that king was the only one to remain in power, dedicating himself to commerce with the Dutch and building some of the most interesting palaces on the island.

One of these palaces, Tirtagangga ("water from the Ganges"), is about ten miles north of the city near a sacred fountain and a temple. The country residence is simple and sober, but the garden unfolds on three levels, each organized on a terrace with large pools connected by canals and falls. The grand basin at the lowest level features a long narrow island with various round pools and, in the center, jets of water. Elegant stone balustrades line the rigidly geometric paths in the garden, and animals, also made of stone, animate the pools with small streams of water. The peaceful garden, one of the most striking in Bali, is just one of many in the Indonesian archipelago that have survived for centuries.

The garden of a family village in Ubud, in the center of Bali.

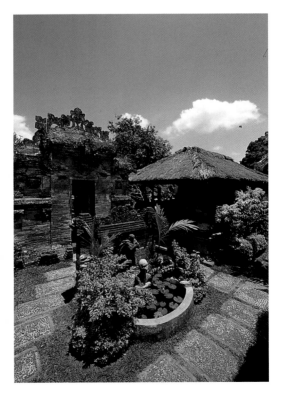

A paved and winding path across a temple garden in the small city of Tabanan in Bali.

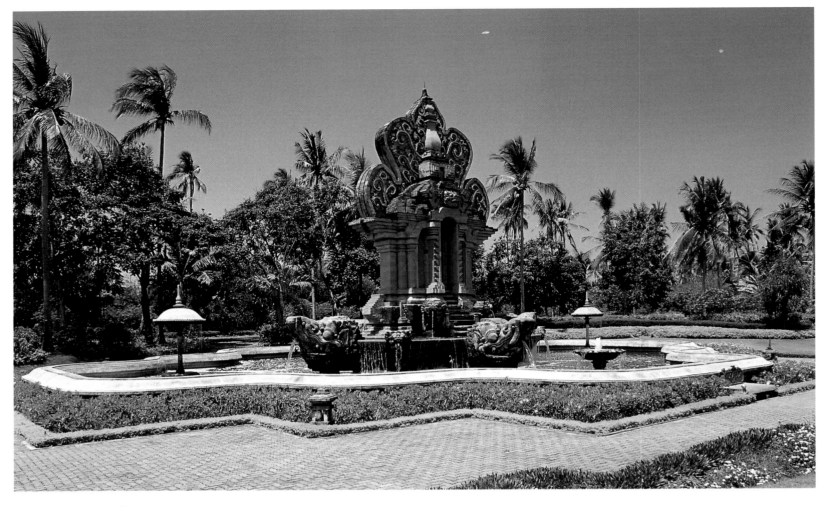

The Nusa Dua Hotel,
one of the grand
resorts of Bali. Its
garden comprises
numerous pools and
portals, including one
that welcomes guests
as soon as they enter
the access drive.

Right:
The Suranadi Hotel
on Lombok, a small
island next to Bali.
Formerly a residence,
the structure is still
at the heart of a
luxuriant green space.

Far right:
A doorway of the
temple of Kungklung
on Bali. In front of
it extends a parterre
where different types
of grass design
variously colored
chessboards.

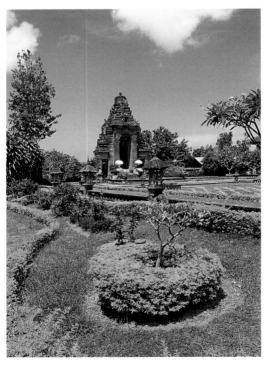

A zoomorphic stone fountain in the garden of Tirtagangga in Bali, erected in front of a royal residence that is today open to the public.

The garden of Tirtagangga, one of the most elaborate in Bali. The various terraces, pools, and plays of water recall the Western garden developed in the seventeenth and eighteenth centuries.

Myristica fragrans

Cocos nucifera

Top:
Vanda miss
joaquim

Above:
Tristellatia
australiasiae

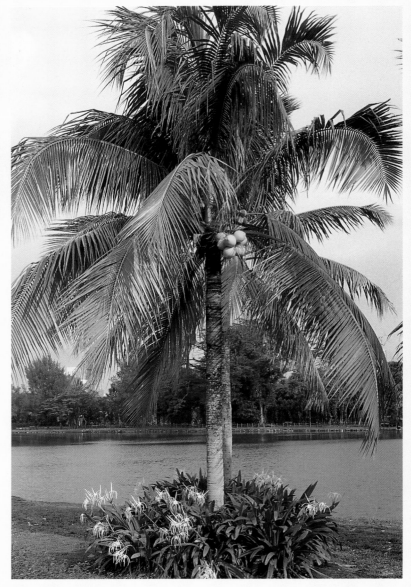

Cyrtostachys renda

FLOWERS AND PLANTS OF INDOCHINA

An area of interchange between tropical Indian vegetation and equatorial Indonesian vegetation, the Indo-Chinese region boasts seventeen thousand species of plants. It is difficult to render a precise climatic division of the territory due to both its length and the influence of the monsoons.

The latitude is undoubtedly important; the alternation of the seasons in the northern part of Indochina contrasts with the climatic uniformity of the Malaysian peninsula, where—thanks to constant temperatures and abundant rains year round—a luxurious equatorial evergreen forest rich in creepers, epiphyte plants, and dense undergrowth grows. Among the characteristic plant species are dipterocarpaceous trees, extremely tall plants that bloom simultaneously in groups once or twice every ten years. Also in this zone are *Myristica fragrans*, whose seed produces nutmeg, *Eugenia caryophyllata*, whose dried flower buds yield cloves, the guava *Psidium guajava*, which belongs to the myrtaceous family (as do the previous species), and ginger *Zingiber officinalis*, a common ingredient in Oriental cuisine. Climbing shrubs include *Strychnos nux-vomica*, pepper *Piper nigrum*, the malpighiacea *Tristellatia australiasiae*, and the unique thorny palms that produce rattan. Also indigenous to Southeast Asia are the coconut palm *Cocos nucifera* and the sealing wax palm *Cyrtostachys renda* with its characteristic basal red leaves. Mangrove formations, with aerial roots called pneumatophores, populate the inhospitable salty coastal swamps.

In the northern part of Indochina, in the heart of a tropical monsoonal climate, to the west is a zone where the rainy season lasts from April to November and to the east is a zone where the wet season begins in November and ends in February. A tropical forest with deciduous species prospers

Left:
Nelumbo nucifera

Below left:
Saraca indica

Far left:
Nelumbo nucifera

Left:
Delonix regia

Psidium guajava

Eugenia caryophyllata

*Musacca of the
Heliconia type*

Heliconia

in the more humid area, while a kind of savannah with bushy and prickly forestal formations develops in the drier section. The tropical forests of Burma, Laos, Thailand, and Cambodia—composed of an arboreal strip of deciduous plants and an inferior strip of evergreens—are dominated by the famous *Tectona grandis,* or teak tree, and by such species as *Dipterocarpus tuburculatus, Shorea obtusa,* and *Diospyros burmanica,* which are replaced, in the drier zone, by bunches of bamboo. In less humid zones are the plants *Fraxinus* and *Ulmus.*

A cradle of agriculture, Southeast Asia is the producer of many edible plants: the mango *Mangifera indica,* the banana *Musa paradisiaca,* and the durian *Durio zibethinus.* Woody plants include *Dalbergia,* the source of rosewood, *Diospyros,* the source of ebony, and various species of the *Pentace* family. Among the colorful flowers are the orchid *Vanda miss joaquim,* the legumes *Delonix regia* and *Saraca indica,* the cultivated musaseae of the genus *Heliconia* with its extremely elegant blossoms, and the sacred lotus *Nelumbo nucifera,* splendid nymphaeacea with many edible parts.

Longing for Europe

The islands of the Philippines are numerous, over seven thousand, almost all of them quite small. Luzon, where Manila lies, is the largest and most important. Among the countries of the Far East, the Philippines is perhaps the most Western. Much of its architecture is European, and the artistic expression is a fusion between European precedents and local tradition.

Outside the capital are plantations, especially coconut plantations, which epitomize the blending of the cultures. Villa Escudero, for example, to the south of Manila, features a vast formal garden between the street and the residence. The design is classically Italian, but the plants are different; the blinding white of the objects that emphasize the design and the palms that delineate the boundaries are also indigenous rather than European elements.

The tradition of gardens is important not only on the plantations but in the Intramuros area, the historic center of Manila. Among neoclassical buildings, antique and modern and surrounded by spacious porticoes in wood, are shady, fragrant green spaces, which both enlivened the life of the early colonists and recalled their home countries.

A corner of the garden in the city residence of the Toda family, in a residential quarter of Manila.

The main house on the private island Ermana Mayor, on the west coast of Luzon, and the surrounding gardens.

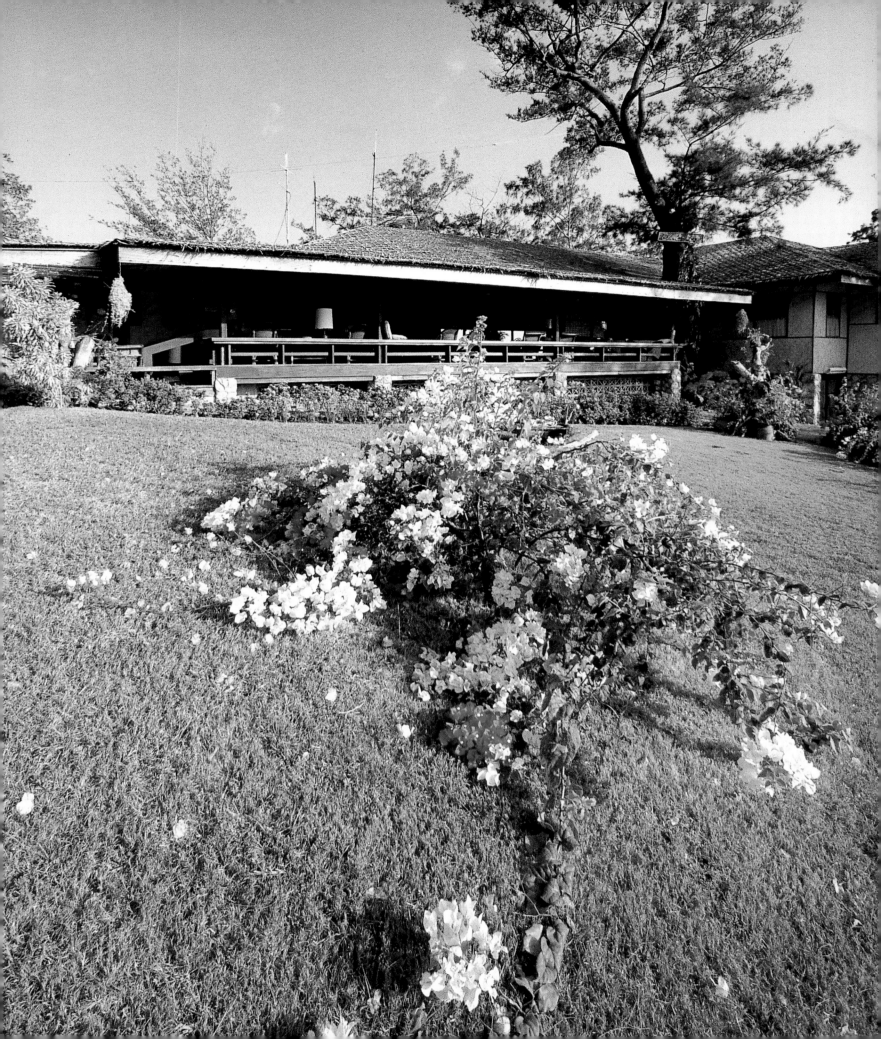

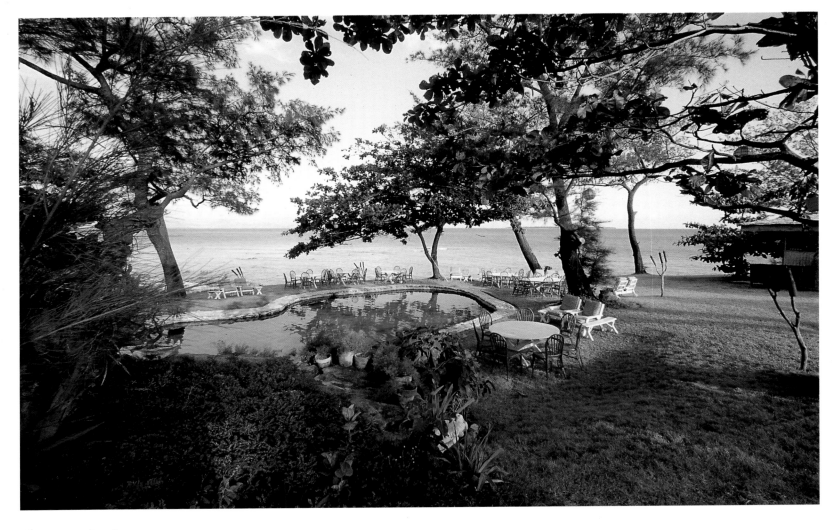

The stone swimming pool of the main house on the island of Ermana Mayor.

The island of Ermana Mayor and the garden around the main residence. A mango plantation surrounds the site.

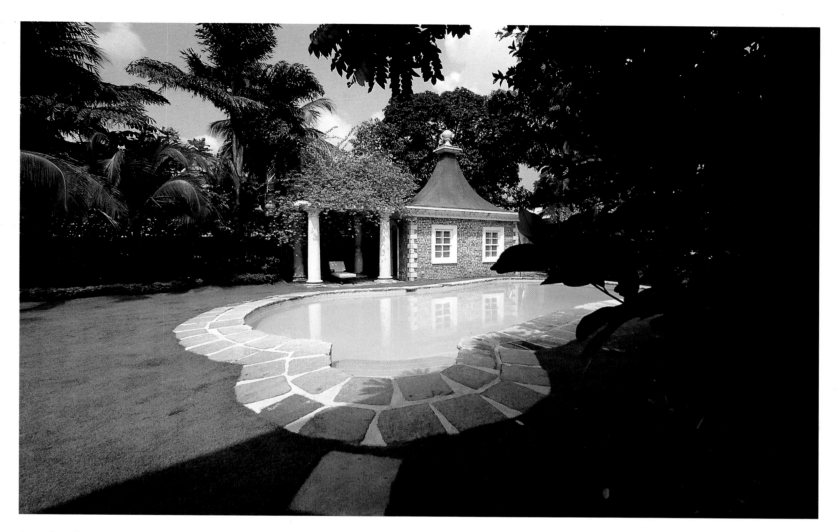

*A pool in the
luxuriant garden
of the Virata house
in Manila.*

*The coconut palms
leading to the formal
garden in front of
the main house of
the vast Escudero
plantation. The
buildings and gardens
were inspired by
European garden
culture and adapted
for the climate and
the local vegetation.*

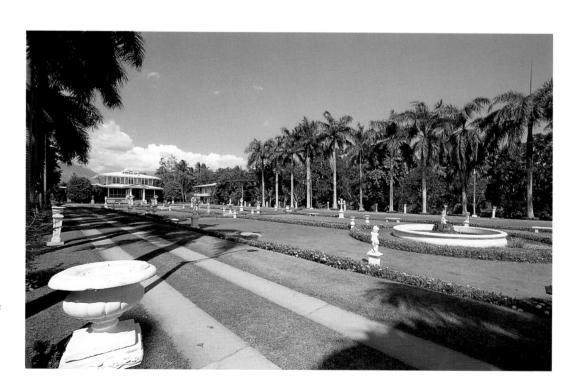

A myriad of islands adrift in the immensity of the largest ocean—these are the lands of Oceania, separated by geography and history. The islands of Oceania have not had a great impact on the history of the ancient and modern garden but do offer fascinating green spaces.

For the most part, garden traditions have been imported, both for their forms and their plant species. Landscaped Anglo-Saxon green spaces, where geometric forms have been reduced to the minimum, are predominant; closer to the Equator, natural forms, more luxuriant and varied, are equally present. In addition, certain gardens, inventive, artistic, and freed from the debt of history, transform the islands into open air museums.

Gold in the Garden

Australia

In about 1817, Edward Hargraves, an Australian who had participated in the race for gold in California, discovered the precious mineral near Sydney. The discovery galvanized development in Australia, especially when gold was found on several other sites. Land prices rapidly tripled, and the countryside was transformed into what appeared to be the surface of the moon, full of holes, craters, and piles of refuse. Fortunes as sudden as they were ephemeral were made and lost, and gold miners became famous for their excesses.

Nevertheless, the epoch was fruitful: it provoked a marked population increase as well as the development of a national Australian identity. Many people invested their enormous new wealth in property and real estate. The miners, for instance, built houses that were sometimes curious and occasionally grotesque but often elegant and refined. Materials were combined in unusual ways to give life to new and picturesque solutions. Local stone, used for buildings and gardens, almost exclusively English in style, represented the continuation of the extraordinarily lush surrounding vegetation. Greenhouses, temples, gazebos, fountains, and sundials contributed to the decidedly romantic atmosphere of the new gardens. Many of these green spaces—sited in the incomparable Australian countryside, observed by kangaroos, and today open to tourists—represent oases where a particular time has stopped.

Preceding pages:
The garden of the
Coolah Creek farm
in Pandora, near
Beaudesert, and its
Moorish-inspired
portico.

Below:
The landscaped
garden surrounding
the Coolah Creek
farm, one of the
largest in the hinter-
land of Brisbane.

A bench beneath
a giant tree in the
Coolah Creek farm.

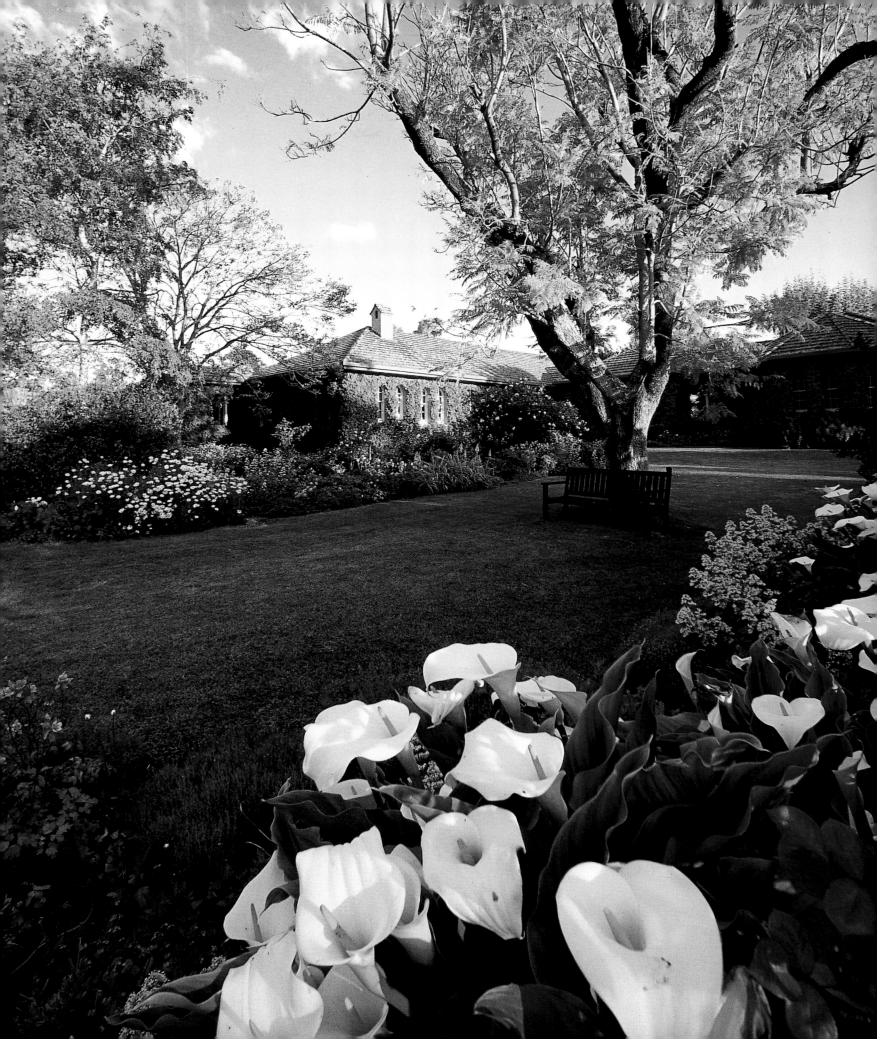

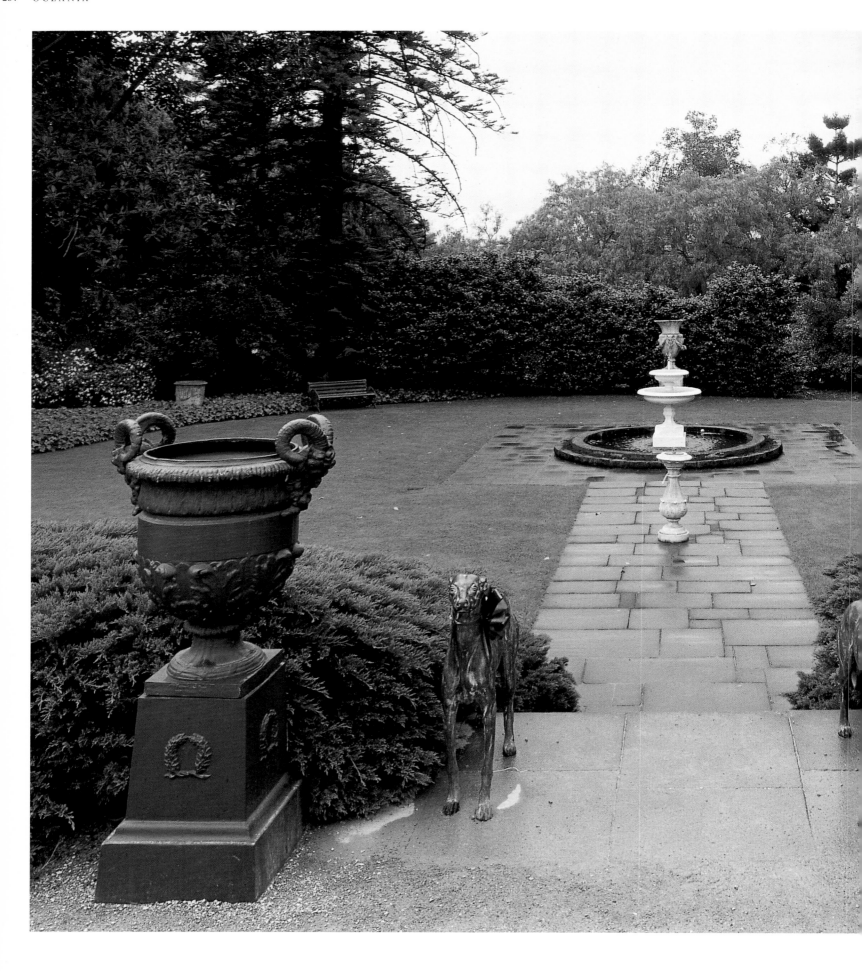

The formal gardens of
Como House in
Melbourne, an eclectic
residence built in the
nineteenth century.

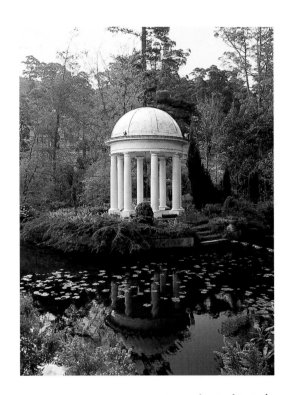

A neoclassical temple
in one of the romantic
gardens in the state
of Victoria.

The simple garden of Smithfield House in Toowoomba, to the west of Brisbane, an old aboriginal settlement.

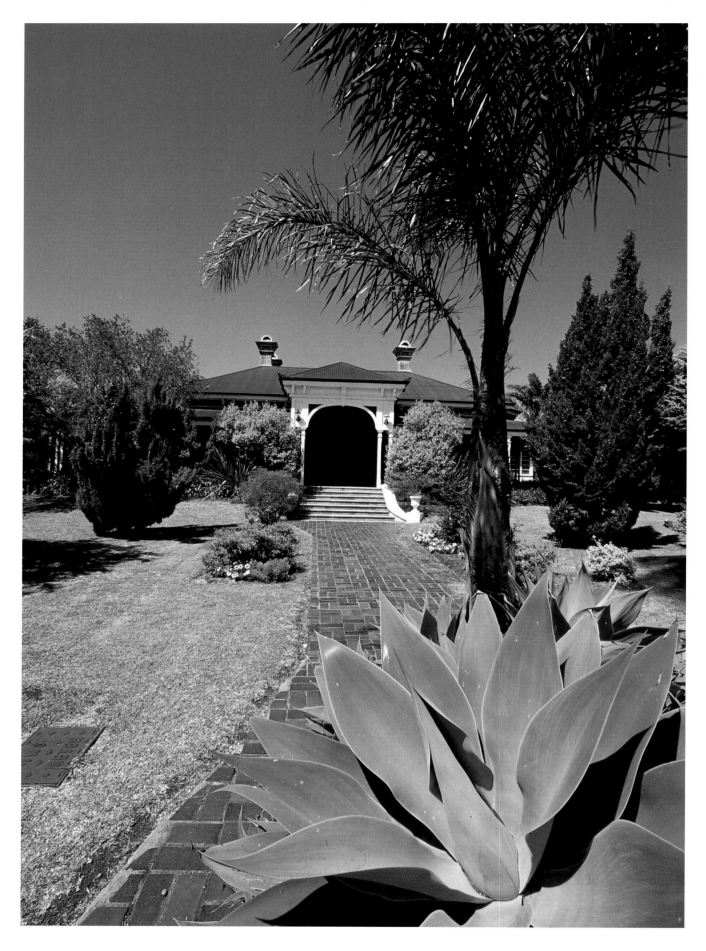

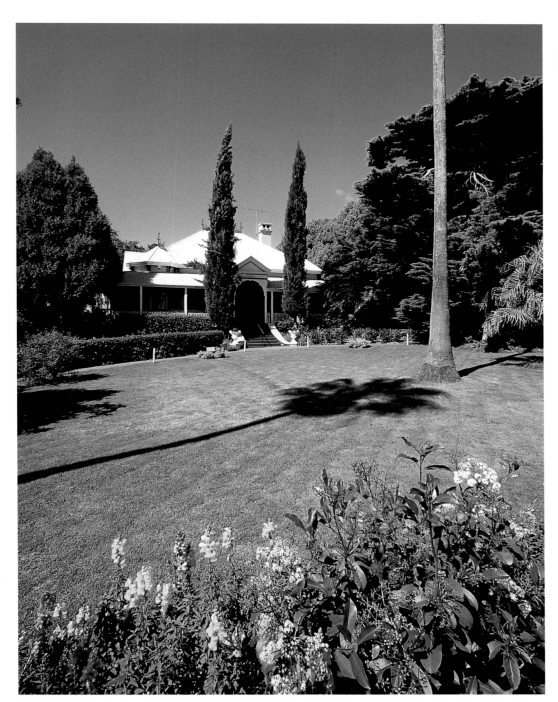

Kensington House in Toowoomba, which is surrounded by green space. Two tall cypress trees frame the principal entrance.

A pool surrounded by flowers in the middle of the lawn at Vaucluse House in Sydney.

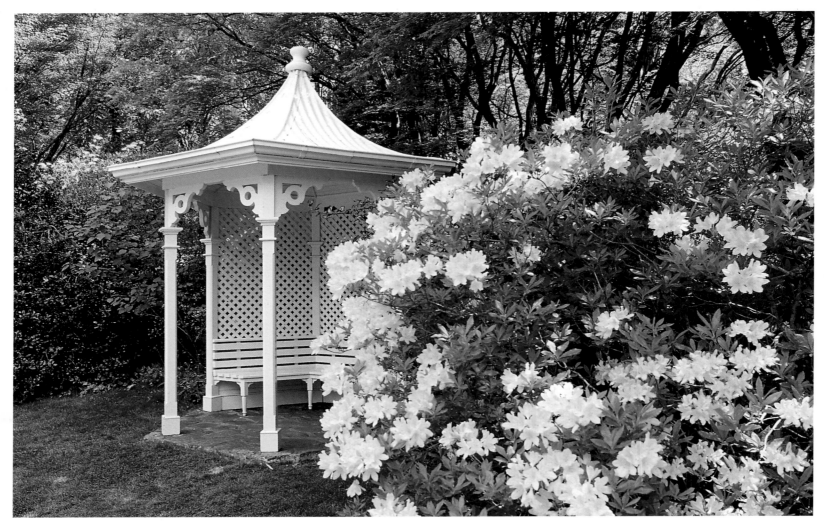

The park of Nooroo House in Mount Wilson, a town in the Blue Mountains in the province of Sydney. The design is primarily Victorian, like that of the wooden gazebo.

The gardens of Lewisham House, close to Melbourne. The contemporary residence is predated by the grand landscaped park, in which are bridges, gazebos, and other structures.

Opposite: Several pergolas on axis with a sundial, in the garden of Witycombe in Mount Wilson. The pergolas are covered in and surrounded with a great variety of plants.

Pacific Serenity

This arc of volcanic islands in the center of the Pacific Ocean constitutes an immense tropical garden where orchids are endemic. The rich volcanic soil and the complex terrain favor a variety of microclimates that have contributed to extremely diverse vegetation. On the island of Lanai, for instance, a distance of three miles spans the tropical coastal climate and the "English" climate of the interior, which remains swathed in fog half the day. The vegetation—decidedly continental—changes simultaneously.

There are few formal gardens in the Hawaiian Islands; geometry is a rare extravagance. Instead, green spaces are developed more by subtraction than by addition. The flora is so dense that it is necessary to cut rather than to plant to create a garden. The garden has been adapted as well to life that unfolds both outside and inside. Terraces, verandas, patios, and pergolas unite the interiors with the exteriors, and plants are everywhere: bougainvillea, hibiscus, ginger, and giant *puakenikeni* and jacaranda trees, as well as orchids of every color and dimension.

Contributing to the rich variety of vegetation on the islands are Victorian conservatories where rare plant species are raised. In addition, Hawaii has a tradition of gardens that display the work of various artists. Both private and public, such green spaces take advantage of the extremely pleasant climate to move even the museums outside.

Lanai, one of the smallest islands in the Hawaiian archipelago. The bluffs above the sea border one of the island's golf courses.

A Victorian greenhouse in the garden of the Lodge at Koele, in the center of Lanai.

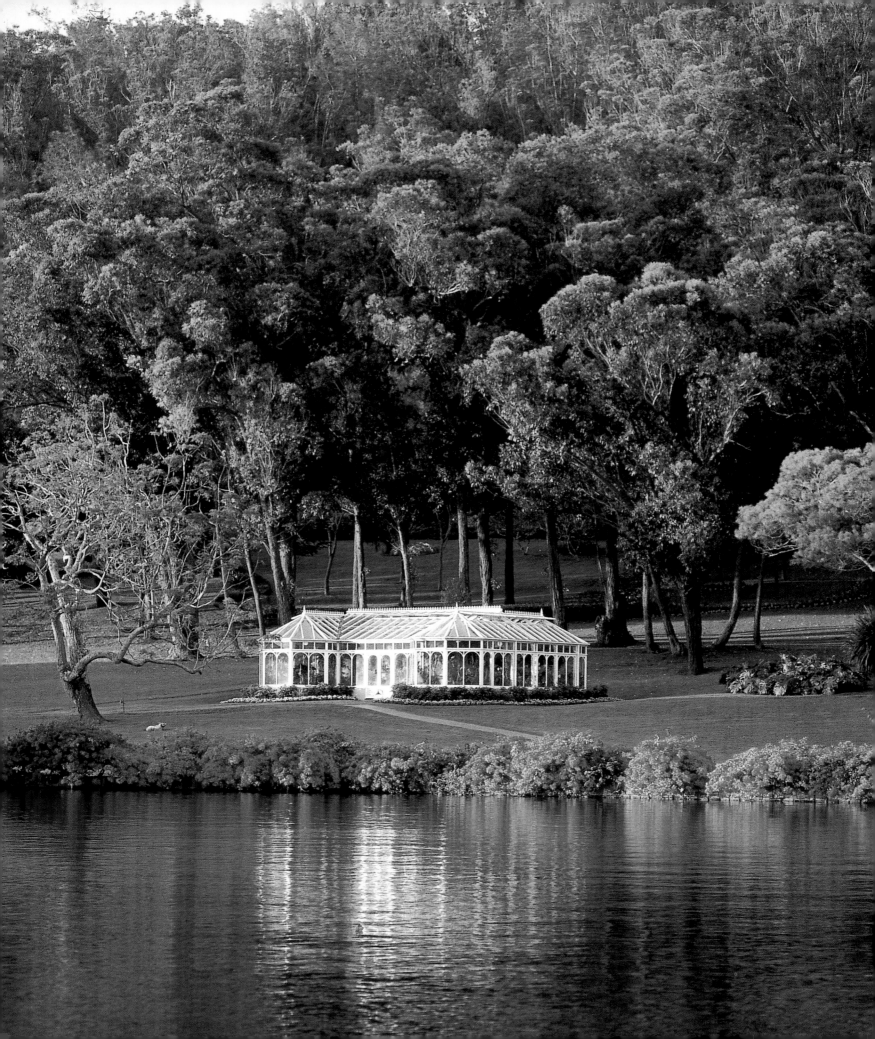

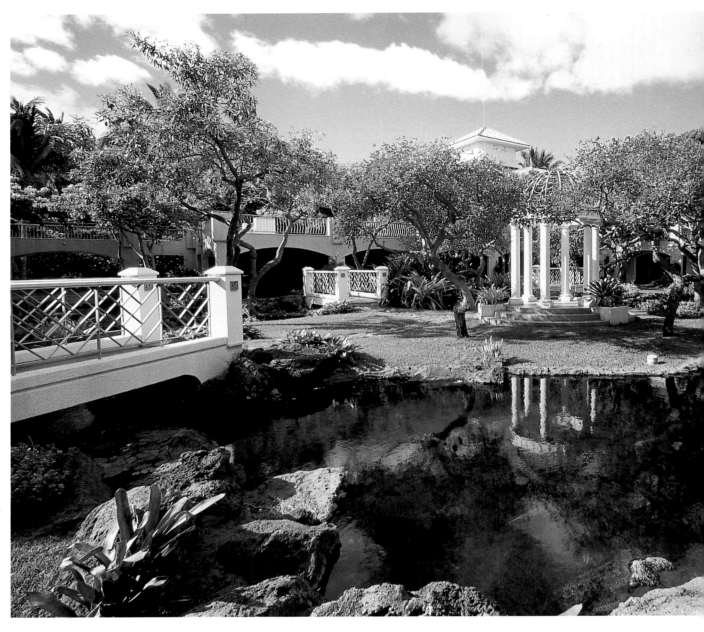

The gardens of the Manele Bay Hotel in Lanai, which feature tropical flora as well as canals, waterfalls, bridges, gazebos, and rocks.

The parterre of the Lodge at Koele, formal and very European, on the island of Lanai.

Overleaf:
The gardens of the
Manele Bay Hotel,
which hang partly
over the ocean.

The gardens of the
Manele Bay Hotel,
where paths lead
to different kinds
of lodging.

Heavenly Terraces
in Honolulu, with
a rich collection of
artworks skillfully
placed throughout
the green spaces.

Ricinus communis

Senna surattensis

Schefflera actinophylla

Sesbania tomentosa

FLOWERS AND PLANTS OF HAWAII

The mountainous and irregular Hawaiian Islands, which emerged from the Pacific Ocean millions of years ago, constitute the northernmost Polynesian archipelago. Mauna Kea, a volcano of almost fourteen thousand feet, and other peaks make the islands of Hawaii among the highest oceanic islands.

The first colonists brought drastic change to the coastal vegetation: extensive forests were cut to the ground and many exotic species introduced by humankind replaced original plant life. Some of the imported types of vegetation, which have become almost naturalized, are *Ricinus communis,* which grows in disturbed and rather dry places, *Senna surattensis,* which is leguminous with characteristic leaves and grows in the undergrowth of the forests, and *Schefflera actinophylla,* an araliacea nicknamed "octopus tree" because of the form of its floriferous branches.

Forests rich in ferns and plants of Indo-Malaysian origin cover the humid northeastern mountainsides; species of Mexican and Andean origin, suitable for conditions of greater aridity, occupy the western leeward mountainsides.

Between 2,300 and 4,000 feet, above a strip occupied by open and thinned forests, grows a dense forest similar to the rain forests of other parts of the world. *Acacia koa, Metrosideros polymorpha,* and various lobeliaceous species are commonly found in this zone. Above this area develop high-mountain formations with shrubby and herbaceous plants, including the gigantic silver swords *Argyroxiphium sandwicense,* endemic arborescent composites similar to the *Senecio* of the high African mountains.

Situated thousands of miles from any great land mass, the Hawaiian Islands have undergone an intense process of specialization that has led to

*Argyroxiphium
sandwicense*

*Lipochaeta
integrifolia*

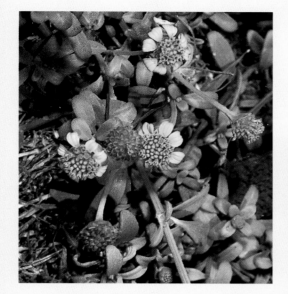

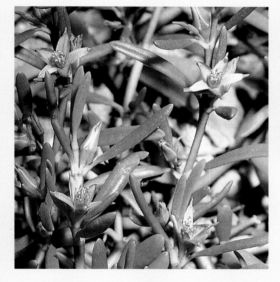

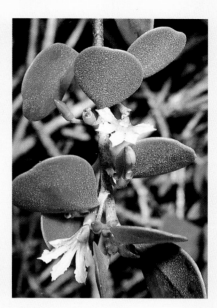

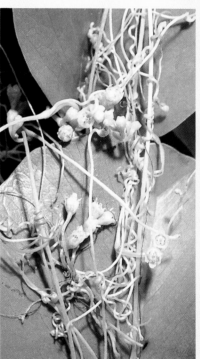

*Sesuvium
portulacastrum*

*Above right:
Scaevola coriacea*

*Right:
Cuscuta sandwichiana*

the development of numerous exclusive species: Hawaii has the greatest number of native plants in the world—close to 90 percent. In addition to the silver swords are the leguminous *Sesbania tomentosa*, the rare goodeniacea *Scaevola coriacea*, the composite *Lipochaeta integrifolia*, the halophilous aizoacea *Sesuvium portulacastrum*, and the parasitical cuscutacea *Cuscuta sandwichiana*. Yet despite its richness and variety, Hawaiian vegetation is mostly composed of unoriginal plants; in fact, the greatest number of native plants are classified as extinct, endangered, or threatened by the exotic varieties introduced by humanity.

Bibliography

For those areas where no specific volumes are available, studies on villas, castles, and palaces that deal with gardens as well—even if only indirectly—have been included.

General Works

W. H. Adams. *Nature Perfected: Gardens Through History.* New York, 1991.

E. de Ganay. *Bibliographie de l'art de jardin.* Paris, 1989.

B. and L. Gibbons. *Il giardino abitato.* Bologna, 1992.

P. Grimal. *L'arte dei giardini: La cultura del giardino attraverso la storia.* Salerno-Rome, 1997.

P. Hobhouse. *Gardening through History.* New York, 1982.

G. Jekyll, L. Weaver. *Arts and Crafts Gardens.* Woodbridge, Great Britain, 1997.

G. Jellicoe, S. Jellicoe. *The Landscape of Man.* London, 1975.

M. Laird. *The Formal Garden: Traditions of Art and Nature.* New York, 1992.

J. Lehrman. *Earthly Paradise.* London, 1980.

E. MacDougall, R. Ettinghausen. *The Islamic Garden.* Washington, D.C., 1976.

G. Mader, L. G. Neubert Mader. *Giardini all'italiana.* Milan, 1987.

C. W. Moore, W. J. Mitchell, W. Turnbull. *The Poetics of Gardens.* Cambridge, Mass., 1991.

M. Mosser, G. Teyssot. *The Architecture of Western Gardens.* Cambridge, Mass., 1990.

E. B. Moynihan. *Paradise as a Garden in Persia and Mughal India.* New York, 1979.

D. Ogrin. *Giardini del mondo.* Milan, 1995.

A. Petruccioli. *Il giardino islamico: Architettura, natura, paesaggio.* Milan, 1994.

F. Pizzoni. *Il giardino arte e storia.* Milan, 1997.

G. Plumptre. *Il giardino d'arte.* Milan, 1989.

H. Pückler-Muskau. *Giardino e paesaggio.* Milan, 1984.

M. Rothschild, K. Garton, L. de Rothschild. *The Rothschild Gardens.* New York, 1996.

M. Symes. *A Glossary of Garden History.* Haverfordwest, 1993.

A. Vannucchi. *Il giardino: Storia e tipi.* Florence, 1994.

G. Van Zuylen. *Il giardino paradiso del mondo.* Milan, 1994.

M. Venturi Ferriolo. *Giardino e filosofia.* Milan, 1992.

R. Vessichelli Pane. *Il giardino.* Milan, 1994.

H. Walpole. *Saggio sul giardino moderno.* Florence, 1991.

W. Warran. *Giardini tropicali.* Milan, 1991.

F. Zagari. *L'architettura del giardino contemporaneo.* Milan, 1988.

Americas

J. Arrigo, D. Dietrich. *Louisiana's Plantation Homes: The Grace and Grandeur.* Stillwater, Minnesota, 1991.

B. Barney, F. Ramírez. *La arquitectura de las casas de hacienda en la Valle del Alto Cauca.* Bogotà, 1994.

R. Burle Marx. *The Unnatural Art of the Garden.* New York, 1991.

Caribbean Style. New York, 1985.

J. W. Cooper. *Antebellum Houses of Natchez.* Natchez, Mississippi, 1983.

Fazendas: Solares da Região Cafeeira do Brasil Imperial. Rio de Janeiro, 1990.

M. Folsom. *Great American Mansions and Their Stories.* Mamaroneck, New York, 1963.

F. Gagnon Pratte. *Maisons de campagne des montréalais 1892–1924.* Montreal, 1987.

G. Gasparini. *Casa venezolana.* Caracas, 1992.

D. K. Gleason. *Virginia Plantation Homes.* Baton Rouge and London, 1989.

M. Griswold, E. Weller. *The Golden Age of American Gardens.* New York, 1992.

A. Haas, N. Sapieha. *Gardens of Mexico.* New York, 1993.

I. Macdonald-Smith, S. Shorto. *Bermuda Gardens & Houses.* New York, 1996.

D. K. McGuire. *Gardens of America: Three Centuries of Design.* Charlottesville, Virginia, 1989.

N. G. Power. *The Gardens of California.* London, 1995.

M. Randall. *The Mansions of Long Island's Gold Coast.* New York, 1987.

R. Rendón Garcini. *Haciendas de México.* Mexico City, 1994.

J. Rigau. *Puerto Rico 1900: Turn-of-the-Century Architecture in the Hispanic Caribbean 1890–1930.* New York, 1992.

M. Sáenz Quesado, X. A. Verstraeten. *Estancias: The Great Houses and Ranches of Argentina.* New York, 1992.

R. Schezen, S. Johnston. *Palm Beach Houses.* New York, 1991.

R. Schezen, J. Mulvagh, M. A. Weber. *Newport Houses.* New York, 1989.

A. Spoule, M. Pollard. *The Country House Guide.* Boston, n.d.

T. Street-Porter. *Casa mexicana.* New York, 1989.

G. Tellez. *Casa colonial: Arquitectura doméstica neogranadina.* Bogotà, 1995.

Europe

W. H. Adams. *The French Garden 1500–1800.* London, 1979.

M. Batey, D. Lambert. *The English Garden Tour.* London, 1990.

J. Borg. *The Public Gardens and Groves of Malta and Gozo.* Valletta, 1990.

P. Bowe, N. Sapieha. *Gardens of Portugal.* London, 1989.

J. Brown. *Arte e architettura dei giardini inglesi.* Milan, 1989.

H. Carita, H. Cardoso. *Portuguese Gardens.* Woodbridge, Great Britain, 1990.

Castella: Guide universel des châteaux du Benelux. Lierneux, Belgium, 1992.

Castelli d'Ungheria. Budapest, 1991.

S. Chirol, P. Seydoux. *La Normandie des châteaux et des manoirs.* Paris, 1989.

H. F. Clark. *The English Landscape Garden.* Gloucester, 1980.